The Hot Shoe Diaries

BIG LIGHT **FROM** SMALL FLASHES

Joe McNally

New Riders

VOICES THAT MATTER™

The Hot Shoe Diaries: Big Light from Small Flashes

Joe McNally

New Riders
1249 Eighth Street
Berkeley, CA 94710
510/524-2178
510/524-2221 (fax)
Find us on the Web at www.newriders.com
To report errors, please send a note to errata@peachpit.com
New Riders is an imprint of Peachpit, a division of Pearson Education

Editor: Ted Waitt
Production Editor: Lisa Brazieal
Interior Design: Charlene Charles-Will with Kim Scott
Compositor: Kim Scott, Bumpy Design
Indexer: James Minkin
Cover Design: Charlene Charles-Will
Cover Image: Joe McNally

ISBN-13 978-0-321-58014-6
ISBN-10 0-321-58014-1

9 8 7 6 5 4 3 2 1
Printed and bound in the United States of America

For Annie, the only light I need.

Acknowledgments

In the spring of 1981, America returned to manned space flight. I was assigned to shoot the first launch and landing of the space shuttle. I had no idea how to do it.

I was not alone. There were a bunch of us young pup photogs going down to Kennedy Space Center to cover this big roman candle heading into heavens, and none of us knew squat about shooting a launch. The last manned American space flight had taken place 20 years previous, and during that hiatus, there was about as much photographic interest in the space program as there was in covering meetings of the regulatory board of the local utility company. In other words, zero.

So we went to lunch with Ralph. Ralph Morse, longtime *Life* staffer and dean of American space photography, was *the* expert in shooting launches, having covered the original Mercury 7 astronauts in the early days of the space program. Ralph, even though he was on assignment for *Time* (which made us his competition), sat down and told us how to do it. Every step. Held nothing back. Gave us the what for and the how to of photographing a launch.

He was comfortable doing that, because he was so confident in his own abilities that he could tell us exactly what to do and still go out there and kick our butt. Which he did.

This was, blessedly, how I was raised, photographically speaking. Knowledge was shared and passed on. I was mentored, instructed, coached, screamed at, cajoled, ridiculed, pushed, and edited by peerless professionals, both on the shooting side and the editing side. I was relentlessly told that what I was shooting wasn't good enough, didn't cut it, and that I needed to work to get better. Some of this news was delivered in congenial, avuncular fashion. Other assessments were offered in less temperate ways, such as the time I had my film (three rolls of B&W) crushed into a ball by my assigning editor at the UPI and

thrown at me in the middle of the New York newsroom. This missile was accompanied by a pungent appraisal of my meager talents, as well as a brief overview of my ancestry.

During this process of learning—which is ongoing, by the way—I looked at lots and lots of work and, of course, had many photographic heroes I wished to emulate. These shooters had made pictures that formed the high ground I was trying to reach but could only see from a distance and wonder about.

So in many ways, this book, to the degree it is instructional, helpful, or informative, is dedicated to that hall of learning that was created by those shooters and editors who have gone before. Even in the fast and facile world of digital photography, where experience and accumulated knowledge goes stale as quickly as a loaf of bread, and is often viewed with about as much worth, I revere that work, and the people who created it and thus shared it with all of us, much to our betterment.

In the field, these photographers created stunning pictures with tools that were the equivalent of a hammer and a chisel. Shooters like Carl Mydans, Alfred Eisenstaedt, Gordon Parks, Ralph Morse, W. Eugene Smith, David Douglas Duncan, John Zimmerman, Neil Leifer, Walter Iooss, Dan Farrell, O. Winston Link, Robert Capa, George Roger, Arnold Newman, Gjon Mili...the list goes on.

Many of them were there, by the way, on the 28th floor of the Time Inc. building, the floor that housed the photo equipment area and all the photog offices. As a young shooter it was always a thrill to get a job from one of the mags in the building, and have to go up to 28 to get film, or a lens, or a light. I would wander down the hall and bump into Eisie, Carl, Ralph, or Mr. Mili. (The ever formal Gjon Mili, genius of light, was always Mr. Mili.) I could hover at the edge of the lounge, listening

as they would have coffee and compare field notes, like a kid at the kitchen door, peering in and watching as the grown-ups at the table had serious talk.

As a shooter, I am still listening and learning, though the process has taken on different shape and form. That photo lounge on the 28th floor is now called the internet, and photographic field notes that used to be traded over coffee now pulse around the world in, well, a flash. In days gone by, shooters at a big event would roll their images up into yellow cassettes, number them with a marker, and dump them into their bag for processing and digestion at a later time. Now, at those events, their images pipe through lines or fly through the air and are published before they leave the parking lot.

Same deal with the trading of photographic notions, lessons, and technique. There are those wise, gracious, and confident enough to share hard-won knowledge and experience. It is as if they have plugged a high-speed modem directly into their mental vault of photographic expertise and are sharing that with far greater numbers than can gather 'round a table in a lounge.

David Hobby has created a worldwide community of learning called Strobist. Chase Jarvis shares his considerable skills in full on his blog. Moose Peterson dives into problems, sorts them out, and offers pages and pages of solutions, all at the click of a button. Every day Scott Kelby writes, people read and learn. Dave Black, David Bergman, Drew Gardner, Dave Cross, Matt Kloskowski, David duChemin, Michael Clark, Syl Arena...again, too many to list. The tradition of photographic sharing continues. This book follows their lead.

Many opened the door for me to write these pages. My friend Scott Kelby, editor of *The Moment It Clicks*, cleared the fog in my brain, helped me organize my thoughts, and convinced me I could actually write something longer than a two-line email. When you listen to the power and encouragement in Scott's voice, things become possible. Moose, by being the great and wise friend he is, and to be honest, by being a bit of a nag (for a year or so, every time he saw me he'd stare at me hard and ask, "Where's your blog?"), pushed me to embrace writing

as another means of expression that didn't have to involve a camera and a lens.

My family over at Nikon, as always, enabled me to write this book. Thanks go out to Mike Corrado, my blood brother who continues to have faith in a geezer; David Dentry, who explained the science of TTL in plain English; Bill Pekala, friend to shooters everywhere; Melissa DiBartolo, the muse of NPS who juggles the frenetic needs and last-minute wishes of photographers with Solomonic fairness and calm de-meanor; Joe Ventura, who listens and acts on behalf of photographers and their ideas; and Ed Fasano, who keeps the ship on course.

And, of course, there is Lindsay Silverman...the mad genius of flash. Lindsay knows Speedlights like a parent knows a child. Ask him a question about flash. Half an hour later, you will feel like you played a football game, and just got pummeled with more knowledge, tips, and tricks than you could try in a lifetime. It's exhausting. But it is also emi-nently admirable. His knowledge is not dry, clinical, or mechanical. It is the stuff of passion.

Passionate people abound in this community. The folks at Adorama stepped forward this year and partnered with my studio in preserving The Faces of Ground Zero Giant Polaroid Collection, thus enabling me to remain a caretaker of those images and the extraordinary people they represent. My bud Jeff Snyder made that happen, getting me to-gether with the Adorama administration. With a handshake, I became part of the Adorama family. His colleague Monica Cipnic works with shooters everywhere to create opportunities and workshops to teach and share wisdom.

Bogen USA remains an ongoing partner, not only in providing won-derful tools to use in the field, but also in listening and responding to photographers' notions and ideas. Kriss Brungrabber and Mark "The William Holden of Flash Photography" Astmann are always ready with a handshake and an offer of support. Likewise, Jeff Cable and Michelle Pitts of Lexar are in the photog's corner. Every digital picture in this book was made on Lexar media. I have found their cards to be the Fort Knox of digital capture.

I have already mentioned some of the folks at NAPP and Kelby Online Training—Scott, Dave "C" for Canada, Matt K—but there are more. Kalebra Kelby completes the remarkable team that started all this, and has been a wise and wonderful source of support. Dave Moser remains an inexhaustible force of nature, despite being father of brand-new twin girls. Jason Scrivner, "The Scriv," gets it done behind the video camera. RC Concepcion is non-stop ideas, passion, and pictures, and new father of Sabie. And my dear friend Kathy Siler somehow always answers the phone, and always makes the impossible look effortless.

The team over at Peachpit—Nancy Ruenzel, Lisa Brazieal, and Charlene Will—coached, guided, and put up with me. But nobody over there put up with my antics with more grace, erudition, and patience than my editor, Ted Waitt. He has logic, a sense of calm, and an ability to make order from confusion. He is also passionate about photography, asked me the right questions, and bent the whole book in a positive direction.

Dan "Dano" Steinhardt of Epson remains stalwart in his support of shooters everywhere. Martin Gisborne and Bahram Foroughi of Apple receive and give out good ideas in equal measure. Reid Callanan of the Santa Fe Workshops and Elizabeth Greenberg of the Maine Media Workshops continue to create wonderful atmospheres of photographic passion and learning. I made many of the photos in this book as a result of teaching at these workshops, and my thanks go out to the community of models, dancers, and assistants who all share in the uncertain but wonderful world of making pictures happen.

Certainly my multiple families helped me make it through this book. Moose and Sharon Peterson, Laurie Excell, Kevin Dobler, and Joe Sliger, all members of my DLWS family, remained a constant support. As did again my sisters, Kathy and Rosemary, who came to the Vermont DLWS this past year and are now owners of D60 cameras, officially bitten by the photo bug. And, of course, my kids, Caitlin and Claire, who kept asking when would the book be done, and thus kept spurring me to actually make it done.

My studio family was with me every step, as well. Lynn DelMastro, who is my studio manager of 16 years, and my friend beyond words or measure, keeps our tiny studio on course, even on those days when we can't completely figure out what course that might be. Were it not for her constancy, good humor, decency, and business sense, our picture shop would have been shuttered long ago. And Drew Gurian has ably stepped into the first assistant shoes of Brad Moore (now assisting Scott Kelby, to keep it all in the family). Drew has taken to juggling the constant duties of the studio and wear and tear of the road with remarkable calm and good humor.

And, of course, Annie, without whom nothing is possible, either in my life or in the world of TTL flash. She constantly kept me on course, reminding me time and again that not everyone would connect with my built-in, thirty-year store of photo slang, and thus might not understand what I'm saying when I "rack out a lens" or "spark somebody with a pepper." She kept me on the side of reasonable English and understandable instruction. And, as always, kept my heart alive with her smile, her patience, her wisdom, and her love.

Contents

PART III Two or More

This Is Not the Manual

Trust me, you don't want me writing a manual. My ever patient wife tells me I'm the walking, talking, living, breathing definition of "discursive."

In *Webster's*, discursive is defined as "moving from topic to topic without order." Or, even worse, "passing aimlessly from one subject to another; digressive; rambling."

Ouch. Okay, I'm not manual material.

Who are the people who write manuals? They are organized, concise, lucid, meticulous, and analytical. They think in a linear, precise way. They draw hellacious diagrams. They are technically sound, and they think things through. Generally, they are not photographers.

Kudos to the folks who think up all this camera techy-type stuff and then try to tell us how to use it. It's amazing. Astonishing, in fact. Absolutely necessary. No new camera box would be complete without it. That little camera bible, replete with information. The keys to the castle. Inside that book are words, charts, graphs, and diagrams, as richly detailed and potentially rewarding as any treasure map.

Too bad you'll never read it.

Not that I blame you. I don't read them either. What follows on these pages is, indeed, not the manual. The manual is full of certainties and formulas—absolutes, even.

I've been a photographer for 30 years, and that is long enough to know a couple of things.

"This is not a book of certainties. It is not a manual. It is, as the title states, a diary."

There aren't many certainties in this nutty business, and even fewer absolutes.

Especially when you talk about light. Light is quicksilver. Magic. It is here, then it is there. Then it is gone. A scene that's alive with color and contrast draws you to photograph it. You reach down into your bag to change to the appropriate lens, and look again, and it's all gone. Clouds rolled in, and what is left is drab and colorless, flat and dull.

Damn. Maybe you could fix it with a flash. You know, that little battery-operated package of light that is in your camera bag, in the pocket marked "Open only in case of emergency."

For lots of reasons, flash is an even bigger mystery than light that you can see. Quick as a blink, tough to control, surprising at every turn, frustrating one day and even more frustrating the next. You mess with it, cursing every uncertain step, guessing about what to do next (remember, you didn't really read the manual), fumbling with the buttons, the switches, the white balance, and the plus/minus EV controller on the flux capacitor, and the flash accidentally goes and light careens around the room, bounces off the ceiling, clips off a mirror, comes back, hits your subject, and looks—beautiful.

How do you do that again? You pick up the flash in a throttlehold and start screaming at it. "Do that again!" It is, of course, mute. Light keeps its secrets close.

This is not a book of certainties. It is not a manual. It is, as the title states, a diary. It is an ongoing account of adventures and misadventures, of accidents—happy and otherwise—and of successes and failures. It is an irreverent (go figure) brain dump of accumulated knowledge, much of it hard won in the school of hard knocks, bad bounces, lousy exposures, and misguided notions. None of it was present at birth, embedded in my genes, the way the ability to throw a football a couple hundred yards or grow to over seven feet and outrun a gazelle might be for some. (I wish. I always wanted to play center for the New York Knicks.)

It is a book about what I do. To the degree that it is specific, it is specific to that. The opening section, for instance, is titled "What I

Use...and Why and When I Use It." Very accurate. From the moment I walk out my door to the moment I get to location and start wrestling with the job, I talk about every issue that confronts me, or any other photographer.

And when I say "every issue," I really mean exactly that. When you talk about flash, you talk about light. Talking about light means talking about exposure. Which means talking about f-stops, shutter speeds, and exposure values. It means talking about the balance of applied flash versus found, or ambient, light. Do you filter your flash into the scene, unnoticed, like a thief in the night? Or do you wrestle the existing light to the ground, subdue it, and impose your own?

Talk about flash, you gotta talk about color. Which means figuring out white balance and gels, and understanding how colors relate to one another. You need to talk about the direction and quality of the light, so you need to talk about light-shaping tools, which leads to a discussion of grip gear, and what you bring with you in the field.

The flash sits atop the camera, or connects to it via a wire or a set of morse code–like signals that fly through the air, so you have to talk about how these two mildly complicated technological marvels dance together. Each has its own buttons, dials, and controls. Spin those dials, punch those buttons, and you will see numbers change, plus and minus, up and down. You will see codes appear, and acronyms, and symbols. It might feel like math. Do it right, though, and the results are poetry.

Visual poetry. The feel of the light, not the numbers. How does simply programming in +1.3 EV to the flash and −2 EV to the camera translate into a picture that makes you giddy to look at? That makes you wanna show everybody? That makes you print it the size of a highway billboard? That makes those confounding, tedious, and mysterious numbers—go away?

That's an awful lot of what this book is about. Making the numbers go away, or at least add up. Demystifying what at first glance seems to be as simple and decipherable as Newtonian physics. Taking flash (often that hulking, 600-pound gorilla sitting there in the dark, fevered

corners of our collective photog imaginations) as knowable, predict-able, amiable—hell, even lovable as Nigel, my wife's 19-pound cat. Making the moves, shifts, and inputs you make at the camera feel like muscle memory. Intuitive and instinctual—easy, even. More like breathing than, say, juggling, or ballet dancing.

To that end, I repeat myself throughout the pages. At every turn, when dealing with light, the same issues present. They present in different form, but they are still there, hovering around every frame—quality, color, direction, exposure, f-stops, shutter speeds, camera modes, white balances, diffusers, stands, clamps, hot shoes, cold shoes—and I talk about them in turn, again and again. The issues repeat, so I repeat myself. I go over it in this book again and again, the same way I go over it on location, on assignment, again and again. It is how the unfamiliar, the difficult, and the awkward become instinct.

The language of light. It is how we write the story of our subjects. Just like language, we use the same words, over and over. We just put them together differently every time we put our camera to our eye.

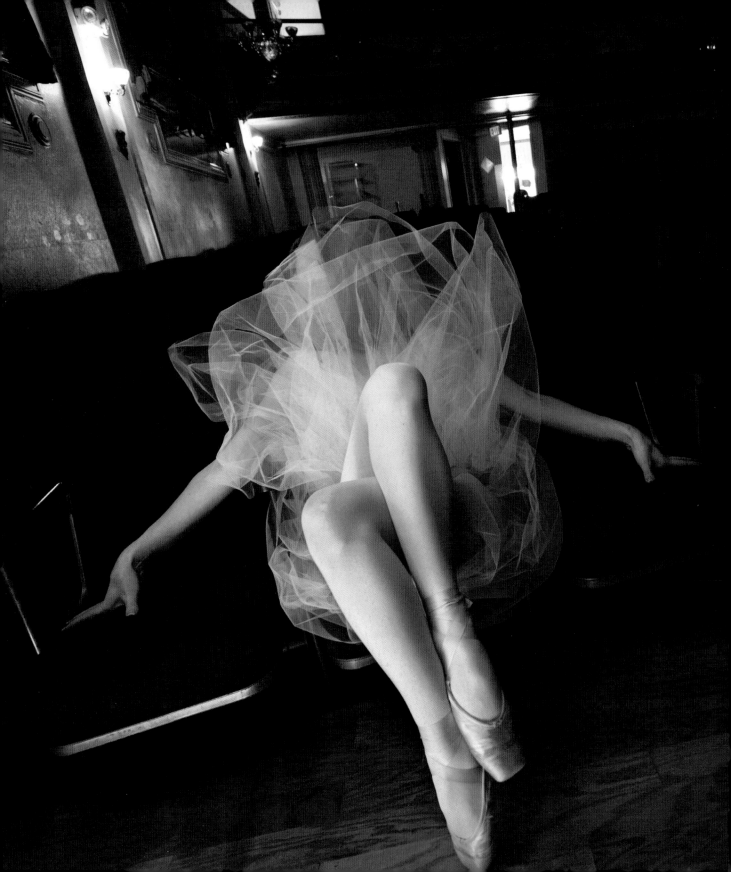

Nuts 'n' Bolts

Or, "Don't worry. As long as you hit that wire with the connecting hook at precisely 88 mph the instant the lightning strikes the tower…everything will be fine."

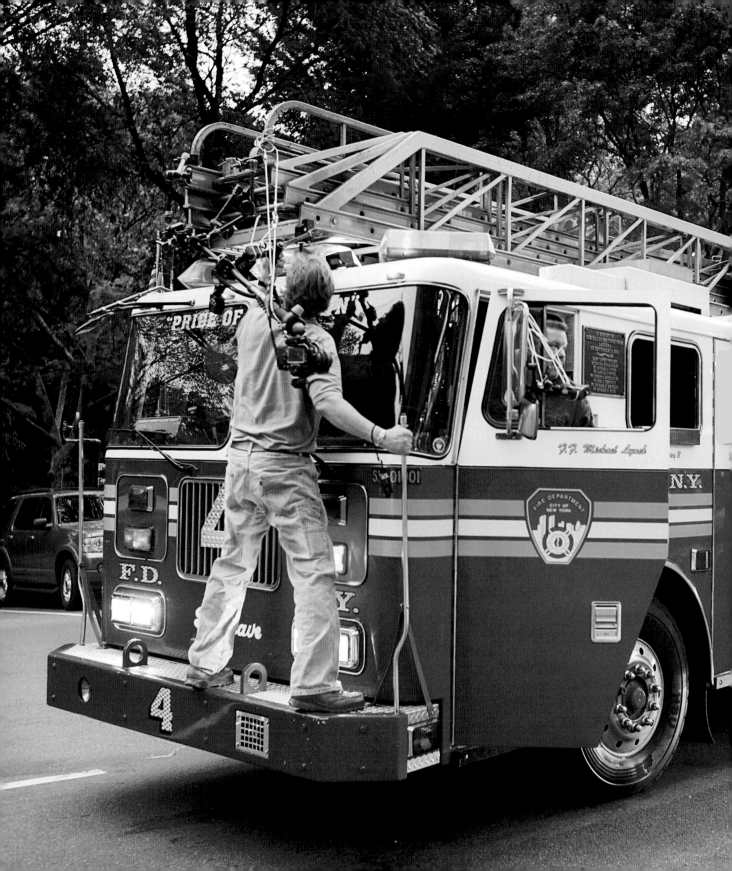

What I Use... and Why and When I Use It

OKAY. HERE WE GO. The whole megillah, right from when I walk out the door with a small flash job in mind. Bit by bit, piece by piece, from the camera to the flash to the flotsam and jetsam of my lunatic imagination.

Alternatively, you could read the user's manual. Wouldn't that be a nonstop good time? Pulls in somewhere around "putting razor blades in your eyes" on the fun meter.

Or, you could convince yourself that your photographic aesthetic precludes the use of "artificial" light, and you only work with "natural" light. Going natural may be fine in other areas of your life. Hug all the trees you want. Grow hair everywhere. Eat lots of fiber. Run naked through the forest and howl at the moon. Start primal scream therapy.

But here's the deal. If you pick up a camera with any sort of serious intent, you will at least occasionally need to use a flash. Done deal. Lock solid. Take it to the bank.

So let's get into it, shall we? First, the camera stuff.

The Camera

APERTURE PRIORITY MODE

I am in aperture priority mode 90-plus percent of the time. It works for me because I vastly prefer to dictate to the camera the f-stop I will shoot at, rather than dictate shutter speed via shutter priority mode. I am comfortable handholding my cameras at all manner of shutter speeds, and since I am often shooting with some measure of fill flash, slow speeds—in the neighborhood of 1/30th, 1/15th, etc.—don't hold any terror for me. I'd much rather be certain of my f-stop, and the resultant depth of field I am getting, than insist on a certain shutter speed.

I am occasionally in manual exposure mode, say, when in a dark room where aperture priority will dictate to me an unreasonably long shutter speed. But, I tell ya, if you only use these cameras in manual mode because, as I have heard on occasion, you "don't trust the camera," or you "don't trust the meter," then you are taking a souped-up Ferrari and driving it like the little old lady going to church on Sunday. Why do that? Use the technology! Take this puppy out for a spin and see what it can do.

"I try to think my way into what the camera is seeing, and how the meter will react."

MATRIX METERING

I live here in the matrix. I rarely go outside. There are two other modes available, for sure—center-weighted and spot metering—but I haven't much use for them. Personal preference.

I always say ya gotta think like the camera, and to the best of my ability I have done a Vulcan mind meld with matrix meter mode. I try to think my way into what the camera is seeing, and how the meter will react. At the same time, it's worthwhile and totally valid to change up the metering mode. Center-weighted mode gives incremental shifts in exposure, especially if your subject fills the foreground and you really don't care about the background much. Shifting into center-weighted mode helps the meter concentrate its efficiency and exposure emphasis in the center of the frame where you want it.

Spot metering is the other way to go, usually in extreme exposure scenarios, such as stage or theater work, where there is drama to the existing light, and you encounter wild and clearly defined swings between what is lit what is not. Spot metering nails the exposure for a very small, key area of the photo, and it has the advantage of being linked with the focus point. The highlighted focus area becomes the active spot for calculating exposure. Good for off-center subjects.

But I still prefer to let it ride with matrix. The camera sees the whole scene and measures it. I make adjustments based on gut instinct,

> "I know, I know, they all say you can't make exposure calls from the LCD. Uh huh. Just like you're not supposed to use your cell phone when you drive."

experience, and what I see on the LCD. (I know, I know, they all say you can't make exposure calls from the LCD. Uh huh. Just like you're not supposed to use your cell phone when you drive.) I like feeling my way, still depending on my eye to make a guess at the adjustments that have to be made. I find this is a handy exercise that keeps your eye attuned to the light, and your radar set up along the lines of what the camera might react to.

If I have to make exposure value adjustments while I am on matrix, the EV button is handily placed right next to Mr. Shutter Button, and with a quick flip of thumb and forefinger, I get whatever EV value I want. This is significant. To change metering modes, I have to take the camera away from my eye. In a fluid situation, that is not a good idea. Try explaining to your editor you missed the winning touchdown 'cause you were switching to spot metering mode. I can keep my face to the camera while I change the EV compensation, eyeballing all that plus/minus info without interruption 'cause it's right there in the viewfinder.

A good thing returned to me from one of the worst weeks of my life. I had moved to New York City, desperate to find a toehold in the big city as a shooter. Didn't happen, of course, at least not right away. Took quite a while to make it stick, and I hadda go at it kinda tooth and claw. The Big Apple doesn't give it up easily.

The first job in journalism I landed was as a copy boy at the New York *Daily News*. Minimal job, minimal pay. I was living in an SRO hotel on the Upper West Side, amidst the hookers, pimps, vagrants, charlatans, cross-dressers, and cockroaches that just come with that kind of place in New York in the seventies.

My apartment was broken into three times. I lost all my camera gear on the last hit. It was the same week I lost my dad. I went home for my union-allotted three days of bereavement. When I came back to the *News*, in my locker was an envelope stuffed with five hundred bucks in cash. Da guys had passed the hat.

With that money I bought a used Leica with a 35mm lens. Had no meter. Had to get used to judging light. My eyes started to see like Tri-X 400 film. Eventually I got myself a Gossen Luna Pro handheld guesstimator-type meter. Stylin'!

With that, I could meter at my position and then guess what I would gain or lose for the scene across the street. Even with the turbocharged computer called a D3 I now have in my hands, it's a game I still play.

Plus, I'm an idiot. If I dialed in spot metering for a specific scenario, I'd forget I was there and spend the rest of the day wondering why my exposures for other kinds of situations were completely wacked.

LCDS, HISTOGRAMS, AND ALL THAT HOOEY!

All that information at the touch of a button. Who'da thunk it, even a short time ago? So here's the deal. Tailor it, shape it, refer to it, and let all that stuff be a handy dandy, loosey goosey guide to get you in the ballpark and keep you there, exposure-wise. But don't make a frame and then turn on the LCD, which is the camera's version of C-Span, and stay glued to it like you're searching the Dead Sea scrolls for new meanings and interpretations. Check it out, to be sure, but don't be a slave to it.

I dial my LCD intensity down a click or so on the D3, and I urge anyone who has an adjustable brightness feature for their LCD to take a look and match the results that work best for them with the feel of their stuff when they launch it on their main computer. In this day of shooting ones and zeroes, nothin's gonna look the same anyway, so at the very least, in your own shop and in your own head, get it right for you. (That's why there is a menu option to adjust the LCD.) Mess with it until you know that little at-a-glance playback device is working for you and the way you shoot.

Histograms are overrated. Handy, to a point, but if all your pictures are bunched in the middle where the camera likes to live, then you are out there in the midst of this wild world filled with color, light, and drama—and occasionally the lack of all three of those, which creates its own kind of tension and interest—and you are making a gray card out of it. Imagine being on vacation and, instead of sending back jazzy postcards or JPEGs filled with high-watt-age RGB-type escapades, you send back—a gray card. "Wish you were here." Your correspondent looks and thinks, "Glad I'm not."

Blinkies, or blinking highlights, are not overrated. These are handy and let you know when an area of your frame is pure white, with no detail. If bits of the whites in your file are blinking, that's most likely fine, 'cause white is white. But if a big swatch of the frame—say, the entire background area—is blinking at you like a digital clock after a blackout, you may have a problem. If this is the case, exposure adjustments might need to be made. (Notice I say "might." You just might wanna blow your picture out and go to highlight heaven.)

ISO

I start my day at ISO 200 'cause the D3 chip is optimized for operation between 200 and 6400. I am always operating the camera at the lowest possible ISO 'cause, plain and simple, it will give me the best quality. ISO 6400 on the D3 is a beautiful thing, but I don't need it too often, and I refuse to use it just 'cause it's there. I will push the edge on my ability to hold the camera at slow speeds, taking that chance in return for image quality.

EXPOSURE COMPENSATION

A mention of ISO leads directly into a discussion of one of the most important and strategic buttons on the camera: the exposure compensation button. Located near your trigger finger on most models, it is the fastest and most effective means of altering the camera's stated exposure. In the automatic exposure modes, it's impossible to bracket as you used to. Now, I realize there's a bunch of folks out there who never spun an f-stop ring on an older style, manual meter camera. With those, if you rotated from f/4 to f/5.6, you got results that were one stop darker. Now, we are in auto heaven. If you punch in a different f-stop, the camera punches back with a shutter speed that gives you an exposure that feels like where you started. (I know, I know, there is an auto bracket feature. You wanna use it, go ahead. Get that priceless, not-to-be-repeated moment in your kid's young life on a bad bracket.) You really don't want to surrender this control, 'cause it is up to you, the photog, to drive the train where you want it to go aesthetically, and not just be a passenger on the camera's exposure express.

Think of it this way—in Photoshop, do you take one of your prized exposures and just let fly on auto levels? No. You are breaking pixels at that point, letting Photoshop behave roughly like a wood chipper, and most folks I know who are particular about their Photoshopping (that would be everyone) would rarely do this. Hell, even the computer boob writing this book knows enough to make a layer and throw down some curves. Those auto modes represent aesthetic surrender. Why do the equivalent at the camera?

> "Now you are making pictures, not just taking them."

So work the EV button. To do this effectively, you have to think like the camera and identify what the camera is seeing. Bright backgrounds will silhouette your foreground subjects, hence you know to program in some plus exposure in order to brighten things for them. If the camera sees a large dark mass in the foreground—say, Uncle Walter looming into the lens when you are trying to do a group shot at a wedding—you know that, in matrix metering mode, the camera will react to that dark mass by potentially overexposing the whole scene. It reaches desperately into the voluminous folds of the crazy unc's cheap suit to analyze brightness, color, and contrast so the pixels have something to chew on. The meter, a highly accurate instrument, does what it tends to do in situations like this—overexpose.

The camera has done nothing wrong in its estimation of either of these instances. It is a machine. It renders its opinions with machine-like efficiency, without regard to nuance, subtlety, or artistic intent. All those things have to be supplied by you. You nudge the camera in the right direction, supplying, say, underexposure to a flat sky to give it punch and color. Or you deliberately place your subject in front of a bright window and overexpose the hell outta everything to give a very vogue-like, high key rendition, and thus veer into close orbit with Ice Planet 255, where there is no sustainable pixel life.

Now you are making pictures, not just taking them. You are using all the controls the camera gives you to break rules, tear up the playbook, and freelance with your picture instincts. No fear! Now, mix this camera EV controller in with some flash, and add the independent plus or minus exposure controls on the flash (to be discussed forthwith, heretofore, and notwithstanding), and oh my, oh my, oh my, go tell it on da mountain, we be makin' the kinda pitchahs mama always told us we coulda done.

Notice I say the flash has independent EV controls. Yes. This is indeed the case. The camera EV is an *exposure-wide* adjustment. A global input, if you will. If you program underexposure into the scene, then you're programming underexposure into the flash, as well. (Interesting twist: If you have the camera programmed with −2 EV and you are in manual exposure mode, the camera overrides the EV message and goes about its business. But—that −2 will still affect the flash input! File that one away, in case you think putting the camera in manual makes the EV adjustment immaterial.) The flash EV we will discuss affects the flash only. It is a local, or selective, adjustment. Read on. The games are afoot!

AUTO WHITE BALANCE

This came to me with the advent of the D3, which has a vastly improved auto white balance feature. Previously, I started my day always in cloudy white balance, which is a slightly warm version of neutral daylight. I'm a people photog, and people look better slightly warm than neutral or cool, so it was a logical choice. Now I find the auto white balance feature of the camera is so balanced that, even with skin tones, I have a fighting chance. Also, when I am in a lovely scene involving fluorescent light in the booth, merc vapor on the loading dock, tungsten over the guard shack, with a little bit of daylight filtering through the grimy windows, the auto white balance feature gives me a far faster, more intelligent assessment of color temperature than I could with my throw-my-best-guess-at-the-color-wheel-dartboard approach.

COLOR SPACE

Why choose a few colors when you can choose lots? Always use the wider color gamut of Adobe RGB. Just makes sense. Colors will be truer and richer, and the transitions between gradations of color will be smoother when you print. You can adjust later for sRGB to give people a good experience on the screen. At the moment of exposure, go in with all guns blazing.

CAMERA RAW

I always shoot raw (NEF), even for what I view as inconsequential bullshit, which actually constitutes most of my work. Ya never know. I shot a stupid job for *Business Week* about a billion years ago. Some gold coins on black velvet. Half-day job. Thought nothing of it. Bored on location. Casual in my approach. Shot less than two rolls of film.

Almost 30 years later, those gold coins have sold more times than any cover of *National Geographic* I've ever shot. I probably have made around $20,000–30,000 from those stupid, badly rendered frames.

So shoot raw, the most bits you can. Then you can either edit tight or expand your storage, but you know you have produced an image that is the level-best quality image you can produce at this point in time, in the known camera and technology universe.

REAR CURTAIN, FRONT CURTAIN, AND RED EYE

Rear curtain. I'm there all the time. It's so important to me that, in the old days, I had a second sync port drilled into a Nikon FM2 by Marty Forscher, the legendary camera wizard of 47th Street Camera Repair. That little modification gave me rear curtain sync, and cost more than the camera was worth. People would stare at that camera, man. Two PC receptacles! It was like having six fingers or a third eye. He wired the custom PC so it would fire the flash at the end of the exposure instead of at the beginning.

Here's the deal. In front curtain, the flash goes off at the beginning of the exposure. In rear curtain, it goes off at the end. Why do we care?

At fast sync speeds like 1/250th, we don't. But when the shutter slows to speeds like 1/30th and below, it's a big deal. Without getting too techy here, at slow flash sync speeds you are blending in the ambient light of the scene, mixing that with the flash. The existing light conditions may dictate that you shoot at 1/15th of a second, but your flash will fire into the scene at, say, 1/1000th of a second. Very fast, in other words. Camera slang for this technique is "flash and burn." You are "flashing" your foreground subject, and "burning" in an exposure for the environment.

At 1/15th of a second, for example, straight-up available light, you'd have a tough time making a sharp frame of the tortoise, much less the hare. But throw a flash at these critters, and you've got a fighting chance at being sharp, courtesy of the speed of the flash. This is referred to as "flash duration." More on this later.

In front curtain mode, the flash not only fires at the beginning of the exposure, but the camera's default setting locks you out from going slower than 1/60th of a second as a shutter speed. Try it. Put the camera in aperture priority, front curtain flash mode. Even in a dark room the camera's shutter will not slide past 1/60th (note: there's a custom setting that allows for slower speeds). Without that setting, the flash and the camera operate together roughly like a bear trap. Bango! No frills, no blurs. This is the old newspaper assignment mode—you know, reserved for the ribbon cutting or the check passing. Hold your nose, shoot it sharp, hit the buffet, and get outta Dodge. (Note: In manual exposure mode, with front curtain set, you can put the shutter speed anywhere you want from 1/250th on down. No restrictions, 'cause, well, you're in manual. This is also true in shutter priority mode, where you are in complete charge of the shutter speed selection.)

Then you've got "slow sync" flash mode. The shutter will drift as normal in aperture priority, but the flash still fires at the start of the exposure.

And, of course, there's red eye. Sorry, folks—not goin' there. Say you're covering the press conference, and in this mode you hit the shutter. In the delay that occurs, the mayor punches out the city councilman, who has just disclosed that hizzoner has been using city funds to rent a Greenwich Village love nest to tryst with high-priced hookers who have been transported across state lines by his cousin's limo service. Arrests were made, people were handcuffed or hospitalized, and you are still there—pop, pop, popping—waiting for everybody's pupils to constrict. Not good.

So I go rear curtain. In front curtain, you flash the subject at the start of the exposure and make 'em sharp, and then, during the rest of the burn, they move or blur right through their flashed image. Doesn't look or feel logical. But, if you start the burn, and they are blurring through the frame and then—*Boom!*—flash hits them, they are sharp (flashed), and all that blur is behind them, where it should be. The suggestion of motion is therefore logical. Your subject has power, direction, and focus. The ghosting, trails, and all that ambient light churn of where they were just a split second ago are back there behind them, where they should be. Think of it as the wake of a fast-moving boat. Where is that located?

So, it don't matter at high speeds, but it's critical at low speeds, so I just leave it in rear.

That's pretty much the camera, now comes the fun part: making it work with CLS!

"Arrests were made, people were handcuffed or hospitalized, and you are still there—pop, pop, popping—waiting for everybody's pupils to constrict. Not good."

Flash Concepts

CLS

What is it?

Stands for "Creative Lighting System." It is a Nikon marketing term referring to the whole shebang— the way the flashes talk to each other and talk to the camera. Describes the entire system, whether you are using one flash on camera, TTL cords, or a bunch of remote flashes. Obviously, the intent and engineering of the whole deal is designed to enable multi-unit, remote, wireless flash photography, so the more remotes you use, presumably the more creative the solution, and thus the term "Creative Lighting System" becomes more and more pertinent as a descriptor.

Why do you use it?

It makes my job easier. It enables me to move fast, and have a flash system that thinks along with me and solves certain problems historically attached to flash photography (big heavy units, cables and wires everywhere, manual controls demanding walkabout adjustment requiring the presence of assistants).

When do you use it?

Use it all the time. There's no exact dividing line between a small flash job and a big strobe job. It's a gut call as to when you cross over into the land of big power packs, assistants, large light-shaping tools, and a more heavy-handed approach. Increasingly, I find that, with the improvement in digital quality at higher ISOs, better batteries with longer life, and more and more attachments designed to soften and control small flash, many jobs and lighting problems can now be solved with the use of these intuitive Speedlights.

I-TTL

What is it?

Acronym for Through-The-Lens metering. It means the exposure is determined from the point of view of the camera, which is essential for accurate assessment of the scene. In other words, the camera figures out the exposure of exactly and only what it is seeing through whatever lens might be attached to it with a very sophisticated on-board meter.

The "i-TTL" business, by the way, is more marketing jazz. (The "i" stands for "intelligent"—it's better.) What it really means is that the sorting out of flash exposure has been optimized for digital sensors.

Why do you use it?

Through-The-Lens metering is really important when using a flash because the camera becomes command central and determines all the components of exposure information based, again, on its point of view.

The flash is not freelancing its own output as it would with "A" mode, where it outputs a value based on sensing reflected light from its position, which may be different from the camera's position.

The camera becomes the head chef assembling all the input ingredients from the flashes, the lens, and the meter, then outputting an exposure it feels is right for what it is actually seeing. It signals to the flash or flashes what they should fire at. It doesn't leave that determination to a solo unit that, being placed out the door or down the hall, might be way off the reservation when conjuring an exposure value. The exposure becomes a sauce, if you will, with a variety of components all blending together information until they become one: the final exposure. The camera's lightning-fast "brain" analyzes these pieces of information and compares them to a pre-recorded data bank of 30,000 (for the D3; it depends on the camera type) exposure scenarios and then makes a determination. It is right lots more than it is wrong.

When do you use it?
Nearly all the time except when I am skinny on power—then I use manual mode on the flash because the manual 1/1 power setting gives me the biggest pop the unit can offer. i-TTL can have its frustrations, because the flash power can vary depending on what the camera is seeing. The stream of exposure information through that lens is ongoing, and often there are variations in that information and how the camera's brain interprets it. I find, though, that i-TTL frustrates me far less nowadays, and it is worth the occasional loop that the exposure mechanism throws me because, just as often as it frustrates me or needs adjustment, it is right on and saves my butt in a tight spot where I need to think and shoot fast. I also put up with it 'cause, ya know, you are throwing information through the air

bundled to photons and light waves and frequencies, and sometimes something's gonna go wrong with that shit. I mean, really. How could it not?

Complaining about it unduly is like being in your car going 85 miles an hour on the freeway, receiving GPS information as to where to go, dialing in ESPN on your iPhone for the latest scores, listening to Howard Stern's rants bounced off a satellite somewhere near Jupiter on your Sirius digital radio, having the vehicle automatically shift from eight cylinders to four in order to save gas, adjusting the temperature for the passenger-side AC to be four degrees warmer than the driver's side, your auto-mode headlights popping on 'cause it's getting dark, and then you call your broker who's spent the day pushing the last of your dough through some high-speed fiber optic cables 'round the globe so you can buy semi-conductor futures on the Nikkei, and you lose the cell signal for a minute. "Goddamn sonuvabitchin' shit don't work! Crap! Dammit! Lost the friggin' signal!!!"

Let us accept the gifts we have with grace and thankfulness.

The Flash

FIGURING OUT THE SPEEDLIGHT LCD

When you have an SB-800 or 900, for instance, programmed to familiar old i-TTL, and you slide it onto the hot shoe of say, a D3, or a D700, or any number of the digital SLRs you've got in the Nikon line, the LCD on the back of the unit changes. Presto! The eerie, glowing acronym jungle. Fear not. We discuss these at length in various ways, mostly associated with picture examples. For now, a quickie on the terms and features.

DOUBLE LIGHTNING BOLT THINGY

It's in the upper left-hand corner of the flash LCD. (With older cameras, you won't see this. Technology marches on. I get questions from time to time about if this stuff works with a Nikkormat EL that was purchased in the '70s and "still takes really great pictures." I'm sure it does, but it won't sing and dance with these flashes the way current camera models will.)

That symbol means the monitor pre-flash is working. And you need it to work. The monitor pre-flash from the master flash does exactly that: it pre-flashes, or fires, telling the remotes to fire their pre-flashes. Based on those pre-flashes, the camera now knows what remotes are out there. It sends a signal to each dictating how it should expose—Group A, go +1; Group B, go −2; and Group C, fire on manual, full power.

The master flash reads the light from those pre-flashes and, in turn, sends more pre-flashes encoded with exposure data. It's kinda like Speedlight morse code. The master flash is the quarterback in a street game of touch football. "Okay, Group A, you go long. Group B, go out 10 yards and cut left behind the parked Chevy. And Group C, you run a post pattern up Mrs. Delmonico's driveway, cut through her rosebush garden, and come out on the other side of the hedge. Hut one, hut two, flash!"

I talk a lot about the pre-flash in this book, 'cause it's so damn important to the success of the system.

I-TTL, AGAIN

i-TTL applies to the flash, too. The camera assesses what it sees in the scene, and that includes what is being influenced by your flashes. That is why the whole deal works, even if you have a remote flash tucked behind an umbrella. If that remote were shutting down independently when it sensed reflection, it would underexpose badly, 'cause the flash's brain is affected by all the light blowing back at it from the umbrella. But the camera does not let the flash think independently. It sees the light that translates through the umbrella and hits the subject. Bingo—highly informed and generally accurate assessment takes place. No loose-cannon flashes out there. The camera makes 'em all stand in line. ("Sir, we have a flash in Group C that has gone rogue. Recommend termination.")

If you get a loopy result, or something's way off, check for pilot error. Check your groups, your exposure mode, your EV buttons, ISO, and all those settings that you used yesterday during that shoot in the coal mine. Check your batteries. If they get low on either the flash or the camera, the system gets strange. Otherwise, if you're on board, and you've got things lined up right, chances are, right from the get-go, you'll be in the ballpark, courtesy of i-TTL.

BL

This stands for "Balanced Light" (technically, Nikon calls it "Balanced Fill Flash"). It means the camera is now in balance mode, trying with all its might to make the foreground and the background roughly equivalent exposure zones. Is this desirable? Sometimes. Like when you are shooting in a fluorescent-lit classroom and you want the front to be nicely lit but the background to also be in register, so you can see all the students. Good to go.

However, if Muffy is on stage in her bunny outfit for the Easter play, under a spotlight, and there is nothing but blackness all 'round (as there often is in a stage environment), it might be best to tap out BL. (Just hit the mode button, it be gone.) Nowadays, with the D3 on matrix metering mode, it is referencing a data bank of 30,000 exposure scenarios, so the flash/camera tandem you've got in your corner might just handle this in reasonable fashion. But when any camera stretches to get its brain around everything from 0 to 255, it can get a little wigged out. The camera sees the darkness and messages the flash: "Arm the photon warhead! Obliterate the darkness!"

The camera, in matrix metering mode and in concert with the flash, tries to brighten the dark world, and the resultant pop of light is right outta *Terminator 3: Rise of the Machines*. (You know, when LA gets vaporized.)

I exaggerate, but be cautious. Might be wise to experiment in these high-contrast situations and tap out BL, and go with straight-up, standard TTL. Also, try changing up to center-weighted or even spot meter mode. Remember, the black wants to be black, so just let it go there, which means you have to make some inputs at camera, including perhaps a bit of minus EV.

AUTO FP HIGH-SPEED SYNC

This gives you the ability to sync a flash at extremely high shutter speeds. Sometimes just referred to as "high-speed sync." Again, we show and tell about this extensively later on in the book. It is incredibly handy, but has limited use. This is not the mode you are in all day, every day, unless you are consistently shooting outdoor graduation portraits of the senior class of the High School of the Great Pyramids, out there in the Egyptian desert.

But, on those occasions when you have to compete with the incredibly bright sun, it is a good mode to investigate. "FP" stands for "focal plane," referring to the blades of the shutter. Normal top-end sync speed for the flash on lots of cameras is $1/250^{th}$ of a second, or slower. In this "normal" sync mode, the shutter is wide open and the light from the flash pops the scene. The shutter closes. Done deal.

> "All this stuff is just stuff, and it helps you fine-tune and otherwise smooth the rough edges of the world you are about to photograph."

That is why the upper limit is set at 1/250th as a rule. It is the fastest speed at which the flash can dump its whole package of light cleanly into the scene, while the shutter is completely open.

Enter high-speed sync. On certain cameras, flash sync can occur at 1/8000th of a second! Holy lightning bolt, Batman, how it do dat!?!?!

In high-speed sync mode, the flash pulses throughout the entire exposure and its output is not complete in one simple pop. Let's talk baseball. Regular sync is like a home run. One shot, one run, over the wall, put that puppy on the scoreboard. With high-speed mode, you build a flash exposure by increments. A walk, a stolen base, then a balk, an error—little by little, we got one across.

Quite literally, the flash is "on" and pulsing throughout the very fast shutter duration. These little bits of light slide through the blades of the shutter in just that—little bits. The flash exposure is "built" in this way. At the end of it, you have this amazing result. A flash shot done at high noon and you were able to underexpose the frikkin' sun!

But, as we note later, the giveback is power. You lose oomph outta the flash, which translates into less f-stop and less flash-to-subject distance. (One way of compensating for this loss of working distance and power is to use more flashes.) It can get, well, interesting. But very worthwhile when working with flash in very bright conditions.

EV COMPENSATION FOR FLASH

So there's EV compensation for the camera, which we have discussed. And, no surprise, there's EV compensation for the flash, too. Aaaargghh! So many things to think of!

Calm down. All this stuff is just stuff, and it helps you fine-tune and otherwise smooth the rough edges of the world you are about to photograph, which, trust me, is not set up in ideal fashion for photographic purposes. When was the last time you walked into someplace and everything was so perfect you could just put your camera to your eye and go click? You will always have to make adjustments. Pushes and pulls and corrections. These little buttons and dials on the camera just help you deal with all that fracas out there. Remember, the world is going full-tilt boogie, all the time, and you are out there with a still camera, for chrissakes. In a world where every day passes as fast and disjointed as an MTV video, where even your average TV show jars the viewer with about three camera angles per second, and where life is a series of quick cuts from the cell phone to the land line to the email to the text message to the rush to the airport for the red-eye flight for the early call...sheesh...and you're out there with a frikkin' *still* camera trying to stop everything. Suspend motion. Hold a moment. Pause. Breathe. Look.

How quaint.

"Simple math, right? No. It's photography, that most inexact of sciences."

So it's not set up for you, right? You are the rock in the middle of the flowing stream, trying to get an angle that makes sense.

Example: You set up and your subject's on the left, and the face is in shadow but there's a nice highlight off his temple that you don't wanna lose. That is coming from the background, which is too bright. You need to flash him to bring him out, but not that much, otherwise you lose the subtlety of the existing light and you end up with a party picture. You are looking to thread the eye of the exposure needle here.

Okay, background's a bit much, but you don't wanna kill it altogether. First things first. Go click, using aperture priority mode. Set everything at zero compensation. Available light. Nothing inputted into the camera on your part. See what it thinks first.

Your subject's dim and the background's hot. No surprise there. But the camera did its job. It looked at the values of the scene and deciphered them in its own soulless, efficient way. This is where you step in.

Need the background a bit darker, so program in −1 EV on the camera. Okay, now the background's looking good. A little more saturation needed? Okay, push it to −1.7. Cool. Lookin' all sorts of dramatic. Of course, our center of attention, the subject, is now a complete silhouette, and at −1.7, that pleasing, separating temple highlight is pretty

much gone. Once again, the horsetrading of location shooting rears up. Want the background darker? Sure, but kiss your highlight goodbye. Okay, we'll deal.

Time to flash the subject. Remember that your Speedlight will be affected by your −1.7 EV input at the camera body. Bango, flash fill, no compensation. We start to see the subject again, but not really. Still pretty dim. The logical side of your brain says, "Okay, the camera is minusing almost two stops. You better plus an equivalent amount on the flash." Simple math, right?

No. It's photography, that most inexact of sciences. It's not a given that the flash power ramp-up must be equivalent to the programmed underexposure on the camera body. You do this by feel, by the look of the light. I would start here by pushing back, and go +1 on the flash. Play with it. See how it feels. It may be enough at +1. Or it may need exactly the giveback of +1.7. Or the person may have very light skin tones and you only need +0.7. Or they may have dark skin and dark clothing and you might find you have to pump even more than 1.7 into the scene, and then still find dead spots, which requires not just more power, but a different direction to the light. So now you gotta get your light off the camera, making it a remote, and trigger it with another flash hot shoed on the camera programmed to

master, or an SU-800, or a built-in programmed to master mode. (Or go to an SC-28 or SC-29 cord and physically hold it off camera.) Once you do that, the picture looks better, but there would be more depth and volume if there was just a bit more highlight off that temple. (Remember the highlight off the side of the subject's head that we liked but killed when we crushed the background?)

You want it back, and you want it gracefully done, in the manner and direction of the light you first saw, which is presumably one of the big reasons you liked this angle for this frikkin' picture. So you go to another light, this one staged roughly in a direction that will effectively replace the highlight you killed while adjusting the overall scene to your liking. You put that flash into another group and start fiddling with it, not only in terms of power, but also color, direction, and quality of light. Which might mean shaping it, gelling it, snooting it, barn dooring it, and putting it on a stand or a clamp. Maybe taking the dome diffuser off. Perhaps zooming it.

Oh my. And you thought you were just taking a picture. We go into great detail throughout the book, and you will find that many of these issues cycle back in many stories and repeat. Yep, I'm gonna repeat myself a bunch in this book, and it's not just 'cause I'm getting old. For now, though, I will keep going with what I bring with me when I go out there and start flashing people. (Uh, lessee, oversize raincoat, brimmed hat to hide my face, uh, hmm...kidding!)

DOME DIFFUSER

Have it on my flash most of the time. ISOs being what they are nowadays, power is not really a huge issue. ISO 200 is a big number to me, seeing as I shot Kodachrome 25 for many years. With cameras like the D3 and D700, even higher ISOs hold no fear. Great quality, and man, you can extend the reach of your Speedlight at those big ISOs. These little flashes pack a pretty good wallop. (I'll leave the parsing out of guide numbers to those devoted enough to dive into the manual pool.)

But the larger issue for me is quality and dispersion of light. I am not usually long-lensing my subjects. I am more of a feature photographer, showing environment, context, and lifestyle, so my range is often in the up-close, five- to twelve-foot range, with fast, wide glass. Hence, if I have a flash on the camera, I'm looking for as much light scatter as I can get. The dome diffuser stays on.

When I go to remote sources, it is more of an issue, though I still keep the dome on most of the time, even when running through diffusion. You are losing a bit of power, but the return on quality—essentially double-diffusing the light—is significant.

"I'm gonna repeat myself a bunch in this book, and it's not just 'cause I'm getting old."

Obviously, the dome diffusers come off when throwing hard light from a distance. Then I am reaching for every bit of power I can get, and I want the light to be hard and shadowy by the time it reaches the subject. So, I take it off, zoom the flash to where I want it, and shoot away.

SPEAKING OF ZOOMING THE FLASH HEAD...

I urge you to play with this feature. Often, when the dome diffuser is on the flash head, it automatically remains at its widest dispersion. However, when you remove the DD, the flash head can then travel with the lens throw. Zoom your lens from 24 mil to 70 mil and the flash will stay right there with you, covering that new lens length with edge-to-edge light output. Check it out—you'll see the numbers change on the flash LCD. (Note: The SB-800 has a max zoom of 105mm, and the 900 goes to 200mm.)

Some strategies. On the SB-800 units, there is a little knob that gets pushed in when you affix the dome diffuser. That locks the flash into the widest zoom. When you take off the diffuser, as I said, the flash follows along when you zoom the lens. Some shooters have notched their diffusers to not push down that knob, so that the flash zooms with the lens even when the diffuser is on. Decisions like this are all to your taste and, most likely, are determined by the run of work you get and the results you are comfortable with.

With the SB-900, the playing field is wider and more varied. You have a more extensive menu and options. For instance, you can program the quality of light right at the flash, before you even get into the zoom feature. You can go with center-weighted, standard, and even. Put the camera on a tripod and aim a relatively wide lens at a white wall. Program these three spreads of light and see what happens to the pattern you create on the wall. Small shifts, but significant. Now you can take that customized quality of light and throw it around via the zoom. It's a good deal. In a game of inches, we just gained a few.

On the 900, one of the significant advances is in the realm of zoom. We can go all the way to 200mm. (This increased zoom capacity is part of the reason the unit is bigger than the 800.) It's worth it, in my opinion. I like the punch of the light at 200 mil. It has a hard, daylight-sun quality to it. Very effective.

FV LOCK AND FLASH OFF

These options are in the camera menu, and they are enabled by pushing either the DOF (depth of field) preview button or the function button. (This array of options is not available on all models of camera. Also, you have to choose in the menu to assign these options to these buttons.)

But, I can do this stuff with my camera of choice, the D3. On that model, the two buttons in question are on the camera body, right next to the lens mount, on the right side as you are looking through the lens. You can access either of them pretty easily with the middle finger of your right hand, keeping your forefinger on the shutter release.

"Think about being in church, at a quiet moment, and you don't wanna draw attention to yourself."

Remember I said i-TTL flash can be frustrating? The flash power may vary, depending on what the camera is seeing. If you move slightly—and maybe pick up more, brightish background value—then your flash output will likely be a tad different. I've never been manically precise behind the lens, as I gladly accept certain vagaries, and even outright maddening events, as part of the price tag for making my living out in the world with a camera. But, if you wanna get brass tacks about your flash output, and you make a frame you really like, and the value is dead bang on, a good move is to program the function button so that with a middle finger tap, you enable flash value (FV) lock. Tap the button, and the flash will no longer shift in output. It will stay locked, right there, until you tap the button again.

Quick field strategy tip. We've talked about the monitor pre-flash as a beautiful thing. Not if your subject is a blinker. Most of the time, the millisecond between pre-flash and real flash will beat even the most sensitive eyes, and you will make your frame before they blink. But there are some folks out there whose eyelids are spring-loaded, and with the pre-flash enabled you will lose half your take or more. FV lock quenches the pre-flash. With FV lock enabled, you get one flash—the exposure-making flash—and that's it.

Then there's the DOF button. I don't really use it much for depth-of-field preview purposes, actually. Kinda got my depth chart programmed in my head. But, you can program that button to enable the Flash Off function (again, depending on what camera you have). You are shooting away, moving fast, and you just want a quickie read as to how the ambient levels are behaving, so you push that puppy (and keep it pushed) and the flash shuts down. (Unlike FV lock, which you enable by tapping once, for Flash Off, you have to keep the button depressed.) But, man, that's still easier than pulling your eyeball outta the lens, then pushing the power button on the flash or even pulling it off the hot shoe connector. Just release the button, the Speedlight is back on. Think about being in church, at a quiet moment, and you don't wanna draw attention to yourself. Tap out the flash, go available light for a few frames. Nice. Quiet.

The Gear

GELS

Ahh, the valley of the gels. These go with me, all the time. One of the big kahunas of light is the color thereof. Hence, gels—these little plastic pieces of crap on the end of the flash—are crucial. I keep two business card wallets filled with them, pre-cut (roughly) to fit a Speedlight flash head. One is my color conversion wallet—CTO (warm gels for tungsten conversion), CTB (blue gels, for tungsten to daylight conversion, used much more rarely than CTO), and green gels (for fluorescent conversion). In my other pack, which I refer to as my theatrical pack, are the wild bunch: reds, greens, deep blues, yellows. This is what you use when you go *Blade Runner* on the whole deal.

> "Gels—these little plastic pieces of crap on the end of the flash—are crucial."

I'm liking the filter holder on the SB-900. It is a fancy-pants thing, designed with a receptor that is able to translate the color of the Nikon-supplied gel to the camera, and, if my D3 is in auto or flash white balance, shift the camera into the color balance that corresponds to the gel (either fluorescent or tungsten). This only works with the specific Nikon gels that come with the SB-900 flash, 'cause they have chips embedded in them that speak to the camera via the mechanism of the filter receptor. It only works when the flash is hot shoed (or linked via SC-28 or SC-29 cord) to the camera, so I have found limited use for all this fanciness thus far.

But...the filter holder is a joy. Means no more scotch/gaffer/duct/masking tape on the edges of your flash. Means if you forgot your tape it ain't gonna blow a hole through your shoot. You can take your own cut gels and just slip 'em into the holder and, voilà, you have color of light without the mess. (Think about cold weather. Gloves. Tape that doesn't stick. This is nicer.)

We talk a lot about gels in the book. All I'm saying here is bring 'em. Always.

BATTERY PACKS

I travel with the Nikon SD-8A and, now, the new SD-9 battery packs. The 8A holds six AAs, and the SD-9 holds eight. Both are simple and elegantly designed. An elegantly designed battery pack? WTF?

They are both slim and fit into your back or jacket pocket. One of the things I dislike about the bigger packs is that, while they have a ton of power, they are, well, big. Try fitting one of those puppies under your suit coat at a fancy event without feeling like you got a lunch box on your hip. I use the SD power packs because they fit well into a pocket or on my belt, and if I blow the flash while using one, I don't blow my warranty. If you encounter a problem when using third-party packs with camera system flashes, the camera maker will potentially red flag it as a non-warranty repair, figuring, many times rightly, that you overloaded the flash with a powerful external source.

Quantum and Lumedyne make terrific battery packs. But be careful. They have a wallop and will nuke your flash if you are not careful. David Hobby over at Strobist has tons of information on batteries and packs, and David really knows what the engineering deal is on this stuff. Strobist, or www.strobist.blogspot.com, is the real deal, by the way. The single greatest source of flash education on the planet.

I play it safe and use the recommended battery packs for my Speedlights and I use the Powerex rechargeable batteries, which run at 2700 milliamps. Again, that is not the product choice after yards of scientific research; it just seems to be what is working reasonably well in the field at this time.

CLAMPS, STANDS, AND LIGHT SHAPERS

Oh, boy. There are probably as many solutions out there as there are shooters. Folks like big stands, small stands, light ones, tall ones, shorties, you name it. Best thing is really whatever works for you.

In terms of brands, I swear by Manfrotto and Avenger, and between the two of them, there is a light stand for every need.

There is one piece of support gear I do have religion about, and that is the C-stand. Now, some folks will look at me like I'm nuts (no mystery there) for putting a tiny light on a heavy stand. They feel it's, you know, overkill. They're right.

But here's the deal. I am always interested in the quality of light, and a big part of that is how you articulate or place the light. Close is often good. The pitch of the light—and thus the angle of approach to the subject—is crucial. I am a nut about this.

Your average stand is your average stand. It works just fine until, perhaps, you run into that situation that dictates the need for a slightly different angle, or a really beautiful, sumptuous quality of light. Then, you want to work the position of the flash. You want to take that Speedlight that is firing through the small umbrella you got with you and wring every drop of quality out of it, which will mean putting it right where you want it.

This is where the C-stand is your friend, and by C-stand, I mean a "C-stand complete." That is the terminology that refers to the base, the main column (or riser), and the extension arm. (If you just

have the base and the column, it is a C-stand, not a C-stand complete.) That extension arm is crucial if you want to place the light in close to the subject, above the eye line, and just about smack dab right up to the cheekbones, and still have it be out of the camera's field of view. With a regular stand, if you want the light in, you have to move the stand in, and there are limits to "in." (Uh, that would be the camera angle and what the lens is seeing.)

But with the extension arm, you can go up, over, and then "in." It's a beautiful thing. Again, I refer to the game of inches that is lighting, and with the C-stand, I can make those inches count.

The Justin Clamp (175F in the Bogen catalog) has been my lighting attachment go-to gizmo for a while now. Very handy, and durable. As I have often said, it turns just about anything into a potential light stand. The current agony of the clamp is that the cold shoe on the JC will not accommodate the hot shoe of the SB-900. I mean, it will—if you go gorilla on it. Then you gotta work it back out, and

severely. I've cracked several. As of this writing, Bogen/Manfrotto has some new stuff in the works that will fit the 900. Stay tuned.

Lots of other ways to clamp Speedlights and affix umbrellas and such. Here is one thing to remember: Get a cold shoe that is really a cold shoe. No metal where the contact points of the flash go, 'cause you could wreak havoc electrically and short out the flash, especially if moisture gets in there. Go with plastic, or put some gaffer tape over any metal on the flash clamp attachment. Just to be safe.

It is much more interesting, actually, to talk about what the light will go through, rather than what it is on. 'Cause that's where the rubber meets the road. Again, quality of light.

HERE WE GO

My Lumiquest attachments go with me all the time. My favorite combo from them is the ProMax sys-

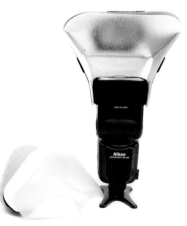

> "Once you set one of these puppies off, light goes everywhere. It's up to you to tell it where to go."

more directional (but still soft) light with metallic and white reflector cards and a diffuser. I've been using the 80-20 for years. Great little device that allows eighty percent of the light to go to the ceiling, while flicking twenty percent of it into the subject's eyes. Great for quick, soft solutions where you have low ceilings and banks of fluorescents. You know, the usual wonderful lighting environments where you are expected to do something nice with this godawful scene in less than 10 minutes.

I also like the Big Bounce and the new Softbox III. Handy, good quality of light, and their relatively large size gives your small flash a fighting chance to grow up and be a big light.

When you mix the tried and true Lumiquest stuff with the new breed of Honl products, you got yourself a fair amount of quickie control in your camera bag. David Honl (is everybody who is good with flash named David?) designed a bunch of lighting

accessories and shapers I really like and go with me all the time.

First building block of Honl's system is the speed strap. You wrap that puppy around your flash head, nice and snug, and you can make it a platform for a variety of light-shaping tools, including the aforementioned Lumiquest stuff. I basically use all the stuff Honl's got out—barn doors, snoots, and grids. The grids are great and come in $\frac{1}{4}$" and $\frac{1}{8}$" sizes, with the latter producing a more narrow beam of light. The snoots and the doors are handy, too.

Remember, even when using a small flash, once you set one of these puppies off, light goes everywhere. It's up to you to tell it where to go, and these accessories are like crowd control for photons.

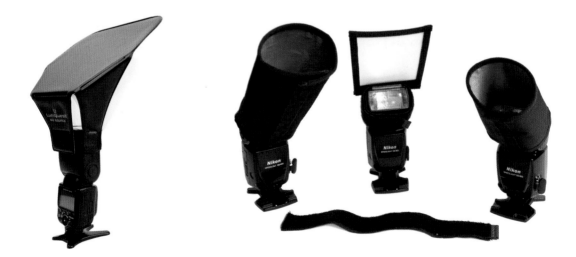

NEXT STEP

Lastolite panels, baby! My first line of defense here is the TriGrips. They are roughly triangular in shape, have a sturdy handle, and fold away nice and tight. No muss, no fuss, very little weight and space, and very effective at producing a softbox quality of light on the fly. Examples of these guys are all throughout the book.

Lastolite's also got circular reflectors and diffusers. Too many to name here. Suffice it to say, all their stuff comes in a variety of sizes and shapes, as well as kits, where you get a diffuser panel that you can cover with a gold, silver, or white reflector. The stuff just rocks, and makes you fast and versatile out in the field without sacrificing quality of light. Sigh. There's that term again. Quality of light. No gettin' away from it.

Then there's the tried and true: the umbrella. Umbrellas are often the very first thing we get acquainted with when messing with light. Umbrellas make the light look nice and soft. You don't have the control of a softbox—which is, literally, a box of light that you can direct and push in one way or another with a fair degree of effectiveness—but there's no question that a quick application of an umbrella, either to shoot through or bounce off

of, is going to improve the feel of your light. The choice to shoot through or bounce is discussed a bit later, and the decision you make in the field at the last minute is the reason I go with the Lastolite All-In-One style of umbrella. I can go either direction with this umbrella—shoot through or reflected. It has a removable backing, which makes it incredibly versatile without adding to the weight or dimension of what you have to carry.

HOLD THE PHONE

This just in. Lastolite came out this year with the EzyBox hot shoe light shaper. I mean, they've had a small-flash softbox out there for a bit, but the new one—this year's edition—rocks. The key? It is bigger, and it has an internal baffle, or diffuser. All that adds up to softer light. I put my Speedlight into the back of one of these, dome diffuser on, and I get

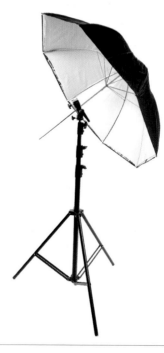

instant softness and direction. It comes as a kit with a bracket, and a little boom arm. They also have what they call "creative diffusers," which are masks you can put over the outer diffuser. Very cool. They will pay for themselves in terms of the amount of gaffer tape you will no longer have to use to shape the light coming out of the softbox.

THE FINAL FRONTIER

Lastolite Skylite panels. Now, these are a commitment, and that's a tough word for any photog. But I use them all the time. They have different sizes—3x3', 3x6', 6x6'. All do different things. All have advantages.

The 3x3' is great, straight up, for portraiture. Nice quality of light. Given the surface area of the diffuser, I often put two flashes through it.

The 3x6' is fantastic for groups. Line it up horizontally over the camera and put two Speedlights through it. (Here's where the C-stand is just about a necessity.) The terror of lighting the group shot gets diminished, pronto. Also, swing it vertical and it just about fills a door or covers a window. Quick. Very cool.

The 6x6' is a big boy. You can still mess with it by your lonesome, though. I do it all the time. It is great as an overhead baffle for hard sun. (Underneath it, you can work magic with a single flash and a Tri-Grip.) It covers windows like crazy. Hard sun pouring through a big bay window? The old six-by makes the nasty daylight smooth as silk and turns the room into a studio. You walk around with a small flash rig and simply tweak the foreground light of whatever angle you choose to shoot.

All three panels live in carry bags. The 3x3', at least, is always with me.

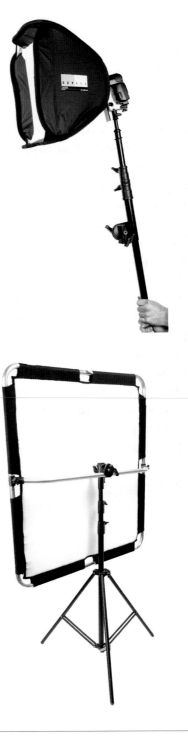

I Almost Forgot...

Those things that make the light that comes through all this stuff. All that techno stuff about EV and high speed and light shaping and cold shoes and hot stuff and, well, what exactly is the machinery we are discussing here?

My system, as I've said, is the Nikon CLS. For the last few years, the flash of choice—unquestionably the best hot shoe flash ever made—has been the SB-800. Used 'em like crazy. Dropped 'em, hung 'em, flashed 'em, snooted 'em, clamped 'em...you get the idea.

They have been, in a word, dependable. High praise, indeed, for a piece of photo gear. They have worked, and worked quite well, in all manner of situations. Outdoors, indoors, as a single flash, or as a flock of units. I still use 'em.

They are going away.

The new flagship of the CLS system is the SB-900, and it is just taking hold now, as of this writing. It's got lots of advantages, many of which are discussed in the ensuing pages. But the SB-800 is a tough act to follow, and I can see for a while still using a mix of these newer Cadillac 900s with that reliable old Chevy in the driveway, the 800.

Nice thing is, they do work together quite well, and my mix right now to go on location is basically two SB-900s and four to six 800s.

The SB-600 is a good little unit, as well, but I tend to bypass it for power and versatility reasons. The kind of work I do often demands that my Speedlights just about jump through hoops like

trained seals, so I have to stay with flashes that will give me the most bang, no matter the buck.

And then there is the SB-R200, the little close-up guy. Now, I would rather sit through a novocaine-less root canal than do close-up work, so the 200 is a specialty item for me. I trot it out when I think I can play with it effectively and maybe, just maybe, it will give me a bit of a twist on what could be just another light setup. I've gotten some cool stuff with it over the years, and I've included some of that in our later discussions. The small size is a big attraction. No bigger than your closed fist, they pack a pretty good punch of light, and can be hidden in the darnedest places.

For lots of good reasons, I never go out without the SU-800 commander unit. It is not a flash. It functions only as a commander. I use it constantly, as it sends out pre-flashes bundled in infrared pulses to control remote Speedlights. It is a great unit if you have your lights in tough-to-reach places. You can get quite creative with the SU-800

"It is so much easier now to speak with light."

if you pop it onto the end of the SC-29 or SC-28 cord. (These have replaced the tried-and-true SC-17 cord, the dedicated TTL cord for units prior to the SB-800.)

'Cause here's the deal. You gotta get that signal to the remote flash. It's line of sight. You can't daisy chain a bunch of signals out there, playing dominoes, hoping one knocks into the other, which knocks into the next. All the remotes need to see the master unit, which is de facto someplace near the camera. (The crucial element here, the area that needs to see that signal, is the light sensor panel, a recessed circle, about ¼" in diameter, located near the battery chamber.) The power of the SU-800 is very handy, and even handier at the end of the SC cords. (The manuals do not attribute additional power to the SU unit. This is a gut call on my part, from field experience. It is a directional signal, so it *feels* more powerful.) You can link up to three of those cords and still get reliable i-TTL translation. Working like this gives you tremendous flexibility in the field, and it's essential when managing flashes in three groups of exposure control. (Also essential here: The test fire button. It trips the groups in sequence—A, B, C. Very handy, especially when someone as daft and forgetful as me is at the lens.) I bounce that signal all over the place, extend it like crazy, whack it off of walls and floors, and make it a location game to see how far and wide I can get the lights. There is new technology out there, like the new breed of Pocket Wizards and Radio Poppers, that are busy taking the i-TTL flash codes and

transferring them via radio waves, and that will be a fun and interesting frontier as lots of folks jump on that bandwagon.

The dialogue between camera and flash that got started a while back is getting amazingly interesting, and adventurous, dicey pictures that, years ago, would have had a very limited success rate are now possible with much more bulletproof results. It is so much easier now to speak with light. Read on, and join the conversation. ☐

A Little Bit of Dis and a Little Bit of Dat

SOME FOLKS MIGHT VIEW lighting something or somebody as a page out of an NFL playbook, complete with Xs, Os, arrows, blockers, and tacklers—an intensely complicated diagram with many moving parts. And, of course, just like any play in football, no matter how carefully mapped, once set in motion the whole deal has a tendency to careen out of control, accompanied by much grunting, sweating, and the possibility of severe injury.

Others might view lighting as a mysterious hiero-glyph, an unknowable set of symbols, daunting as a math problem, as attractive a proposition as a semester of organic chemistry.

Still others may simply view light as magic time, a quicksilver thing that works in our favor one day but not the next. It flickers with a mind of its own and can't be touched or wrangled any more than camp-fire shadows dancing on a wall. You chant and pray to the photon god and hope it works out.

Like they used to tell us in sex ed classes: hope is not a method.

I try to simplify things as best as I can. For me, lighting has never been a numbers game. You know when you program your background to be −1 EV for saturation, and you are flashing the foreground? Logic and math dictate that, given the fact that the −1 EV value will also apply to the flash output, to make the world equal you should apply +1 EV to the flash. Simple, right? Minus one for background, ergo, +1 for foreground.

It don't work like that.

View any sort of lighting plan as a recipe. You take a look in the photon cookbook and there is the diagram of the lighting grid with values and positions and ingredients and subject-to-camera distance and f-stops and three tablespoons of chopped whatever. Blah diddly blah. Okay. Fine. Good stuff. Remember, though, it's not a legal document. *It's just a starting point!*

Any tasty, wonderful photo dish is usually the product of some basic technical skills and com-mon sense, and then a little bit of this and a little bit of that, dashes and pinches of Tabasco and

"We should be able to recognize certain types of light and light sources, predicting how they are gonna feel and look right then and there."

pepper, some steady stirring, some gaffer tape here and there, a little bit of exposure control, some just-right feathering, and then, of course, the right temperature in the oven. Not to mention a healthy helping of the personality of the chef, who is woo-ing, begging, coaxing, cajoling, and otherwise eliciting the most expressive tastes from the ingre-dients that have all been set in motion in the big old pot.

There are some basic lighting ingredients to mix in before getting to the fine points of tweaks, fillips, spices, and presentation.

Color

Color, and control thereof, is a big deal. Color controls the mood of the picture, and thus it affects the mood and interest level of someone viewing it. Light has color, of course, and when doing small-flash lighting, it is important to remember that both the flash *and the scene* have color. These are battery-operated units you can fit into your camera bag. They are not light bazookas capable of blowing away all available light. (This can happen, say, in a headshot/studio scenario, and in those instances we need only worry about the color of the flash.)

But, often, when working out in the world, we will be filtering them into an existing scene that already has a mood and a coloration. We need to decide if we are going to alter that mood and shift things by introducing a new color palette, or if we need to slip our flash light in, subtly and unnoticed.

This plays right to our ability to control and understand color. Now that we live in the world of digital and raw capture, many downplay this notion. The malleability of digital is a wonderful thing, to be sure, but it is not an escape hatch. I have often heard "What's the big deal? If you're shooting raw, you can change it later."

It is a big deal. Raw is not an excuse to not know. The ability to change it up later is a blessing, but we should be able to recognize certain types of light and light sources, predicting how they are gonna

feel and look right then and there. This is crucial, 'cause presumably that will inform what color we introduce via the flash. Warm it up? Cool it down? Gel it so it blends well into a scene and everything looks copasetic? Grab theatrical gels and go Hollywood?

These are field decisions, 'cause guess what? The magic of raw goes only so far. Flick a switch and the whole frame changes color, to be sure, but what if you have a scene that is super tungsten warm and you flash the foreground with a neutral white flash? Now you have two different colors and, if they don't mesh well, the global adjustment of raw is only gonna fix one of 'em. Mix in the wrong color with your flash and you condemn yourself to layers hell in Photoshop, losing yards of your life trying to "fix" something that you could have adjusted pretty seamlessly whilst you had the camera in your hands.

So learn a bit about color.

Quality

Direction

The quality of light is another principal ingredient. Most folks have a visceral, kind of *Yuck!* reaction to bad light, but it is difficult to articulate what might make that good light. Suffice to say it is something you just have to spend time in the kitchen to sort out. Light can be hard, soft, wrapping, harsh, slashing, sumptuous, glowing, ethereal, muddy, muted, brash, poppy, brassy, contrasty, clean, open—it's a little nuts. How many terms get thrown around about light? Lots. Just like there are many kinds of light. Take a look at the spice rack next to the stove. Which one you gonna pull?

The approach of light to your subject is a biggie, too. Front light, backlight, overhead light, low light? All will inform your subject with a different feel, and make that subject look different. Looking different—that's something we want for our pictures, yes? In the millions of photos that get taken every damn day out there, how do we make our pix stand out? Having control of light is very important here, and the direction of light is one of those elements of control.

I'm a people photographer, and believe me, I have made some folks look wonderful and done some others an outright disservice just by the way I brung the light. I always refer to Arnold Newman's portrait of the German industrialist Krupp. Hoo boy. Now there's an exercise in the direction of the light. Hatchet light for the hatchet man. Krup looks reptilian, an interpretation wrought by an effective combo of direction, quality, and color of light. It is light with an attitude.

"Don't shoot 20 frames. Shoot 200. Make mental notes. Look at your pictures. Make more of them."

Remember
These Things

No pixels have to die. The beauty of digital is that you can experiment to your heart's content, and you are belaboring no one but yourself. (And, of course, your wife, husband, girlfriend, boyfriend, kids, pets, neighbors, and anyone else who might be willing to put up with your experimentation.)

You are not running to the photo lab or CVS, racking up processing bills, matching up slides or negs to the laborious notes you took while you were making exposures. "Lessee...frames 21 through 27, the light was camera left at about 10 feet...."

You got it right there in the metadata. Also, make a picture of the light in reference to the subject. A production shot, if you will. That way, you'll have all your exposure info, as well as a visual set of notes to remind you of the physical placement of the light. How high? How far away? What was the f-stop, shutter speed, EV compensation?

Experiment! All of this stuff is just stuff, but it needs the knowin'. Those damn little buttons and dials are mechanical inputs to the camera, but they control functions that have enormous aesthetic implications for your pictures. The fancy-pants digital machines we have nowadays are wonderful and smart, but they are not as smart as we are, and have not a scintilla of stylistic sense or artistic inclination. The program mode and the auto exposure and the auto bracketing are like OPEC, or some other international consortium or cartel that gets together and conspires to make us lazy and dependent.

Break free! Make exposure after exposure. Don't shoot 20 frames. Shoot 200. Make mental notes. Look at your pictures. Make more of them. Find out which ones—which style, color, light, and approach—get your juices flowing. Then, when you get those good ones, you will know how to get back to that place and do it again.

This way, your good pictures will not be accidents.

"Light can be hard, soft, wrapping, harsh, slashing, sumptuous, glowing, ethereal, muddy, muted, brash, poppy, brassy, contrasty, clean, open—it's a little nuts."

Break Rules

There are tons of lighting guides and principles and how tos out there. Many of them have fine information. Dos and don'ts. Precepts. Rules, if you will.

Break 'em.

Remember what Barbosa, that scallywag pirate in *Pirates of the Caribbean*, said to the young Miss Turner when she demanded certain treatment in accordance with the pirate's code of conduct?

"Well, you see, missy, it's not a code, really...more like a set of guidelines."

Ahh, yes. Take a look. Put the light where they say to put it. And then put it where you want it. See what you like.

Remember, just like being in the kitchen, this is all to your taste. Some people will love pictures you would like to not put your name on. Other times, you'll feel like you have presented a virtual masterpiece, and the world shrugs. I always hark back to a colleague who shot a well-known entrepreneur for the cover of *Time*. At the time, this swashbuckling capitalist was all the rage and being viewed as a savior, and my friend was besieged with congratulatory phone calls about the cover, its photographic excellence, and how his camera and lens had perfectly captured the magic and the essence of this manufacturing messiah.

Then, of course, it all unravels. Within a year, it turns out that Mr. Honcho is actually a bad man, and he loses everything and is sent to jail. Another news cover runs, from that very same hero take.

(There were no new pictures to be had.) And my photog friend gets another round of phone calls, telling him again what an excellent job he had done, and how his lighting and approach had nailed the son of a bitch dead to rights, and the image fairly reeked of rapacious, evil intent.

Who's to know? What's right and what's wrong? What tastes good and what doesn't? After all, some people like Brussels sprouts. □

Da Grip

ANYBODY WHO KNOWS ME knows I am somewhat manic about holding my cameras steady, and I have a method. I cannot lay claim to this or take credit for it—it was shown to me by a real good press shooter named Keith Torrie many years ago at the New York *Daily News*.

One of the reasons this method works for me is that I am, somewhat strangely, left-eyed. Right-handed but left-eyed. Dunno why. Ever since I picked up a camera I always put it to my left eye. Little did I know that would create an advantage for me when I started to shoot motor-driven, professional cameras. The extended base of the motor is ideal for tucking into that depression right between your shoulder and your collarbone. There is no pulse or heartbeat there, and no lungs heaving up and down. It forms a perfect support for your camera, if you just swing your shoulder in a little bit. Again, here is the process of literally "becoming the camera." Your body is bracing the camera while your brain and hands command it.

This is me, coming to you as a visual aid, which I apologize for. What I am doing here is showing you a classic way of how *not* to hold a camera and a lens. Notice how I am stooped over? Where is the center of gravity? It is hovering out there in front of my nose somewhere, floating in space. In this posture, with this grip, there is no way that you will

get consistently sharp results and no camera shake or movement. The camera, especially motor-driven cameras, have a fair amount of weight. As a test, try to mimic this posture with your camera, and hold it for a while, like more than a minute or so. The camera's getting heavy, is it not? Your arms are getting tired, are they not?

This type of camera treatment makes for a long day in the field. Not only will you get results that are unsatisfactory, you will, plain and simple, just be exhausted.

Folks occasionally look at their unsharp pictures and curse the autofocus system of the camera. Oftentimes, it ain't the camera. It is a question of operator steadiness. Old-fashioned camera shake, rattle, and roll. It will kill your picture every time out.

So try this.

"You must become the camera, grasshopper! Seriously!"

Where is my weight? Over my legs, the strongest and longest muscles in the body. Where is the camera? Close to my face—jammed against it, really. Where is my support for the camera? Again, as straight up and down as I can make it, over the center of gravity. Where is my elbow of my support (left) arm? Tucked into my stomach, tight against me. All of this is simply the body supporting the camera. You must become the camera, grasshopper! Seriously! Your body has to coalesce around the camera, and this mechanical piece of glass, metal, and plastic must become an extension of your physical being, the same way your picture becomes an extension of your head, your heart, and your imagination.

Now, of course, there's a lot of technology being brought to bear in transferring your imagination and emotions to pixels. The cameras nowadays do just about everything for you except cook your breakfast. In days gone by, there was a lot of frenetic activity orbiting around the camera and lens. For instance, you had to manually focus, and manually change f-stops. You had to figure out exposure externally because the in-camera meter was so crude. You had to change your shutter speeds manually. Now you have to do none of that, so all those fingers flying around have gone away. Gone away to the extent that you don't really need your second hand involved (at least all the time) in the manual operation of the camera. Hence, why not...*do this!*

Do this and squeeze the shutter with your finger. Don't *hit* the shutter button. Just like they tell you in sharpshooter school, just exhale and squeeze. Remember, too, that your first frame, the one you made when you literally punched the shutter button silly 'cause you were so damn excited, may have a tendency to be your least sharp frame. After you make that first frenetic, kinetic input to the camera, though, 'round about your third or fourth frame, when you are not jabbing the shutter but working it in a smooth, collected way—nice and easy—those frames may be your sharpest.

Also, slow shutter speed anxiety is the reason the photo gods gave us consecutive high. Burst the camera. Somewhere in that burst, Jupiter will align with Mars and your pictures will get sharper.

Or, if you are not inclined to keep your left hand clasped over your right, it should not be...*here!*

Try not to use an overhand grip for your lens. That focusing hand, or zoom hand, should be tucked under the barrel of the lens, not resting on top of it. You are not supporting the lens this way, you are simply adding to the weight of it and increasing your chances of shake. Your hand should

"Grab that camera and hang on tight."

be tucked firmly under the lens, supporting the weight of it, kind of like...*this!*

You're reading this and saying, "Okay, numnuts, while it might be fine to wrap yourself like a pretzel around the camera and lens, and chant to the Buddha for the peace of mind, body, and heart that will enable you to shoot sharp at 1/15th of a second or less, whaddya do when you gotta hold a flash, too?"

Assistants are handy, but they ain't gonna be there with you all the time. In this day of light-and-fast, less-is-more, and cheap-is-good, all shooters increasingly find themselves on their own when it comes to field time. Which means most of the time you pretty much gotta hold your own stuff, especially when you are moving and shooting in journalistic, day-in-the-life mode, and not setting up a portrait in a controllable space.

No worries when the flash is hot shoed. Camera is still one unit. But what if you want the benefit of redirecting the light—pulling it off the camera and to the side, overhead, underneath, someplace, anyplace that's not right smack dab at the eyeball of the lens? Ya gotta hold it. In your left hand, 'cause all the cameras have right-hand grips. So now you've got a light out at the end of your left arm and a heavy digital camera gripped in your right, and no point of tether or support for either. You feel like a one-armed paper hanger. So few limbs, so much to do.

Grab the flash. But don't go back into the traditional off-the-camera shooting mode, the one where your left arm is extended all the way and looks like you know the answer and you are desperately trying to signal the teacher. Instead, loop your arm around to the other side, allowing your left shoulder to remain the tabletop upon which the motor-driven camera rests. On the opposite side of your body, your left arm can still maneuver the flash up, down, and sideways. Your right-hand grip of the camera is hugely assisted by that left shoulder support group. Your camera remains at your eye, and you can shoot off-camera flash in a fluid, supported manner.

Apologies to right-eyed shooters. You're screwed.

Kidding. There are a bunch of elements here that can be applied, no matter if you are left-eyed, right-eyed, or a Cyclops. The main thing is to be comfortable and collected around the camera. Remember to hold it firmly, like the formidable machine that it is, and not delicately or daintily, like it's a Fabergé egg.

This is a tough business. Grab that camera and hang on tight. ☐

One Light!

Or, "Say hello to my li'l frenn!"

A Place to Put the Light

WHEN I USE SMALL FLASH, I consciously look for things that look like light-shaping tools. Face it, light comes outta these things in a fairly formless manner. You can send it to the ceiling or fly it off a wall, but when you set off an SB unit, light blows out of it kind of—everywhere.

Especially when you are moving fast and using the units without any light-shaping devices attached to them. Like, on a wedding day. Like, in the bride's room while she is getting ready and tending to her two-year-old twins. Like, when things are complete chaos and you are trying to find beauty, simplicity, and composition both in your head and in your frame.

Off to camera left there was a bank of large bureau drawers running the length of the wall. In the middle, about chest high, was a shelf and a large mirror, topped by an upper set of cabinets. In other words, in the middle of this sea of shelves there was a roughly 2x4' mirror opening. I'm sure Debbie, an extraordinarily beautiful bride, viewed it as a handy counter and mirror setup for makeup and hair. I viewed it as an impromptu softbox.

You know those little plastic floor stands that come with the SB-800 and SB-900? They're handy. I popped my SB-800 on that stand, and placed it on the countertop, facing the mirror. Used another 800 on my camera hot shoe as the commander. Shot aperture priority, and the exposure pulled in at 1/15th at f/2.8, with +1 EV dialed in at camera. I had to tell the camera to overexpose 'cause the meter was reading all those bright windows and under-exposing the foreground. The windows blow out, of course, but all that backlight thankfully ended up fitting the high key, airy feel of the scene. I dialed my remote flash to a power setting that complemented and filled the existing light, but didn't overpower it. Debbie played with the kids, who played with the veil.

The bonus was that the kids, being small, looked up at the veil and, of course, the light. I just let them play with both. ☐

Up to Your Ass in

BEING UP TO YOUR ASS in alligators is the very definition of location photography, by the way. Hidden, ferocious beasts await you in the murky waters of your brain. Somehow, somewhere on location, one of 'em is just out there waiting to get you.

This description has always been a fun way to laugh about the perils of going out into the world with a camera. Then, of course, I found myself really up to my ass in alligators. Seems I had the bright idea of shooting night hunters during a story on the sense of sight for *National Geographic*.

I got into the swamp of the St. Augustine alligator farm at dusk, 400mm lens at eye level, lying on my belly, chin resting in water that smelled a lot worse than the New York harbor on a bad day. Gators, like cats, have a thin layer of special reflecting tissue behind each retina that, with the pupils fully dilated, acts like a mirror to concentrate all available light during the darkest of nights. Just a flick of light from bang on the axis of the lens, i.e., straight flash, is gonna turn those eyes into glowing coals in the dusk of the swamp.

I helped this mood out a bit by underexposing and using a tungsten color balance, which goes very blue in daylight conditions, and super blue in the muted light of dusk. Underexposure emphasizes the gloom of the swamp, makes it look spooky and foreboding—dangerous, in a word. Zoomed the flash to the maximum at 105mm, gelled it with two cuts of CTO to keep it warm in tone, and dialed the power output way down. The flash is just a blip here and doesn't affect the exposure,

Good Bad Light

I ALMOST ALWAYS PREACH the gospel of getting your flash off your camera. Moving that light source even a few inches off the lens axis can often improve the quality of your light. Subtle moves can make huge differences in the look of the photo.

So whaddya do when the crowd is gone, the game is over, the ballpark lights are off, and you have no light stands and only one flash—and holding the flash at arm's length at this type of distance from your subject will have zero effect?

Straight flash it. Leave that puppy on the hot shoe and blast away. I come out of newspapers and magazines, and the ethic there is some picture, no matter how bad, is better than no picture. Many is the time I have held my nose, gone to the happy place in my head, realized I would live to fight again another day, and shot a crappy photo.

But photography surprises you, continuously. Just as you can throw all of your expertise, planning, dough, technology, and effort at a situation and still come away disappointed with the results, likewise, a photo you didn't give a snowball's chance in hell will pop out of the camera and demand attention.

I was shooting for the book *Baseball in America*, traveling alone, moving light and fast. Camera-bag job. Couple cameras, four lenses,

and a flash. I was shooting rookie league ball, the basement division of the minors, where teams are often made up of kids who are away from home for the first time, desperately trying for a toehold on the long, hard road to "the show." I shot most of the story with available light—good and bad—with minor amounts of fill flash bouncing around in locker rooms and dugouts. It was a dream job. No pressure really. No celebrities, no credentials, no restrictions on where to stand and how to shoot it. Just go. Just shoot.

(It was a no-frills job all the way. When I got to location, a NASCAR event had sucked up every hotel room within a couple hundred miles, so I slept at the ballpark in the umpire's room, which had a cot and a couple hundred crickets for roomies.)

I desperately needed a closer on my last night. Something to wrap the story. Something that spoke to the idea of playing for the love of the game, and to the tenuous dream of making it all the way. Something that spoke of just how basic and simple all this was, so far from the lights of Broadway, Yankee Stadium, big contracts, and stardom.

The home dugout was a broke-down mess. If light is the language of photography, straight flash spoke to this scene. It ran as a two-page spread and closed the story. ☐

A Light in the
Doorway

WHERE DOES LIGHT COME FROM, anyway? In our world, it often comes from overhead lights or some sort of electrical fixture someplace in the room. But, when there is no electricity, it comes into the room through windows and doors.

This Tanzanian woman was one of the most coura-geous people I ever met. Blinded by trachoma, she would forage in the fields for vegetation with her feet. After gathering assorted greenery, she would bring it back to her hut in a woven basket. She knew the pathways and maneuvered them with the speed and dexterity of a sighted person. Back in her hut, she would then fine-tune her gatherings by touch with the more precise instruments of her hands. Just remarkable, and humbling.

I followed her into her home to observe this process. It was dark and smoky, with a dirt floor. She began to sort through the day's harvest. What to do? There was no light and certainly nothing to bounce off. Straight flash would destroy the mood and beauty of this amazing scene.

Go with the flow. Light was coming from two places. The far window, near the fire, was not an option. But there was the door, just to camera left of where she was sorting. In the photographer's vest that I routinely wore during extended stays in the field, I had a large, flat pocket by my back. A Lumiquest Big Bounce fit in there perfectly.

I velcroed the BB to my SB-24 and extended it off to camera left via an SC-17 off-camera cord (the precursor to the current SC-28 and SC-29 cords). It was held by my interpreter. I worked quickly—moments like this don't linger—taking my cue from the direction of the soft, shady light coming in the door and bouncing off the dirt. The big swatch of diffusion material over the front of the Big Bounce softened the light from my flash, but still gave the listless daylight a touch of spark and contrast.

The doorway was in the shade, but on the far side of the hut the sun was blazing through the only window, catching smoke from the fire in a theatrical way. To expose for this light, and pick up some inte-rior detail, I simply played with my shutter speeds, leaving my f-stop (around f/5.6, as I recall) for the flashed foreground constant. This is known as "dragging" the shutter, or lengthening the shutter speed to accommodate the ambient light level. The slower the shutter speed, the more available light will factor into the exposure, softening the effect of the light from the flash.

I was working in the tribal villages in central Tanzania for *National Geographic*, doing a story on sight. Many of these villages had been ravaged with trachoma, an ugly and painful disease that, over time, causes blindness. My subjects were routinely extraordinary. This woman's sense of touch was so evolved that she could tell a weed from a vegetable with her fingers, and do it quickly. At one point, she came upon such a weed in her basket and thrust it at me, saying through the interpreter, "See! This is not food!" ☐

The Swamp,
Revisited

NO ALLIGATORS HERE, even though it looks like I'm with some bad asses up country in Cambodia. Which was the idea.

I was shooting a commercial job, producing a military calendar. The requirements of the job were painstaking. Make it look absolutely real. Real uniforms, real military protocol, real activity—just not real soldiers.

We had to cast talent for all our scenes, and then have that talent supervised by military advisors and trainers, usually retired vets who really knew what the deal was supposed to look like.

So this special ops mission, which does look like enemy territory in the tropics, is actually a lake in Connecticut, in the spring, in very cold water.

I'm not up to my ass here. I'm up to my neck, trying to keep water out of my D2X. My assistant, Scott, is also busy keeping his nose above water while holding a C-stand extension arm with an SB-800 hooked onto it via a Justin Clamp. Light is camera right, being triggered via monitor pre-flash from the SB-800 that is hot shoed to the camera. No umbrellas or light-shaping tools required here. Zoomed the light to 105mm so it would hit our lead subject and little else. Gelled it with a full cut of CTO to mimic the color of rising morning light. Re-upped the warm ante by dialing in a cloudy white balance at camera. Shot aperture priority, dialing in −1.7 EV at the camera, thus making sure the dark colors of the scene stay rich and saturated. If I let the camera go where the meter told it to go, the whole scene would be blown out, because the only light out there, the faint beginning of sunrise, is behind them, and from my angle the lens is seeing a lot of darkness.

Let's talk about this for a minute. I say this a few times throughout the book, and it's important: When you make a plus or minus EV change at the camera, you are making a global adjustment, to borrow a Photoshop term. That means you are affecting both ambient and flash values. Going by the book, minus-ing exposure into the overall scene, which mutes the background, would then logically require dialing a corresponding amount of plus power into the flash to keep the foreground subject lit well: −1 for the background equals +1 for the foreground flash.

But this ain't math. And location photography often requires you to throw the book away and make up your own solutions. A −1 for the camera doesn't always demand a +1 at the flash. You have to pull the flash back into line more by feel than by numbers. And be prepared to be surprised every now and then.

Or a touch confused, to be honest. In the early morning murk of that lake, with water up to my chin, I recall being very fond of wireless flash technology. I might have been in a lake physically, but I was at sea mentally. I had rising morning backlight, fog, dark, soaked uniforms, and a common reference point—skin tone—was gone, replaced by dark, mottled camo paint.

Plus, I had some reflection and bounce off the water. Hmmm....

The camera and I had a little chat. Me to camera: "You figure this out?" Camera to me: "No way, man, it's your job. You're making the fee, you figure it out!"

So we worked it out together, mostly by trial and error, with me making adjustments to the flash power from the master. Logically, you would think that underexposing the whole deal by almost two stops and using a pretty heavy gel would belabor the Speedlight and, via the master flash, I would be asking it for more power, along the lines of +1 or +2 EV, or even more. (I had figured on this happening, so Scott had the remote SB-800 powered up with the SD-8A external battery pack, and we had spare AA batteries in the boat.)

But it didn't work out that way. Logic often does not prevail on location, especially odd ones like this. The flash did fine at just about its normal rating. No extra power really needed. I think that worked out 'cause I didn't need a "normal" power input to make the scene work. Dark and moody, with just enough light, sufficed. Also, I had the flash zoomed, which increases its punch, and I had it pretty close to our subject.

"The happy accident here is the watery, wavy quality of the light."

Also, via the monitor pre-flash from your flash, the camera's brain is assessing reflectivity, contrast, and color, and determining that this world it's seeing is pretty damn dark. It's not looking at skin tone. It's looking at camo paint, dark, wet fatigues, and muted pre-dawn light. The exposure message to the flash is clear—light this puppy up! If I had been running the camera at normal exposure, for instance, I would have had to dial down the flash. But the global underexposure input I made took care of both the ambient and the flash levels.

I try to remember to think like the camera. Historically, meters have always liked a middle gray. That is less true now, because the multi-faceted camera meter system in say, a D3, is super sensitive and has a bigger database than the Pentagon. It deals with extremes real well. But, honestly, I didn't want to get back into that water to do a re-shoot, so I kept checking in on it to make sure it didn't try to pull this moody, dark scene back to the middle of the histogram scale, back to gray.

The happy accident here is the watery, wavy quality of the light. Didn't plan it that way. I was just telling Scott to make sure he angled the light to get to our commando's eyes, and get past the brim of the hat. When he tipped it like that, it bounced up and off the water, filling him like I had a gold-sided TriGrip floating under his chin. I'm also catching a tiny bit of flare from the light passing through the fog laying on the lake's surface. Uh, just like I planned. Thankfully, there were no other accidents that early morning in the lake. ☐

Tune in to
Station "i-TTL"

THE CAMERA METERS WE GREW UP ON were just like the televisions we grew up with. Some blacks, a few whites, but the world inside those big boxes was mostly gray.

Now, we have i-TTL: intelligent-Through The Lens. That means the camera is metering for exactly what it sees, then relaying that info to the flash. The Speedlight has the monitor pre-flash going on, which is cool. The camera has the matrix meter heated up, and the lens is pitching in with critical focus distance info. "Range: 27 meters and closing! Plot firing solution!"

The camera's brain is operating at a millisecond-to-millisecond clip, analyzing incoming intel and info, comparing it to a databank of prerecorded exposure scenarios and offering up what it figures is the reasonable and right solution for the scene in the viewfinder.

Very sophisticated. Very fast. Very accurate. Most of the time. But not always.

It can be frustrating.

You went to the camera store and plunked down a bunch of dough for one of these sophisticated machines with the hope that the sting and pain of disappointing pictures is behind you. It's a reasonable expectation, given the hype of digital. 64 billion megapixels! Shoots at 77 FPS! It's got BL! FP! i-TTL! LCD! It cost you LOC (Lots of Cash)!

So, now, I get, ACE (Always Correct Exposures)?

Uh, no.

The flash and the camera are, indeed, having this sophisticated conversation, and a lot of information is being exchanged and inter-preted. But there's the key—interpretation. Just like any conversation, there is room for interpretation and different points of view.

Think of the camera as the left side of your brain. Analytical. Com-fortable with numbers. But do those numbers add up to what the overheated right side of your noodle wants to say and see? Not at all. That's when you take control or, in the words of the song, you take that hot rod Lincoln of your imagination and "shove it on down into overdrive." You wrench the camera out of the safe zone—the happy, smooth hills in the land of the perfect histogram—and push that puppy into the passing lane.

See this scene (below, left)? The camera's not wrong. It's doing its job. On matrix meter, it is looking at the value of the overall scene. It sees sky, lake, and—ooops—the lone blurb of a person, up front but rather small. This foreground object has literally no light on it. The camera's brain thus largely ignores this lightless shape. Instead, it factors for the big swatches of reflective stuff, i.e., the sky and lake. Bye, tiny human in front of the camera!

No amount of resuscitation is gonna bring this person to life. In the board game called *Exposure!* he is a loser by, oh, about three or four stops. If you go into override mode and, say, spot meter this man's face, which is at first glance a reasonable option that the camera offers, you might get a look at him, but then the sky and the lake will nuke out and he will become an isolated, mostly soft, noise-filled, barely recognizable individual in front of…nothing.

No way that's gonna work. That's an environmental portrait without the environment. The way to do it, obviously, is to apply flash. Artificial light. From the camera's point of view, or thereabouts.

Okay, bango, straight flash attack! The camera meters for the scene as before, when he was silhouette city, and the flash brings him up to speed, exposure-wise (below, right). Now, he is there. Part of the picture. We can see him. But given our straight flash, unflattering treatment, do we wanna know him?

Hardly. The handling of light here is bludgeon-like. Straight, hard flash. The firing squad of artificial light. "Sir, do you have any last words?" *Pow!*

Okay, not good. Let's move on and get the flash off the camera, shall we? This is remarkably simple to do, via some sort of commander signal from the camera that tells a remote flash what to do, and at what power. When I say "some sort," I mean that there is more than one way to do this.

You can use the pop-up flash. Built right into models like the D700, D300, D90, D80, D70, and… sheesh, check the model you have. Many of 'em have pop-ups. Some do not function as a commander, but the middle- to higher-end models do.

Remote flash photography is the best use of the pop-up! You can also use a Speedlight as a master

"Just like any
conversation,
there is room for
interpretation
and different
points of view."

flash. Put it into master mode, and it will direct up to three groups of flashes. Same with the SU-800 (which is not a flash, just a commander). Smaller and cheaper than another Speedlight, the SU-800 is directional and powerful. It is a very handy way to trigger remote lights.

In this instance by the lake and the sky, I resort to a one-light solution, off to camera right. My first move is to make the hard flash better by putting the remote Speedlight behind a Lastolite TriGrip diffuser panel. This device, which I use regularly, is a triangular-shaped springy deal that collapses really small but gives you a tremendously movable, versatile way of shaping light.

You can plainly see the result (opposite page, left). Still a gray lake and sky, but the light on Doug is very nice. It is character-driven, strong but soft. Could have stopped here, but the gray is, well, gray. In the realm of portraiture, when working with people and controlling the action, all bets are off. I can change the look of the picture at will, and color is one element that plays a huge role in a portrait scenario.

So I put the camera into an incandescent, or tungsten, white balance. When you shoot in daylight—especially muted, fading daylight—in this balance, the world goes blue. Very cool and cobalt-like. All of a sudden, with a flick of a button on the camera, the lake water comes alive with color, as does the sky. Give this ambient blue condition a −1 EV input, and the blue gets rich and saturated—the scene gets moody instead of muddy.

It's the boxcars of photography bumping into each other again. Use of light opens the door to use of color, which speaks to the use of camera, which speaks to pushing all those little buttons and dials.

So here I pushed the white balance button and changed the color response of the camera. The ambient condition is daylight, right? So's the flash. If the daylight's going blue, my flash goes blue, and thus my man goes blue. Seeing as he is not a Vegas headliner or auditioning for a guest gig on *Six Feet Under*, this blueness is not desirable.

A warming gel fixes my guy. One full CTO gel brings my flash back into line. It turns my daylight-balanced flash into a tungsten-balanced flash. And because I programmed a tungsten color balance into the

camera, this will render my flashed subject as neutral, or with a presumably even, or normal, skin tone.

But be cautious. If you parse this equation out with a cut-and-dried, two-plus-two-equals-four kind of mentality, you could get burned. The flash is dominating the up-front portrait subject, to be sure, but not completely. Depending on the shutter speed you are using, there will be an incremental "bleed" of the ambient light condition onto his face. In other words, the flash solution for him will not be entirely flash. It will be a mix of the light. Not much ambient mixes in, but some does. As I say at the beginning of the book, think of yourself as a chef in the kitchen. Five parts flour to one part sugar. The sugar part, small as it is, affects your result.

The slight ambient bleed will be cool in tone. So a full cut of CTO ain't gonna cut it. Gotta go with more. How much depends on your taste. A quarter? A half? Another full?

There is no right or wrong answer to this. It is all up to you in terms of the look and feel of the picture, whether your subject has a tan already, or whether his or her complexion is very neutral and could use some revving up in the warm category. Careful, though. Push it too hard and your subject ends up looking like the great pumpkin.

Doug here ended up needing just a small bit of additional warmth (below, right). I also moved him closer to the light source, which effectively creates a more complete coverage from artificial light. I am quite close to him, with a 12–24mm lens racked out to 22mm on a D2X camera. (Being a DX camera, the feel of that lens throw is about 33–35mm.) By being close to him, I enable the placement of the TriGrip diffuser to be close to him. It is hovering, camera right, about a foot or so from his face. The SB-800 unit is about a foot behind the TriGrip.

The result is a studio in the wilderness. □

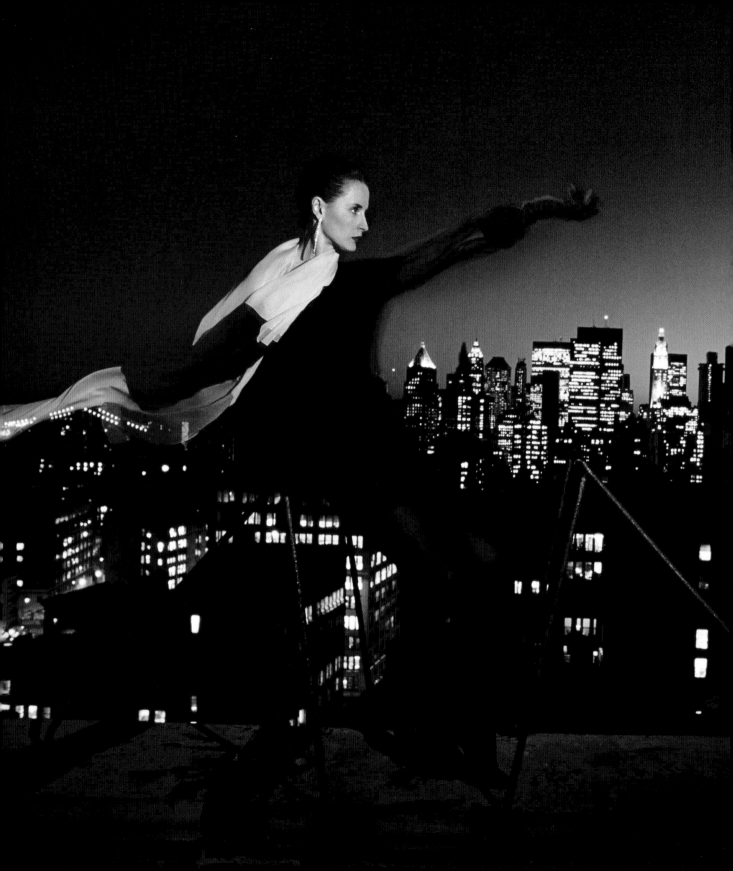

Up on the Roof

MY FRIEND, RITA, is still my friend, even though the first time I ever met her I asked her to stand on a flimsy fire escape 17 stories up in New York, in a howling wind, wearing stilettos, no less.

It was a beautiful sunset. Not as beautiful as it looks in this picture, but it was, shall we say, getting there. I just helped it along.

Whenever you shoot a cityscape at dusk and all the lights are coming on, it is helpful to remember that a great deal of the artificial light in the frame is greenish in color. There is, of course, a mix of lights—fluorescent, sodium vapor, mercury vapor, tungsten—and therefore a mix of colors. But the one that really dominates is green.

You can eliminate a lot of the more sickly green by putting a magenta filter over the lens. This is a very familiar indoor technique when we are confronted with overhead banks of fluorescent lights in offices, schools, and hospitals. Slap magenta on the lens and you really clean things up, from shadows to highlights to skin tones. But it works outdoors as well, especially when looking at a skyline like New York, which is the whole enchilada when it comes to mixed artificial illumination.

Adding a flash to that basic filtration scenario complicates things a tad. The flash is balanced for daylight. Neutral and clean. Not green. What happens when you use a flash and you have a magenta filter on the lens of the camera?

Everything it hits is gonna go pink. Makes sense, right? You are filtering the whole world at the lens, so everything pouring into that lens is gonna get a little ruddy. If it's already green, no problem. It balances out at neutral. But if it's white, or "normal," the kind of light that comes out of a flash, the next stop is the nursery. Oooooh, how cute! Kootchie kootchie coo! Everybody's pink!

Take a picture that has normal skin tones and launch it into Photoshop. Go to Image > Adjustments > Color Balance. There's a magenta slider in there. Pull it all the way to the left. Get the picture?

The way to avoid this is simple. Put a green gel on the white light source. That's what I did here. The Speedlight is camera right, on a very tall stand. Garth, my assistant, is hanging onto that puppy like Captain Ahab bringin' 'er into the wind. The light has no diffusion, umbrella, softbox, nothing.

The wind made the decision about a light-shaping tool real easy. I have lost umbrellas off of buildings, and I once saw my 12' silk and frame rip out of its stand and cartwheel off a pier into the New York harbor, taking with it a monster Gitzo tripod and a 12' ladder.

So I went with hard light, which the lovely Rita can handle. It was metered TTL, which at the time meant off the film plane, a very dependable way to meter. No wireless technology here, though. I had to use SC-17 off-camera cords, the predecessors to the SC-28 and SC-29 cords, to maintain communication with the flash. Now it would be a simple wireless transaction, with the master flash signaling power levels to the remote.

The hard flash, off to camera right, is green, courtesy of a fluorescent conversion gel (which comes with the newer generations of Speedlight, like the SB-800 and SB-900). We'll talk about these gels and conversions a few times in the book, because working with and blending color is pretty damn important. What I did was turn the daylight Speedlight into a fluorescent Speedlight. But, because I corrected for fluorescence at the camera via the magenta filter, Rita is rendered normally. The ambient cityscape, pretty greenish when it hits the lens, gets cleaned up a bit by that same filter. It's not perfect, 'cause there's so much funky green out there in the urban jungle, but it helps. If you want to experiment like this in the world of digital white balance, just program the camera to normal daylight, the same basic color temperature as Kodachrome, which this pic was shot with.

Who is the big-time beneficiary of adding 30 points of rosy color to the whole scene? Mr. Sunset, of course! The sky dives into shades of pink and red and purple. Sunset on steroids! □

How to
Light a Fence

A FENCE IS JUST A FENCE...unless you have an SB-800 AF Speedlight.

Flash has always been painful, right? Especially painful in the cold. Really, really painful in the kind of cold that exists in Yellowstone National Park in January. Batteries dying, trying to work the camera, work the flash, meter the sky, meter the flash, meter your diminishing heart rate....

Now we have wireless flash! Pretty fancy stuff. Cameras and flashes keep talking to each other, even when you can't say a bloody thing 'cause your teeth are chattering like Carmen Miranda's castanets.

I shot this first pic (page 74, top) available light, straight up, on a D3 with a 14–24mm lens. No big deal. The D3 meter handled Yellowstone severity with aplomb, taking in extreme highlights—steam, bleached white snowscapes, and hot flaring sun— with very little EV compensation dialed in and the camera flying on matrix metering mode. Okay, the camera's working, but my eyes are not. Cool fence

but flat light. My first frame has all the punch and verve of C-Span. But it's late in the day, and the sun has set—off to camera right. With the last of my unfrozen synapses firing, I think, what if I could make the sun come back?

I slapped a full cut of CTO (warm gel) on the flash, turning it the color of a bedroom lamp. Warm light. The colors of the sunset. Problem was, I left my dome diffuser on. With that puppy on there, the SB-800 flash defaults to its widest zoom setting (14mm) and light goes everywhere. Look at this second pic. Light is spilling and sloshing and— because the flash is camera right, close to a white snow fence—creating strong lines of white highlight that pull the eye to the edge of the pic and then, bye bye! I might as well have put up a highway sign: Exit Photo Here.

Always remember, whenever you set off a flash, light goes frikkin' everywhere. Which means some goes straight ahead and some goes immediately off to the sides, the floor, everywhere. So, you can apply this note to self whether you have the light up close by a frozen fence or whether you are in a corporate office with white walls. The closer that light might be to a surface, especially a white surface, the more it's gonna heat up. If you have it in your photo, it's gonna scream for attention. So whaddaya do, especially in a spur-of-the-moment, quick-and-dirty situation?

Took off Mr. Dome Diffuser and zoomed the flash to 105mm, giving the light a hot core. This is not something you ordinarily seek, but it's appropriate here. The light becomes concentrated, and you literally throw it in a more directed line towards the center of the action where you want the light— hence, the reader's attention—to go.

The other assist you can use here is the old hand gobo. Now this might sound like something you would want to do in private, but it's actually a very effective, no-frills light controller. Simply put your hand on the side of the unit where the spill is causing you problems. Stuff it right up against the light. That will "cut," or control, the amount of light heading in the direction you don't want it to go. The offending edge of light then falls off dramatically, and maybe, just maybe, your dear reader stays with this fence for a nanosecond longer than they might have before they click back to streaming video of WWE. (The term "gobo," by the way, is one of those tribal dialect kind of things that come from the moviemaking folks. It literally means "go between optics." Hence something that goes between the camera and the light, or between a frozen fence and the light.)

A little light up front, and now I've got a lever over the sky tonality. Pulled the exposure on the sky down via a −1.7 EV dialed into the camera, then dialed a little more power (+1.7) to the flash and made three frames. Really happy for the wireless control features here 'cause that heated van back at the parking lot was looking real good, and the wireless deal got me back in there a lot quicker than working with, say, a Norman 200B or some older flash system that I started off in the business with, and which would now be the rough equivalent of striking two rocks together to make sparks. ("Joe make fire!") □

Cheap Arena Lighting

ANYBODY WHO'S EVER COVERED high school football, or even college ball, knows what happens before every game. The coach gives the emotional speech—win one for the ol' blue and gold, or green 'n' gray, fight, fight, fight, etc.—and then the team collapses into the middle in a jumping, yelling, throbbing scrum.

Trying to cover this with a camera in your hands is a one-way ticket to the hospital, as younger, more powerful guys clad in body armor slam into each other vertically, horizontally, and repeatedly. You can try a Hail Mary, holding your camera desperately overhead, but when you realize that most people on most football teams are there for a reason—they are big sumbitches, made more so by shoulder pads and helmets—that Hail Mary becomes more like a frikkin' Novena. It just ain't gonna work, at least most of the time.

So how about an overhead? Not from a ladder, no. You'll just get knocked off and end up in the middle (or worse, the bottom) of this athletic mosh pit you are trying to cover. You have to stay mobile. And your camera's point of view has to be someplace you can't be—about two feet above the center of the action.

So, fly the camera.

Huh? On the Nikon D3, go into custom function Q7, the camera-hover mode. You can direct flight via the WT7L joystick (sold separately). Kidding!

Pop that baby on your monopod—hopefully a good, sizable, sturdy monopod. (I prefer Gitzo for this kind of stuff. Solid, lifetime gear.) Make sure it is on there securely! Run a remote cord to the camera, or, if you want to get fancy, use a Pocket Wizard. I tend not to use a PW in this instance 'cause you gotta hold the transmitter and mash the button with the free hand that you don't have because holding the monopod is a full-time, two-hand job. Best to run a hard wire right to where your fingers are gripping the pole. (There are a variety of remote cords available. For something simple like this, the Nikon MC-30 works fine, though it is only 2.6' long,

demanding you buy an extension, the MC-21. Ya gotta do what ya gotta do. This will fire the camera in either single shot or consecutive modes with a simple button push.) With this cord, you can hold the pole and punch pictures at the same time. Make sure you snug the remote wire (via tape) tightly to the pod. If it is loose and dangly, one of those guys throwing the old "V" in the air is gonna snag his hand in it and pull your whole rig down into the middle of a screaming, levitating, testosterone stew, complete with helmets, pumping arms, and jumping legs equipped with cleats.

Here's where straight flash is your friend, if you handle it right. Ya gotta have a pop of light from the camera to fill and clean up your frame. If you relied on the almost assuredly dismal stadium lighting you find at most smallish athletic events, you'll be screwed, 'cause the leaping, frenzied kids you are trying to shoot will be all over each other, on top of each other, and, most importantly from your perspective, shadowing each other. Here is where deep, dark shadows, so essential in some other kinds of pics you might take, are going to close you down and consign your hoped-for, hot-stuff, five-column-jubo picture on the front page of the sports section to the better-luck-next-time hard drive. Those arena lights are coming in at very steep angles to the action. Steep angle, steep shadow, no picture.

Anybody who knows me knows I tend to rant and rave about straight flash as the bad juju of strobe photography. Aha! Once again, location photography—situational and fluid—trumps conventional rules and wisdom. Here, it is advisable, even required, to use a straight flash, albeit with

prudence and in restrained fashion. Not hardcore, big bang flash, but fill flash. Flash done with a light touch. Flash that doesn't completely look like flash. Flash that mixes well with the neighbors, Mr. and Mrs. Ambientlight.

In other words, flash running at a minus EV value. Minus-ing your flash a touch is crucial in situations like this. If you blast at full power, you nuke the dudes under the lens, and all the guys on the edges of the frame go dark. (Remember, flying this camera overhead calls for a super wide lens—even, as in this instance, a fisheye lens.) So you have to blend light.

You are mixing ingredients here. You don't want any one element to overpower the other. So, like a good chef, you must experiment with this type of an approach. Bracket a bit, both your flash power and your shutter speed. You won't be able to do that in the 30 or so seconds the team is cheering themselves on, so rig the camera and go out into the stadium during the pre-game time and experiment with anybody hanging around. Mess with the flash power, see how it looks and feels. A bit too brassy and strobey looking? Dial it back. Feather it a little. Use the dome diffuser! Spread the light as much as you can! (You could even, say, use a Lumiquest flash attachment here; it will soften and spread things even further than the dome diffuser will.)

Another good tactic here is to lower your ISO. You may have to shoot the game action at ISO 75,000 so you can stop fast-moving bodies with a fast shutter speed, but in close, in this realm, you don't need $1/250^{th}$ of a second. So you can ease up on the ISO gas pedal. You can skate by with a slower shutter speed 'cause the flash is what will give you your core of sharpness. Remember up front in the book when we discussed flash duration? The flash fires fast—at maybe $1/1000^{th}$ or more of a second—even though you might be firing the camera at $1/60^{th}$, or even slower, if you enjoy living dangerously. (And you should. It's out on the edge, where you might fail, where you are uncertain of your results, where you are taking your chances—that's where your best pictures live and roam. Go out there and get 'em.)

I shot this somewhere around $1/15^{th}$ to $1/30^{th}$ of a second, ISO 400, aperture at roughly f/4. (Don't need tons of f-stop with a fisheye.) The flash is dialed down at about −1, and hence it mixes with the ambient light but doesn't overpower it, and it does the job of helping to retain some sharpness and stop some action. Of course, I am also in rear curtain for the flash. Always rear curtain with this kind of motion-driven flash mix.

One photo. Lots of issues. □

Make the Sunrise

HOW MANY TIMES HAVE WE GOTTEN UP for a bad sunrise?

And, because we love shooting pictures so much, how many more bad sunrises will we continue to get up for?

Shivering in the dark, wondering if we got all the gear, climbing up some hillside or big-footing our way through a forest or field we don't have a permit for, or climbing over a fence and wondering if the folks who own the property also perhaps own a large dog. We are out there making a bet on light and clouds and camera position, a bet so flimsy that it makes taking a flyer on the high-roller slot machines in Vegas look like sensible financial planning.

And then, of course, nothing happens but clouds. Unlike Vegas, when the light don't happen, we don't even play. Pack up and go home.

Unless, of course, you brought a flash.

Now I'm not suggesting an SB unit can do the job of the sun. Far from it. But in a pinch, when you got a salty-looking Cape Cod lighthouse keeper in front of your lens and you got a buncha clouds over your eastern shoulder shutting down the morning light show, you've got, you know, options.

Pop open a TriGrip reflector and use the gold side. Light bounced off this will go warm, the color of sunrise. Don't even have to gel the light. Hold it off to camera left, as close to the edge of the frame as possible. Pop an SB-800 (or 600, or 900; for me here, it was an 800) off the TriGrip. Angle your subject's face into the light, as if he's looking at the sea for a lost ship. Bingo—beautiful light, simply made.

Be careful with the position of the reflector. See the catchlight in his eye? Just about in the center. You don't want to hold the Speedlight too low or it will light up his jacket and cast an upward shadow on his face, which does not look natural. Keep the whole rig—light and reflector—just above his eyes. Also, moving that panel in as tightly as possible completely shadows his face from any other light. It gives you control.

The giveaway, of course, is that there is no golden glow on the lighthouse. That's okay. There could be clouds over that piece of the sunrise. Possible. Some kind of haze over the water. Again, possible. We have all seen all manner of things destroy

a good sunrise and cause us to pack up our camera bag and our hopes, and trudge to the nearest diner to recharge our optimism for the next sunrise with a double stack of chocolate chip buttermilk pancakes, a side of bacon, three glasses of orange juice, a hot cinnamon roll, and a vat of coffee.

Anything can happen out there. The clouds may part for a few seconds, letting wondrous light touch the face of our subject. But hey, while you're waiting for that particular miracle of light, you might grab a Lastolite TriGrip reflector, use the gold side, with a handheld remote SB-800, dialed into Channel 1, Group A and triggered by a hot shoed master SB-800. The master unit tells the remote SB to fire at +1 EV. You need a bit more power than normal, 'cause on aperture priority mode the camera EV is adjusted to −1.7 for good saturation and color, and you lose some lighting power by reflecting it off the TriGrip. My white balance advice here is to go cloudy. Cloudy white balance has the feel of a warm sunrise, even when there isn't one.

Shot this in about 30 seconds as a demo for a Digital Landscape Workshop class. Shot maybe a dozen frames. Like it. Wish I had shot more. ☐

Light as a
Feather

TELL THE STORY.

You know why they call it "fill"? 'Cause the glass is already just about full. All you have to do is pour a little more in.

This "little more" is just that—a little. With fill, you aren't making whole-sale changes or dialing in a new round of f-stops. If we were discussing a piece of writing, we would talk about fill as reading between the lines. It's not there in black and white, but something is being said. It's tough to get your head around, but as little as a third of an f-stop can alter the mood and intent of a photograph.

Louie Cacchioli and I are taking a ride on the Staten Island Ferry in the early morning light. We intersected after 9/11, when Louie came to the Giant Polaroid Studio on the East Side of New York. There, I photographed him with a huge camera and about 30,000 watt-seconds of light on white seamless. Out here on the ferry, with a camera and a hot shoe flash, my mission is different. I am trying to use what's around me to create a mood and tell a story.

A big part of that story is Louie's relationship with New York, the skyline, and that huge, missing piece: the World Trade Centers. I needed to reference him and lower Manhattan. That meant I had to work against the light, piping up the East River, opposite to where we were standing.

Working against the light might not be the brightest thing to do, or even result in the best pictorial photograph. But I couldn't simply shoot him in any way I wanted. I was on assignment for *Life*, and on assignments like these, there is a mantra that repeats endlessly in my head: "What is the story? What is the story? What is the story?"

"I am trying to use what's around me to create a mood and tell a story."

I had to go behind him and connect the dots. Louie and Manhattan. But how do you know anything about him? Shoot without fill, and he's an interesting silhouette without detail. Just another person on the ferry. There's information on the back of his jacket that is crucial to the mission of the photo. FDNY. Gotta see it.

The fine print of the logo is floating in the dark sea of the jacket. If you shoot the jacket with available light, you blow the background, which is crucial to the picture. If you saturate the background, then the jacket and the information disappear.

Fill flash with minus EV is the solution. Using a light-shaping tool that softens and spreads the flash impact helps. I put on the Lumiquest Big Bounce, which kind of flaps around in the wind a bit but does the job of making quick, smooth light. I programmed in just a bit of fill, about −1 EV, and stepped back. (The Big Bounce also knocks some of the stuffing out of the flash.) I wanted just enough detail to see the jacket, but I didn't want to announce my presence via hard directional flash. Using it weakly with the light shaper eliminates one of my big concerns—that the light is directly hot shoed to the camera, something I usually strive to avoid. Do it right, and nobody will know where the flash is coming from. Do it right, and nobody will even know you used a flash. The light is hiding in plain sight. Louie is looking out at the city, alone with his thoughts and memories. Any light you use should just leave him alone. □

Father
Pre-Flash

SO DONALD LOOKED OVER at me and asked, "Joe, do you want me to be Jesus or Moses?" I said he could be either. I just wanted him to be leading his people to the land of accurate flash exposure via the mechanism of the monitor pre-flash.

He said, "Okay, I'll be Jesus, then. People tend to call me that already."

"Really?" I asked, mildly surprised. "I didn't know that."

"Yeah," he said. "I walk in and people just go, 'Oh, Jesus Christ, it's him again.'" His eyes were twinkling.

With Donald, the picture tends to take care of itself, so my account here is not so much about this frame, it's about what the flash does, and how it operates. It's about those lightning bolts, hence my imagination goes to Zeus, clouds, Charlton Heston, biblical references, etc. Yep, I'm strange. Look at a lightning bolt symbol on the LCD on the back of a flash, and next thing you know, I've got Donald out there with sky and the clouds, parting the Red Sea.

See the Flash Gordon lightning bolts at upper left on the flash LCD? That means the monitor pre-flash is operating. That's it. Just means that puppy is working. Why do you need it to work? Even more pertinent, what the hell is it?

When the camera looks at a scene to make an available light picture, the meter takes over and starts reading the scene—highlights, shadows, the whole megillah. When you introduce the flash, though, the camera needs to meter for another influence. It has to cipher a value for how much light the flash is going to generate.

This is where monitor pre-flash makes an entrance, and a pretty splashy one at that. Milliseconds before the real flash occurs, the Speedlight emits a series of pre-flashes. (Think morse code for flash.) At fast flash sync speeds, like 1/250th of a second, you don't really even register them, because the time lapse between the pre-flashes and the actual flash is so short. At longer shutter speeds on rear curtain sync, you will notice separate, distinct bursts of light.

The monitor pre-flash is doing exactly what its name suggests. It is "pre" flashing the scene, communicating to remote SB units, telling them to pre-flash, and then reading light reflected from those remotes (and its own light). Once all that info is deciphered, exposure data is encoded and popped back to the remote Speedlights, telling them how to behave. This all happens virtually instantaneously. This little wink (actually, series of winks) of light helps generate a huge amount of information for the camera's brain to chew on. (Talk about fast food!)

The monitor pre-flash helps the camera's very sophisticated meter to tune itself to the exposure situation it is observing using data like reflectance and color info. In the exposure wars, you've just gone from throwing a hand grenade and hoping for the best to attacking the scene with a laser-guided, heat-seeking missile.

Without the monitor pre-flash, the camera would be flying blind and making sweeping guesses instead of precise judgments. Will they always be the right call? No.

No! No, you say?! Wait just a damn minute here. I just bought this fancy-pants camera (instead of paying my mortgage this month) and you tell me it's not gonna give me the right call, make my stock picks, lower my cholesterol, and introduce me to a beautiful woman?!?

No, it's not. But don't return it and demand a refund. There is hope. □

The "Killer Flick of Light"

Q: AND WHAT, PRAY TELL, is the Five-Point-Palm-Exploding-Heart Technique?

A: Quite simply, the deadliest blow in all of martial arts. He hits you with his fingertips...at five different pressure points on your body...and then lets you walk away. But once you've taken five steps...your heart explodes inside your body....

— *Kill Bill, Part II*

Okay, okay, the killer flick of light is nothing like that. I watch too many movies. Certainly not as deadly, but highly efficient for cleaning up the job. Not a lot of light. A flick. A kiss.

It's the little things that count. I did the heavy lifting and lit up the arena for a *Sports Illustrated* cover story on the top-rated college basketball team of that year, which happened to be the University of Wyoming. That means, of course, that I went large, and had about six or eight 2400ws Speedotrons (big power packs, big studio

lights) in the ceiling. Every time I made a frame, all of downtown Laramie browned out. Having introduced enough light to lift the roof off the building, I mighta thought I was done, and to a large degree I was. Witness a couple of fan type pictures and such. Those big lights in the ceiling did their job, and I just shot wherever I wanted to—court, fans, hot dog vendor, you name it. But there was more to it than that.

Arena lighting, whether it is a small high school gym or an NBA arena, thrives on distance. Huh?

Yep. Counterintuitive to a degree, to be sure. (And, of course, when using Speedlights there are limits to the distance you can put them before they run out of oomph.) But, generally, the further away you have your lights, the better. That gives the light a chance to spread, and rattle around and soften edges and shadows, and getting them up high avoids nasty angle of incidence/angle of reflection type hot spots off the polished gym floor. (Polished wood is a bear to light. You can get highlights off it as bright as a flash hit off a mirror. Demo this for yourself by going to a gym, which most likely has a highly varnished wood basketball court. Put up a flash at one baseline at about 10 feet high or so, roughly the height of a basketball goal. Then go to the other baseline and shoot a medium telephoto lens back at that light, with your camera at the same angle you placed the light, which of course means you gotta be on a ladder. You've just created a roughly equivalent angle of incidence/angle of reflection, which is sometimes highly desired in lighting scenarios. Not here, though. The wood floor will be blasted with a screaming highlight.) So it's best to tuck those flashes up and away from the action, in the ceiling or high in the stands.

That leaves you set up to shoot action. You get a lot of side light, back light, some crossing shadows, all fair enough for game coverage. But what happens when you wanna get close? Like, close for a portrait. Tighter, in other words. Not so much recording the scene and the action, but dealing with

"Its job is to put a catchlight in the eye, pop the face just a tad, and direct the eyes of the viewer right to that face. Oh, yes, I see, he's the star!"

■ Loathed on the road but loved at home, the dapper Dembo plays by his own rule: "Hey, basketball ain't nothin' but a show."

■ The Deeses (left) whoop it up at Bud's, in Laramie, with the Guv (center) and a posse of regulars.

They're Jumping For Joy

All Wyoming is wild about the Cowboys, whose Fennis Dembo could lead them to the NCAA title

BY CURRY KIRKPATRICK

THE DEESES OF GEORGIA—BENNY FROM MOUNT VERnon and Nancy from Alma—are out on the town in Laramie, Wyoming. Wyoming? Well, actually, *Lahrmuh, Wyomin'*, as pronounced by the Deeses, who, since they moved here in April, are never so much understood in Wyomin' as they are believed in.

At this moment they can't even be heard above the shrill carousers in Bud's Bar, a tiny wall in the hole across the tracks in Lahrmuh that most flatlanders couldn't find with a canine search party. You have to listen closely to hear that the

"I already have too many variables rattling around in my head to allow the flash to have a mind of its own."

a personality that you need to get across to your readers.

For this type of shooting, arena lighting will give you some unfavorable shadows and unsparked eyes. Not a bad thing, 'cause you weren't lighting a portrait to start off with, you were lighting a big box of a building. But when keying in, it is often best to resort to the killer flick of light. That light can be right on camera—in other words, straight flash.

Yikes! You go to all that trouble to light the damn joint and now you go to straight flash! Say it ain't so!

But the straight flash (or handheld just off camera) is not going to look like straight flash. It will blend seamlessly into the sea of photons you have sloshing through the arena. Its job is to put a catch-light in the eye, pop the face just a tad, and direct the eyes of the viewer right to that face. Oh, yes, I see, he's the star!

That's the approach here. I'm on a ladder, the arena is lit (which means the court and the cheer-leaders are lit), and Fennis, our star, is flying at the hoop for me to make one of the more cheeseball openers for *SI* that I have ever made. For this, a hot shoe cleanup light was a given. He's got to lift out of the frame, not be part of the scrum of highlights and shadows you get from the overheads.

You don't need to be in an arena to do this, either. You can be in the corner office. You know, the ones where important folks get to sit 'cause

the view is terrific. The view is fabulous because there are floor-to-ceiling windows! These will re-flect almost every light you put up! Every photog's nightmare.

The executive portrait here was shot for one of the Kelby Training videos I have had a ball doing. Though, about midway through trying to light this room, it would not have been a good idea to ask me where my mood was on the laugh meter.

Big windows, big problems, most of which we solved with big lights and large swatches of black material to black out white walls and flash hits. We were pretty cleaned up, and had a decent quality of light finally wrangled for Jeff, our patient executive, but there was something missing.

A light in the eyes. I had gone to great pains to provide smooth overall light from big soft sources, and make the room look "nice." Yeah, nice and flat. When I put Jeff in there, with his dark suit and muted wardrobe, he basically—disappeared.

Time for the killer flick of light! I asked my as-sistant, Brad, to pull out an SB-800, take the dome diffuser off and zoom it to 105mm, maxed out. I got my eye in the camera to watch the edges of the frame, and had him maneuver that light as close to Jeff as possible. It is literally an inch or so out of the picture. On the Speedlight menu, we selected SU-4 mode, which is plain and simple, old-style optical trigger mode. Whenever I use this mode, I simply go

straight to the "M" setting. That way, I know exactly how much light the Speedlight will put out, 'cause I am dialing in the power myself. I don't let the flash make its own decisions here. I already have too many variables rattling around in my head to allow the flash to have a mind of its own.

This way, when I give it a try, I add or subtract power manually, as I see fit. Generally, the flash is so close to the subject, if you give it too much gas you'll knock the poor person's eyeballs into the middle of next week. All you need is a touch. Just a spark to the eyes, which produces a catchlight. Here the SB flash produced a minor hit in the window, which is easily fixable.

There are a couple of ways to trigger Speedlights in conjunction with the bigger packs. One would be to use a radio trigger, along the lines of the Skyport system or the Pocket Wizards. These will fire both studio strobes and Speedlights. (When triggering with radio units, program your SB unit to manual mode. Adjust the power at the unit.) The other way to fire them is as I have described above, using SU-4 mode and the internal light sensor window in the SB-800 or 900. (Can't do this with the SB-600. With older models, check out what's possible. The SB-80 and the SB-26 have optical sensors, others don't.) Program your Speedlight into manual mode, and dial through the power settings until you get just the right mix. If it looks like straight flash, it's too much. If the face is still murky, it's too little. To use kitchen terminology, it's a dash of light. Or, if you are a fan of martial arts flicks, the killer flick of light. Oh, yeah.... ☐

How to Light an Elf

LIKE MAGIC.

First off, give your petite subject an oversized hoodie, which makes her look even more, well, elvish. The hood forms a neat swirl around Hannah's lovely face, and the deep blue of the sweatshirt mixes well with the twilight blue of the sky. Which, of course, is just a happy location accident. If I told you I planned it, I'd be lying. I looked at the first test frame on the LCD and thought, "Holy shit, that actually works!"

"On location, never go audible with your interior desperation."

Try not to blurt that out on the set. It doesn't inspire confidence in your subject or your client, both of whom desperately want to feel that you are in complete control and have thought all this through. On location, never go audible with your interior desperation. When it does work, I completely understand and identify with that refreshing, wonderful, bracing, "It's actually gonna be simple!" feeling that radiates through your noggin (and elsewhere) on the rare occasion when the picture feels successful and effortless. For a few brief and shining moments, it means that you don't have to be an angst-ridden puddle of insecurity at the camera. It positively makes you want to Riverdance.

What a pleasant sensation! The little voice, the one that usually is whispering, "Don't shoot it that way, numnuts! It sucks! They should have hired somebody good. You'll be lucky to be shooting Santa portraits at the mall after you turn in this dreck," is quieted and replaced by another. The tone of this voice is mildly astonished. "Wow, this isn't going to be like putting my nuts in a vise-grip! I'm not going to be tortured and troubled on this particular photo jaunt. I won't be besieged by all those doubts—most of which, actually, are certainties, proven repeatedly over time—that I don't really know what I am doing. This is actually going to work!"

I hear lots of voices when I am at the camera. Most of them are profane and self-disparaging, and they speak to me in words I would describe as, well, *inside* words.

Enough. This is a simple, nice portrait, done quickly—and good thing, too, 'cause the light was dropping like a stone, and the deep blue of the twilight goes a long way toward making the picture worth looking at. Of course, the real reason to look at the snap is Hannah, in all her lovely whimsy, swaddled in a hoodie about 30 sizes too big for her but somehow, as females do, making it look as good as any Dior gown.

One of the reasons you're drawn to her face—partially hidden by all the dark material—is that while the light is pretty, it is basically hitting her face and not much else. I am using an SB-900, programmed in the menu for an even distribution of light. It has the dome diffuser on it, and it is shooting through a Lastolite All-In-One umbrella. The light is handheld and quite literally just a foot or so from her face.

If I had used the entire umbrella, I would have risked lighting up a whole bunch of the material around her face, weighting it, exposure-wise, too heavily. This would have been especially true of the areas of her shoulder and arm that are nearest the light. They would have heated up. No way to avoid it.

Ahh, but maybe there is a way to avoid it—and therein is the reason I am devoted to the All-In-One. It can be used as a reflective umbrella when the black/silver opaque outer skin is in place. Take that skin off, and you can go into shoot-through mode. Take half the skin off, you got, well, half a shoot-through, or a shoot-through that will produce a gradated type of light. Orient the hot half of the brollie up near her face and the dark half low, and you concentrate nice light up where you want it while the rest of the frame retains detail but doesn't scream for attention.

I took it a step further and experimented with taking the lit-up half of the umbrella and indiscriminately striping it with black gaffer tape. No science to this, obviously; I was just trying to break the light pattern up a bit and not make it a solid wall of light rushing at her.

We knocked off some frames very quickly. (The whole shoot took less than 10 minutes.) No time for tripods, even though I am shooting this at ISO 400, f/5.6, and handholding a shutter of almost one second. No sharpness problems, if you notice. A little vibration to the background, to be sure, where the Vancouver docks are all lit up. But up close, there is little or no ambient light on Hannah's face, hence the illumination is probably ninety percent flash. Flash fires fast—let's say $1/1000^{th}$ of a second—so my shutter drag for the sky and the docks does not trouble me. I pull the focus carefully, right on her eyes, and shoot like mad.

Once again, here is the beauty of the flash in close. Great quality. Very little battery drain. Fast recycle. Crank away on consecutive high mode while the sky disappears. One flash. TTL mode.

The photo elves are with you. ☐

Make the Available Light Unavailable

WHY WOULD YOU DO THAT? Why would you go from the safe haven of light you can see, touch, and feel into the mysterious, uncertain, and quite possibly dangerous land of flash? That's like sailing across eel-infested waters and then climbing the cliffs of insanity! Inconceivable!

Think of it this way. That available light is available to you, for sure, but then again, it is available to everybody. You can make a picture that will look kind of the same as the guy next to you, and kind of the same as the guy next to him. Then all of you submit those pictures to the same magazine, or agent, or stock house, and the reaction is, "Hey, wait a minute, these all look...the same." It's like Angelina Jolie and Reese Witherspoon showing up on Oscar night wearing the same dress. Quel embarrassment!

In a world of sameness, where there's a Starbucks, a Gap, and a Pizza Hut on every other block of every other town you've ever been to, there is vibrance and joy in difference. In an era of pictures-by-the-pound, fast-food photography—royalty free, rights free—it just might pay to step back and try to make your pictures the equivalent of a mom-and-pop shop, the old curio store, or the place where the locals really eat.

One path to difference is to use light in creative and unexpected ways. Out here on the road, in the middle of No Place, Nevada, the sun had gone down. There was still plenty of light, but it was cool, subdued, and expressionless. It was, you know, available but unexciting. I put Chris, our actor/cowboy, up against an old barn side that had lots of cool stuff stuck on it, and made a picture (below, left). A very average picture. (That's being kind.) It was a record of the scene, not an interpretation. It was shot at 1/80th at f/2.8.

But what lingered in my head was the sun going down over the distant hills on camera left. It had disappeared behind those hills just when it was about to get colorful and interesting. (Available light will do that to you.) So I put up an SB-900 with a full cut of CTO on it, and placed it on a stand at about the angle the sun had been. The CTO turned the clean, neutral white light of the SB-900 into the color of sunset. The SB-900 was especially advantageous here because of its capacity to zoom to 200mm. When you zoom the flash head to 200, you concentrate the light. It gets punchy and direct, kind of like, oh, the light of a late afternoon sunset.

"Safe, as in…blah. A smooth exposure. Publishable.
But nothing with edge or difference or color.
So, I got rid of it. All of it. I took over the controls
and put the camera into manual mode."

I aimed it at a pretty steep angle to the wall (triggering it with another SB-900 I hot shoed to the camera). Made another frame at 1/80th at f/2.8 (opposite page, right). You can see the scene warm just a touch. The camera is doing its job. It is blending the flash and the available light in a reasonable way. Remember, it's a machine. It does what it does. Like a food processor, it chops, slices, dices, and blends, all with the aim of uniformity and in worship of what it perceives to be the happy place—the land of the histogram, right in the middle of things. Safe, in a word.

Safe, as in…blah. A smooth exposure. Publishable. But nothing with edge or difference or color. So, I got rid of it. All of it. I took over the controls

and put the camera into manual mode. I dialed in 1/125th of a second at f/5.6, underexposing the scene by about three stops. Predictably, I got this (below). Ordinarily, you'd say, "Whoops!" and check your settings. But here, in this dark place, is where I wanted to be. Now I have control.

What happens when you open a camera shutter in a black room? Nothing, until you light it. I had turned this roadside scene into a black room via the use of shutter speed and f-stop. The camera sees almost nothing now. It is waiting for input. It is waiting for light.

Made another exposure, this one with the Speedlight firing and hitting the actor and the wall in a hard, intense way, creating lots of highlight and shadow areas. The SB-900, zoomed at 200mm and gelled warm, gave the scene life, dimension, and color.

You can do a lot with one flash and a stand by the side of the road. You can make the sun come back. ☐

Put Stuff in Front of Your Lights

LIKE A BALLERINA. I'm thinking of having a couple of ballerinas come with me on every assignment. You know, they would just step along "en pointe" behind me. When we came upon something interesting, or especially if we came upon something uninteresting—like an assignment to shoot the mayor's press conference, or a groundbreaking, or the arraignment of the school superintendent who was taking kickbacks from the cement supplier for the new schoolyard and at the same time sleeping with the pastor's wife—I would just tell 'em to go over there in the foreground or background. Then, at least, there would be a reason to put the camera to my eye.

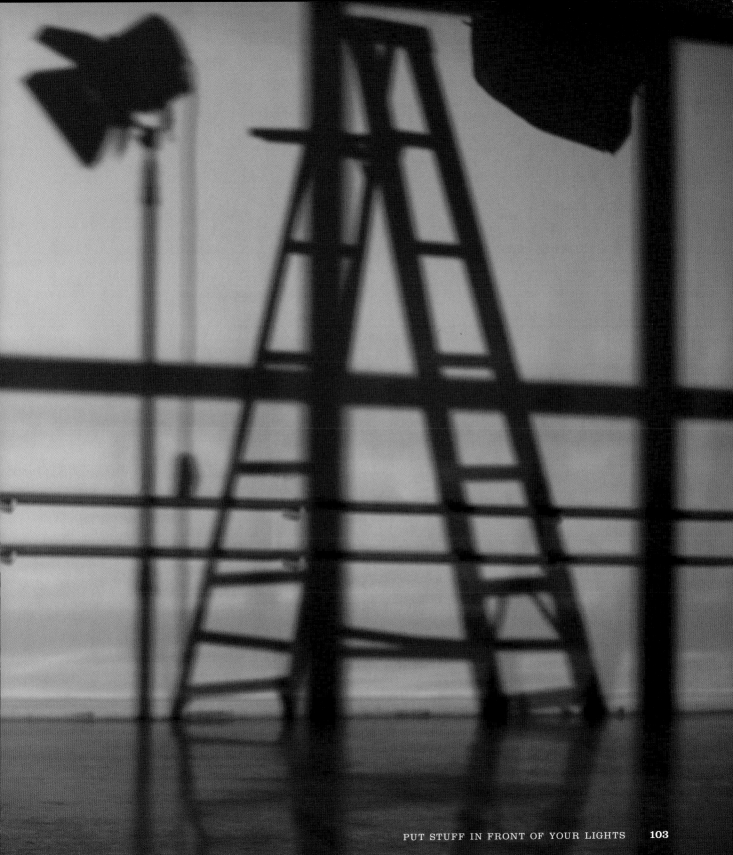

> *"The smaller the light source relative to the subject, and the farther away it is, the sharper and harder the shadows will be."*

I actually think that would be a good program: assign a ballerina to every poor sumbitch of a working shooter who is regularly getting un-illustratable assignments from word editors who wouldn't know a good photograph even if it crawled up their zeppelin-sized pantaloons and bit them in their ample buttocks. I'm going to work on this.

But back to the matter at hand. Lights, camera, action...shadows! The deal is, the smaller the light source relative to the subject, and the farther away it is, the sharper and harder the shadows will be. I mention this a number of times 'cause it is mildly counterintuitive. One instinct might be to move the light closer, making it more powerful, and thus get great shadows. Not the case. Do an experiment. Put something up—a lamp, a ladder, a tripod, something that will cast a definitive shadow. Put your light close, and expose. Then make a series of exposures as you move the light away 20, 30, 50, 100 feet. Watch the shadows define themselves.

So, I accomplished step one. A lovely ballerina. She is in a very basic, box-like classroom. Bare walls, piano, mirror, and bars. A classic dance studio. Much like a photo studio—an empty room. Dancers and photographers are alike here. What do we fill this empty room up with? Our imaginations. In this bare space, she is the life force of the picture, providing the beautiful, fluid gesture. How do you grace this scene with light? There were big windows, but they weren't helping. It was raining and miserable outside, with dark clouds. It was basically f/0 out there.

You could put a light up close, with an umbrella or a bounce. That would be okay. Might even be, you know, nice. But if you think outside the room— the box you and your camera are in at that moment—you might just try putting the light out in the street. Which is what I did.

There is one SB-900 lighting this whole scene and it is 80 to 100 feet from my subject. It is out on the rainy street, encased in a Ziploc baggie, run up a large stand to about 18 feet, and tended to by Brad, my very wet and miserable assistant. I have another SB-900 hot shoed to the camera. The flash head is turned around and aiming out the window, where the street-based 900 is picking the signal up easily and pumping out light. Once again, I am using my trusty friend, Mr. CTO, on the remote SB-900 to warm up the whole scene and make it feel like late afternoon, directional, golden light. There is no dome diffuser action here. The unit is racked out to max zoom, 200mm.

But that ballerina, beautiful as she is, would float in the space were it not for the ladder and the movie lamp we drug over into the flight path of the photons. Kept pushing and pulling them into line, and some measure of graphic sense. Those elements make shadow games on the otherwise nondescript studio wall. She then becomes a curved and graceful figure hemmed in by hard, sharp geometry. The shadows are crisp, singular and black. One light, far, far away. □

Dad!

"WILL YOU STOP EMBARRASSING ME with that SB-900 Speedlight and the D700 with the built-in flash in commander mode?!"

My 16-year-old daughter, Claire, like most girls at this stage of her life, has precious little use for her dad. Except, of course, as a highly mobile ATM. And when her photog dad takes camera in hand...oh boy, we're talking pain bordering on root canal.

Though, to her credit, she did ask me to make a few snaps at her sweet sixteen party, but I was limited in how many I could take. Kind of like being a rock-and-roll photog, allowed to shoot for three songs before being ushered out of the arena by security.

Claire's sweet sixteen party was a very low-key affair involving 40 of her friends, a party bus with a dance floor, disco lighting, and smoke machine, as well as a sound system that basically turned the bus into a giant four-wheeled woofer. I was willing to do this for her because, as I told her, it was very similar to what my mom and dad had done for my sixteenth birthday, and I felt I should extend the experience to her.

We collaborated on putting the party together and I was, of course, exasperated—insisting on safeguards, wanting to know who was coming, if their parents okayed it, and the like. She would just roll her eyes and say something like, "Dad, you wanna quit bein' a butt cheek?"

Anyway, just like any celeb shoot, ya gotta get close, work fast, and disappear. My camera is a D700 with a 24–70mm lens. The shot was made at ISO 800, at 24mm, at 1/8th at f/4, with –1.7 EV dialed in at the camera. On aperture priority, the camera will try to open the scene up, with the meter making a desperate leap to get back from the disco inferno to the smoother, safer tones. Smooth and safe are not the tonalities of this party animal of a bus. Plus, trying to open up for that dark background will give me a shutter speed I can't effectively hold, even with a flash mix.

The remote SB-900 is handheld by my other daughter, Caitlin, and has a full cut of CTO (warm gel) on it, just to make it feel a little jazzier and less like straight-up white light flash. It is being triggered by the built-in flash on the D700, acting as a commander flash. At close quarters, the little pop-up thrives. It is unerring in triggering the remote.

And that's all you want it to do: trigger the remote. Why go to the trouble of involving (and thus boring and embarrassing) both of your daughters just to come outta there with a straight flash picture? As they would say, "How random!"

"Anyway, just like any celeb shoot, ya gotta get close, work fast, and disappear."

No. Go into the custom menu and get to the option for bracketing/flash. Go to the section for built-in flash. When you select it, the default shows your pop-up in TTL flash mode. Get outta there by clicking down to the option for "commander." Click right and you will see the categories for built-in, and Groups A, B, and C. Click up on the thumb wheel until the "TTL" next to built-in changes to "---." It is now gone as a flash and will function only as a commander/trigger and not impact the exposure of the scene.

Then punch your way down to the groups, and if you are on the bus with one remote flash, you needn't go further than Group A. Let it ride at first as an i-TTL Speedlight at 0.0 EV. Test it, and if it looks and feels good, you are done with the menu. If it needs adjustment, ya gotta cycle through the menus again, get back to that group, and plus or minus it as you see fit.

The built-in will continue to fire a monitor pre-flash and that may be a bit confusing, as you might think it's a real flash. It's not. The built-in and the remote Speedlight need the pre-flash to communicate. But, if you program it right, as I indicate, the pop of light coming from the camera will be solely an exchange of information, and there will be no hint of straight flash light in your picture.

Now that you are set up, you can shoot your 10 or so frames and get off the bus. Notice the make-out session starting in the back? Time for dad to leave.

Capture NX 2 was used to darken faces and protect the, uh, well, innocent. □

80 Plus 20 Equals Good Light

I'VE NEVER BEEN VERY GOOD at math, but I know the Lumiquest 80-20 light attachment adds up. Whenever you get into a situation with an overhead drop ceiling and banks of lovely fluorescent illumination, you need to tweak that light to your advantage. In addition to being green, the available fluorescent bulbs are overhead, which means that the top of your subject's head will be lit just fine. That's okay if you're doing photography for a hair salon, but in most situations you want to see people's eyes.

With all that light pouring down on them from the ceiling, those eyes are probably shadowed to some degree. You need to move fast, correct color, and fill the face in a natural, easygoing way. In other words, you need to light without lighting.

I say this because, unless you're really a masochist, you don't wanna light the whole frikkin' place. Let a sleepin' dog lie, as grandpa used to say. Just use the light that's there. Correct it, expose for it, and then let it be. It will do a lot of the heavy lifting for you.

Let's take a stab and say the overall exposure of these places runs somewhere around 1/30th of a second at about f/2.8 or f/4, ISO 400. That's a pretty good guess. With row after row of fluorescent fixtures, it's like a light blanket, right? Not a very pretty blanket but, you know, it covers the waterfront for you. It frees you up to concentrate on your subject—the folks up front in your photo.

This is where I often reach for the 80-20 attachment. Crank the Speedlight straight up, take the dome diffuser off, and velcro the 80-20 to it. Most of the light (eighty percent of it, actually) goes straight up and hits the ceiling, mimicking the existing ambient light. The trick of it is that twenty percent of the light flicks forward, filling your subject's eyes and face. It does this gently, easily, and, most importantly, unnoticeably. The operative word here is "unnoticeably." That means, in addition to using this nifty attachment and correcting for the color of the scene, you also have to be careful on the power throttle. Think of your subject as a rare and delicate flower. Use a spritzer, not a pressure washer.

The Lumiquest 80-20 is about moving and shooting when you don't want to make ripples in the existing light pool. You are "filling" the scene— in other words, supplementing the overall supply and quality of light.

"The moment is more important than the light."

You are dependent on the ambient light for exposing most of the frame, and thus are subject to its whims and colors, which, in the case of many, many work environments, is gonna be green.

How do you seamlessly continue to work and not have everybody looking like they're in an aquarium? Make your flash green. Huh?

Make your flash green. You've got green light in the room but white light from your flash. Apples and oranges. You've got to make it all apples. In this case, green apples. Do this, and you have a uniform color to the light hitting the pixels.

Out come the fluorescent correction gels. Just like CTO (tungsten or warm) gels, they come in various intensities, from quarter (very light green) to half and full. In an enclosed fluorescent environment, go with full green. Slap that puppy on the flash. (The SB-800 and SB-900 come with a full green correction gel.)

Now turn your attention to the white balance of the camera and program that to fluorescent. Experiment! Many digital cameras have ways of making incremental shifts within a specific white balance selection. Make some of these shifts. Look at the results and find a pleasing color balance. Remember, too, that the white balance you sort out for the fluorescent room in this building might not work tomorrow when you are shooting a job in another building down the block. There are many types of fluorescent tubes, from cool to warm, and they look different as they burn and age. The room you are shooting today might have brand new tubes in it, whereas the room you shot last week still had tubes that got put up during the Truman presidency.

How to cope with the vagaries of location color? There are so many ways to do it now, in this digital time of ours. With lots of cameras you can do a "preset" white balance for a particular color environment, using a white or gray card. (Ways to do this vary, so check your camera instruction manual.) You can do this either with available light or with a flash. Done properly, the camera will most likely return a very pleasing color solution, 'cause it's pretty smart. If you want to be adventurous and experimental, you can switch the white balance to Kelvin, which allows you to dial in your preferred color temperature numerically.

Or, you can get antediluvian about it and program your digital camera to a straight-up daylight white balance, the same color that was inside most of those yellow boxes you used to buy from Kodak. Then, with a green gel on the flash, you can filter your lens with roughly 30 points of magenta, a time-honored solution. Historically, that was the tried and true fluorescent solution. Full green on the flash and 30 magenta on the lens would give you good skin tones, give or take a couple of points.

But the real important thing here is if you use the 80-20 with a green gel, and seamlessly blend light and color, no one will know you were there.

Which, when you are spending time with an incredibly courageous little girl, blind since birth, who navigated the hallways of her school by using a clicker to bounce sound off the walls, is very important. You have to move and shoot, lightly and quickly.

Or, when you are in an emergency room and see a nervous little boy about to get a shot for an allergic reaction to a bee sting, is definitely the way to go. Less is more. The moment is more important than the light. ☐

Lacey Light

I OFTEN USE WINDOWS and whatever is in 'em to corral, shape, direct, and otherwise twist what might have been a straightforward softbox solution. Light comes through the windows anyway, so it's a reasonable thing to do. Softboxes do a good job of mimicking soft window light, but they are designed to be smooth, even, easygoing light. Often that is what you want, and they are the perfect ticket.

But what they aren't is surprising. If you throw a light through a window, it could become a softbox with attitude. It might take on the shape of the window enclosure, or the shadows of the framework, or the slight color of the dirty glass. If there is a curtain, depending on how it rolls and furls and creases, it might just impart to your light a variation in f-stop, intensity, feel, shadow, and pattern.

The lace curtain in question here is old, yellowed, and bedraggled. It has seen many a sunrise and, most likely, never seen a washing machine. It is warm and patterned, and when my SB-900 flies through it, the light gets warm and patterned, too. Henna-like, the lace pattern paints itself all over the model, who has a lovely and regal look that somehow fits the light.

One light and old lace! Shot it at 1/250th of a second to kill all the ambient light hanging about, and f/8 gave me nice sharpness to her and the light patterns. Without the swirls and shadows, the light is nice. With them, the light is nice...and interesting. ☐

Strobe Strategy

LINDSAY SILVERMAN OF NIKON is gonna hate me for this one. You see, to Lindsay, the mad scientist, genius, and general all-around muse of flash, it is not a strobe. It is a Speedlight. A flash, if you must. But never a strobe.

And, you know, he's right. Strobe comes from the Greek word "strobos," which means "act of whirling." The classic description that goes with strobe would refer to a stroboscopic, or repeating, flash-type of light source. The gumball machine atop a police cruiser, for instance. That would be a strobe.

The word "Speedlight" also comes from a Greek root, meaning "marketing term." Kidding!

Anyway, the title of this story was too good to resist.

I ain't messin' with the strategy part. That's for real. Ya gotta have a strategy out there in the field. Sometimes it has to be really well planned out, and sometimes it has to be ad hoc, seat-of-the-pants, carpe diem stuff. No matter the type, simple or elaborate, it is also always subject to change.

National Geographic inserted me in the loop as the NASA photographer of record for STS-95—otherwise known as John Glenn's return to space. It was an honor and a great opportunity. It also meant I was going to spend 17 weeks working the hallways of NASA, inside classrooms and simulators, often working with bad light or no light. It was going to be fill-flash city.

Or so I thought. Senator Glenn was totally cool about whatever I needed to get the job done. He wanted the mission documented. But, true to his military roots, he would invariably say yes to my requests, but also caution me always to check with Curt Brown, the mission commander. Anything I wanted to do vis-à-vis the crew or the mission had to be run by Curt.

"Last thing to do here is be aggressive and move in with the flash power dialed up to Kaboom!"

Curt was a great pilot with vast shuttle experience. He had lots on his mind, obviously, between getting his crew ready for the mission and dealing with the extraordinary press attention John's return to space was causing. He was also visibly rankled by the fact that absolutely no one was paying any mind to anything else about the flight other than John. So he was, in a word, crusty. About one stop short of outright difficult.

His first words to me: "No flash."

Yikes! Seventeen weeks of available fluorescence, dark holes for eyes, and ISO ratings from the dark side. Hmmm...what to do?

Thankfully, it was a job I could stick with and work. So I gulped and said, you know, "Fine." What the hell else am I gonna say to the mission commander?

But after a week or so, the crew was getting comfortable with me around, and I was the subject of some astronaut (read: pilot) humor, all of which I weathered in good-natured fashion. I broached it again, describing the use of flash as an experiment. Try it, you might like it!

Curt said yes. Okay. Last thing to do here is be aggressive and move in with the flash power dialed up to *Kaboom!* I shot on manual, and for the first couple of days of the "flash experiment," I stuck 'em on 1/128th power. Teeny, tiny little flick of light. Barely registered on the old eyeball scale.

No raised eyebrows. Thankfully, Curt ignored me. Dialed it up a bit. Bit more. Bit more. After a few days, I was shooting full-blown TTL, with Lumiquest attachments, and bouncing light off of space shuttle walls and classroom ceilings, and working shoulder to shoulder with the crew, often in cramped quarters.

Last thing you wanna do in these instances is dial up your flash—along with your sense of journalistic imperative—and challenge the big dog. Best to be elastic about this stuff. Give some ground. You'll get it back later. □

Smoke
and Windows

ONE SIGNIFICANT ADVANTAGE of the SB-900 is definitely the 200mm zoom option. The ability to gather light and punch it out with concentration and force over a distance gives these small flashes a range and versatility they have not previously enjoyed.

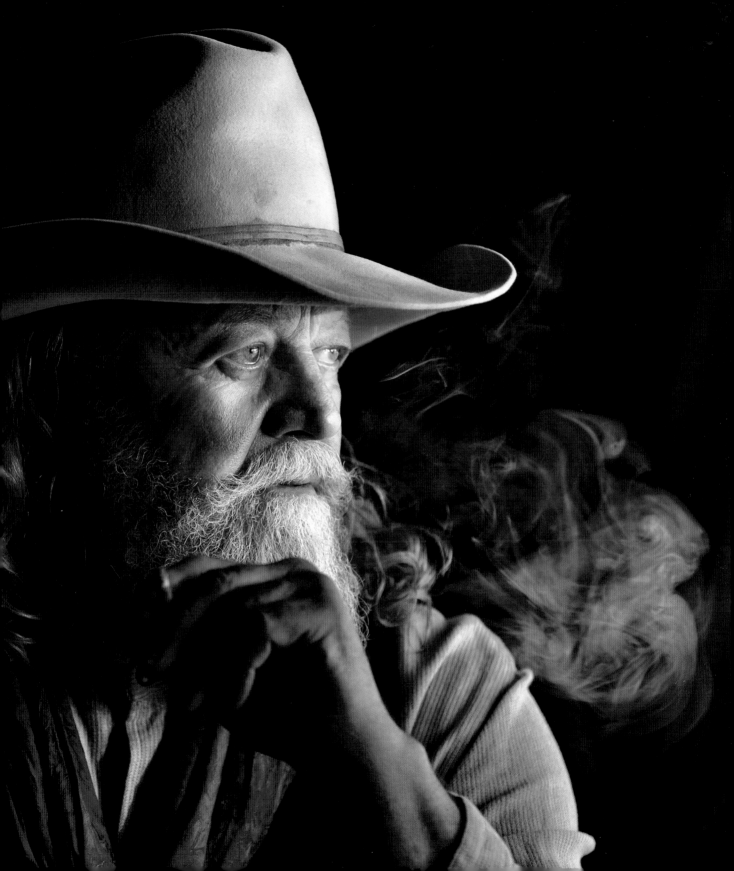

> "I stay with matrix metering 'cause I'm addled, and if I dial in spot meter mode I'll forget about it and be metering like that for the rest of the day."

This solution is one light—an SB-900, out on a porch, with a warming gel (half CTO). I am triggering it with an SU-800 unit, again, pulled off my camera with the SC-29 cord. I can shoot the very directional and linear triggering impulse to the SB-900 out on the porch through one window while my subject, Thomas Wingate, looks through another and creates his own smoke-filled-saloon atmosphere.

Used a long lens (70–200mm, racked out to 170mm) to isolate my subject and shot aperture priority with the camera EV dialed down about two stops. Reason for that, of course, is that the majority of the frame is dark and the camera will react to that darkness and basically nuke the foreground.

Two ways to avoid this: realize this is happening and dial down your EV and leave the camera on matrix metering for the whole scene; or go to spot meter mode and get a true value for the core of the picture, which is Thomas's face. Either way will work. I stay with matrix metering 'cause I'm addled, and if I dial in spot meter mode I'll forget about it and be metering like that for the rest of the day.

The SB-900 in the street is handheld, by the way, as is the camera. Shot about 10 frames. Having the camera and the flash talking i-TTL is a great way to work on the fly. ☐

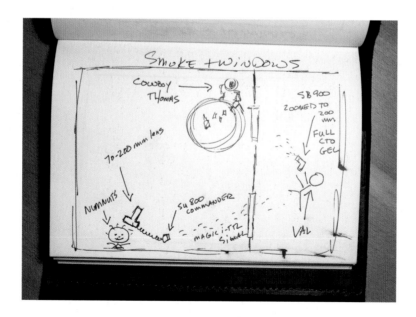

Hakeem
the Dream

AND HE WAS, IN FACT, a dream to work with. An uncommonly gracious man, he well earned the nickname The Dream by leading the Houston Rockets to two NBA championships in the '90s while winning all sorts of MVP-type awards. *Sports Illustrated* asked me to shoot him as a cover story for their popular "Where are they now?" yearly issue.

While Hakeem was a dream, I had to shoot him in Houston, a city rarely referred to as "dreamlike." It is a city of strip malls and hard, flat light. The sun comes up fast, burns through all the crap in the air, and hits your pixels like a thrown punch. Pretty, it ain't.

I had one day with The Dream, and I knew I would be fighting light all the while. One of our most important jobs as photogs is to manage bad light well. It is an ongoing battle we often lose, especially on a day like this, when working fast is at a premium. He's a celebrity, after all, and you have to check the clock as carefully as you check your exposures.

Hakeem is a devout Muslim, and showing that was a big item on *SI*'s agenda. He was cool about it, as he is very active in educating people about Islam. In front of his opulent home, he maintains a garden area where he prays and studies the Koran. On these compressed-coverage days, you simply have to be direct and say, basically, let's go pray. He took a small Koran and, thankfully, got engrossed studying it.

I say "thankfully" 'cause I was sweating bullets in the harsh light of Houston and saying my own prayers to St. Jude for a decent frame. The light was kicking my ass, and I was basically in triage mode. The patient (the job) was dying, and decisions had to be made—all fast, and none of them particularly pretty.

First line of defense was to keep it low tech. My assistant, Brad, positioned himself to camera left, in the hot sun, with a gold Lastolite TriGrip. These are easy, quick, and very effective at redirecting hard light. As you can see, there is a warm highlight on Hakeem's face (below, left). This is courtesy of the

"One of our most important jobs as photogs is to manage bad light well."

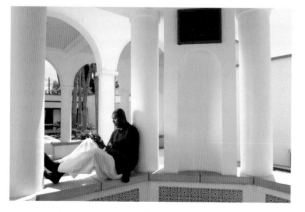 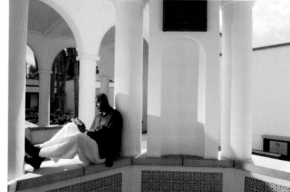

gold reflective surface of the TriGrip, which pulls out detail in his dark skin. Nothing else is really affected. I make an available light series of pix, and the exposure for the interior of the small temple is bright and fairly high key. There is also a hole in my frame, where the sky used to be.

Next step: go to flash. Brad stays in the same spot, aiming an SB-800 bang on to Hakeem's face. It is zoomed to 105mm to get some direction and punch. With Brad behind the column on the left side of frame, I have the additional problem of getting that light unit to see the signal from my hot shoed SU-800 commander unit. I solve this by popping the SU-800 onto an SC-29 cord and holding it out to my left, snaking the signal to Brad's light behind the structure.

As you can see, the flash did its job (opposite page, right). Zoomed to 105, it hits my subject hard. Now I really have him lit, which is great, but what is the giveback? (Remember, this is photography. There is always a giveback.) Here I lose detail inside the small temple, and Hakeem casts a sharp

shadow. It's also a big shadow, considering he is 7' tall. The bright, airy quality I had in the available light shot is gone, replaced by a less appealing darkness. But, while I sacrifice the inside of the prayer structure, I get back my sky. The upper right piece of the picture now has definable detail.

I could have gotten the interior area back a bit by filling from camera by either bouncing another light off the ceiling or using a shoot-through umbrella, but I nixed those ideas as soon as they passed through my head. The ceiling was colored tile and about five miles high, and trying an umbrella meant setting up a stand, going to the cases, and figuring out another light—and I was simply moving too fast. As I mentioned, jobs like this often amount to a series of unappealing decisions you make at the camera.

Neither of these pictures was published, by the way. *SI* did run a more centered version of the flash solution (above), which was also a frame with problems. If you look at the background, there is a highlight skipping off the backside of the left column in

the picture. Brad is out there with the flash, and that hard flash grazes the white painted surface, producing a blip that is, oh, about 30 times hotter than anything else in the picture. It is a small thing, but I'm here to say I never saw it. (After this job, I immediately bought a Hoodman loupe, and I always travel with it. On sunny days, looking at your LCD without it is just about useless.)

We closed the day with a leisurely, 30-second portrait session. Hakeem was heading to a real estate meeting. (He is one of the biggest private landowners in all of Houston.) I saw the skyscrapers, the re-flected crane, and a pre-storm sky, and, promising to be brief, I asked him to stop. Brad stood to camera right with a handheld SB-800 aimed at Hakeem's face. I underexposed the background, which gives the sky punch, and simply threw hard light at his face via i-TTL signal. I shot five frames. We were done.

SI liked the job. They were very happy with the pictures, even though they didn't use many of them. I didn't get happy, of course, un-til I heard they were happy. You get that word from the client, and you exhale. This was the type of job you survive. You don't really excel. You won't use the pictures in your portfolio. But you survive to fight again another day, when you can hope for the light to bend in your favor instead of going after you like a junkyard dog. The best thing you can do on a day like this is just hang in there—keep thinking, keep looking, and be patient behind the camera. A picture will come. Might not be the one you thought you were after, but a picture will come. Jobs like this are all about tenacity.

That skyscraper pic didn't get published either. Neither did my fa-vorite frame of the day—a straight-up available light picture inside a mosque. In that lineup of Muslim men, there is no doubt who used to play center for the Houston Rockets.

I lost the cover to the Hanson Brothers, the bad boys from the movie *Slapshot*. It's one of my all-time favorite movies, so I didn't feel bad. Just hadda tape on the foil and go after my next job. □

"The best thing you can do on a day like this
is just hang in there—keep thinking,
keep looking, and be patient behind the camera.
A picture will come."

FP Means
Good DOF

ONE OF THE MANY BENEFITS of auto FP high-speed sync is limited depth of field. I say this advisedly, of course, 'cause shallow depth of field may not be where you want your picture to live. But when doing portraiture, there is no better way to direct the viewer to the face of your subject than by throwing everything else out of focus.

In bright conditions with digital, you are fill flashing at 1/250th of a second at f/11 to f/16. Not good, most of the time. You will be stressing that small flash like crazy, draining your batteries at a precarious rate, and slowing your pace of work down to a crawl. Auto FP high-speed sync can easily come to the rescue here, depending on how close you can work that flash to your subject. Remember, sliding into FP mode is a neat trick, but this, too, requires the flash to spool up and perform Olympian feats.

But here's the silver lining: limited depth of field. In auto FP high-speed sync mode, you pretty much want to be as wide open with your f-stop as you can go, with the flash as close as it can go. That can be a beautiful combo.

If you look at our friend Lealynn on the boat (on the following page), she is in the shade of a canopy. The camera is looking out on other boats in fairly bright sunlight. The shade on her is not a problem; foreground flash is gonna handle that. But there is literally nothing to be done about the bright quality and quantity of light on the background.

Now there will be folks who trot out the potential solution of neutral density filters. That is viable, absolutely. In fact, in my camera bag I almost always have the Singh-Ray eight-stop variable neutral density filter. Pricey little sucker, but it can save your butt, say, if you want to do panning and motion in an overabundance of light, as some clients will request you to do.

But when working up close, the auto FP option is way cool, and it's simple to do. Make sure in the menu of your D3, D700, D300, D etc., that you find the custom setting titled "bracketing/flash" and go to flash sync speed, and check off the high-speed option. Once you change the custom setting, you'll see a little asterisk at the far left. You are now poised to automatically slide into auto FP. Which is a good thing, 'cause in aperture priority mode, which is where I live most of the time, you can forget where you are treading sometimes with your shutter speed, which shifts constantly as you input different f-stops or as the camera sees different scenes. If you are not tracking it, you can occasionally slide above 1/250th of a second and out of the realm of normal flash sync. With the FP option on, you will still get sync, albeit most likely underexposed sync. But, depending on your mindset,

bringing back some underexposure in post is probably easier and less of a hassle than dealing with an entire section of the frame that just got blacked out, which is what used to happen regularly with older cameras.

(This can have serious ramifications. I have a friend and good shooter who started his career when he was in the military back in the '60s. The upper end of flash sync at that time was 1/60th of a second. He was shooting such good stuff that the impressed base commander assigned him to shoot his wedding, which he did, working flash on camera all day, but unfortunately at a shutter speed higher than 1/60th. When asked to lecture about his career, he shows a couple of these efforts, which are terrible—mostly black frames, with maybe a bit of the bride's dress and the base commander's shoes visible. The next picture he shows is a shot of himself, riding a tank in Vietnam. Serious stuff, this flash photography.)

I digress. So you now purposely go into auto FP high-speed sync mode with the SB unit. (You can use this mode with flash on camera and also with remote flash units.) You are close to your subject, as I am with Lealynn. The flash is camera right, same as it was in the first picture, but now I have changed up lenses, going from wide to telephoto and pulling the frame in tight to her. I shot auto FP at 1/800th of second at f/2.8—wide open on my 70–200mm zoom.

Those huge boats in the background of the first solution—wide lens, big f-stop—are now gone, replaced by soft, almost backdrop-type color and uniformity. They are no longer an element, they are just a texture. Your eye stays with the lovely Lealynn, lit by one SB-900 flash and shot through a TriGrip diffuser panel. ☐

Flash in
Real Life

DOING A *NATIONAL GEOGRAPHIC* story on the human brain, I met three-year-old Jody Miller, who I came to call "goose," and her amazing parents, Lynn and Al. Jody had a rare syndrome called Rasmussen's Encephalitis. She was having over 150 seizures a day, and they were overtaking her tiny body. The only way to save her life was to perform a radical, dangerous surgical procedure called a hemispherectomy. They were going to remove the right half of her brain.

There's no place I feel more like a bull in a china shop than in an operating theater. I've shot dozens and dozens of surgeries, from heart transplants to hip replacements to a cosmetic type of procedure known as a coronal (yuck!). You have to be calm and quiet, knowing when to move and what not to touch. Your greatest friend on these days is the head nurse, who runs the show and knows the doc well. If you approach respectfully and rationally, he or she will show you the ropes, give you a small, out-of-the-way area against the wall to stage your gear, and, in general, save you from doing something irretrievably stupid. And there is no type of job I can think of where the old location rule of "show up early" is more applicable.

The Miller family invited me to document Jody's perilous journey for *National Geographic*. When a family allows a stranger with a camera into the desperate and emotional struggle for their daughter's life, it is a gift that can never truly be repaid. All I could do was stand in awe of their courage and faith, and try to do my job while my heart was pounding in my rib cage for this little tyke I had come to be very fond of.

You can't see the brain, right? You can only see the effects of the brain by observing behavior. Right there is the conundrum of the story. I was assigned to photograph something I could never actually see, thus everything I was destined to record was one step removed from the reality of this organ.

Unless I was allowed to photograph a hemispherectomy. During the surgery, a large section of Jody's cranium was removed, exposing the living human brain. This was an astonishing moment, a view of life that few people ever see, and if I did my job right, the photos would allow millions of people to witness it.

So this is not the time for mistakes. Not gonna get this one back. Time to rely on intuition and picture skills, and shoot and move effectively. Not the time to dwell on the numbers. Not the time to stare at your flash like it's a moon rock, or try to parse out the Rosetta Stone of the instructional manual. Feel it, shoot it. Move with care and confidence.

The numbers play a role, and they are consequential and important. A lot of this book is about the vocabulary of light, and under discussion are the tools and terminologies we use, from SB this and that to auto FP, flash sync, i-TTL, matrix meters, and RGB sensors. All of which are cool and bear rightful discussion. But this particular story is about how these tools are just that: tools. They stand in

service to the mission we are all about, which is communicating.

Smart, dedicated flash units helped me here, enormously. The intuitive, responsive technology we have been given as shooters facilitates us in tough spots like this. The biggest hurdle—beyond the hubbub of an operating room in the throes of a life-and-death situation—is, plain and simple, the extremities of light. The surgeon's spotlights are much hotter than the rest of the room. I was shooting slide film, which has little forgiveness and less exposure latitude. Witness the picture of Jody, asleep on the table, prior to having her head shaved. (Her hair had never been cut.) She is almost glowing in the light, and the rest of the room is dark. Works for this frame, but the rest of the time the camera was gonna have to see more than just what the spotlights would allow.

I had to give those spots their play, right to the edge of blow-out, but then bring back the rest of the room via the use of flash. With older units, this would have been tedious and fraught with difficulty

and inconsistency. With smart flash units sensing the scene and talking to the camera's meter, I was able to shoot at this edge with a lot more confidence. I shot some things with straight-up available light, moving around the edges of the table, staying quiet and out of the way.

But then, in close, the light at the surgeon's hands is so intense and defined, the rotation of light to shadow is as sharp as the scalpel he is wielding. Hands were drifting in and out of this pool of light, vanishing and reappearing. I had to enlarge the range of what the film would see. (It's the same now with digital, which has a lot of similarities to transparency material in terms of handling the extremes of exposure.)

I put on a medium-size Lumiquest diffuser (nothing big, which would be too dangerous to control that close to the sterile field) and had one crack at a full view of Jody's brain before that hemisphere disappeared. I was on center-weighted exposure mode, so the camera meter reacted to the intense core of the light, and the flash effectively washed around the edges of the scene, bringing back some context and, more importantly, the delicate ballet of the surgeon's hands. Without that bracket of hands and instruments, the picture would simply be an emotionless record of the exposed tissue. The hands provide context and explain the situation, giving it humanity and drama.

I was very nervous prior to the surgery. I looked over at Dr. Sumio Uematsu, an incredibly skilled and sensitive surgeon, who stood at the head of the operating table. Jody was already sedated, deeply unconscious. I said nothing, not wanting to be a distraction. He looked over at me, and asked, "Right side, right?"

"I believe so, doctor," I gulped. He nodded, and I could see his eyes twinkling and the smile behind the surgical mask.

Jody lost every drop of blood in her body that day, and was entirely transfused with a new supply. Her family and friends were in the waiting room, talking, praying, hoping. She came through, and is now a vibrant, college-bound teenager with aspirations to become a teacher.

The frame I made that day has been included in a *National Geographic* anthology of their 100 most important pictures. ☐

Light 'Em, Dano!

EVER SINCE WATCHING *HAWAII 5-0*, I wanted to ride in one of those outrigger-type canoes. Finally got my chance by figuring it might be cool to put a bagged SB-800 out on one of the outrigger struts, lighting a rower, and shoot at dusk, with the sun setting and the waves crashing.

So that is how I got to be an ass-backwards, 200-pound hood ornament perched in the front seat of one of these boats, facing the crew, who were understandably struggling to keep the boat stable and moving despite having acquired something akin to an anchor in the bow.

First things first. Figure out where the camera is gonna be in relationship to the lead rower, your primary subject. I had to be riding backwards, watching the action with a wide lens—in this case, a 12–24mm f/4 zoom attached to a D2x camera. I have a long and unfortunate history when it comes to expensive electronic equipment and bodies of water, and I was a tad worried, to be sure. The rowers did nothing to allay my fears by telling me, "You know, dude, there's no absolute guarantee the boat's not gonna tip."

Let's not do that, okay? I had the camera in my hands, and kept faith that both of us would stay dry. No way that was gonna be the case with the SB-800. That was in for a soaking. I Justin Clamped that baby out there, eyeballing the angle of the light by sitting in the lead rower's seat and having my assistant, Scott, turn and tweak its direction. When we got the angle set, we gave the omni-directional ballhead on the clamp a real good crank to fix the position, then we gaffer-taped the hell out of the clamp itself, winding the tape around and around the wood strut it was attached to. Final touch was to double-bag it with Ziplocs, and seal those bags at the base of the unit with heavy-duty zip ties. Also threw a few zips on top of the gaffer-taped clamp, just for good measure.

(Can't say enough about zip ties. If you are ever thinking about attaching a camera or a light in a tough, precarious spot, bring along a whole bunch of them in various lengths. They will save your butt, big time.)

Set this SB-800 as a remote to Channel 1, Group A, and then programmed my SU-800 trigger to correspond. That is crucial. The sensor has to see the signal from the master flash. Except I wasn't using a master flash. The SU-800 was new to me at the time. I had not used it in the field. So, continuing in the grand tradition of photographers using first-time gear on a big job, that was the only trigger I took on the boat with me.

Right away I had a problem. The SB unit had its sensor pointed toward me, but the unit itself was at a radical angle, an extreme hard right from the camera position. The SU sends a powerful triggering signal, but it is more linear than what would originate from a hot shoed SB flash. In other words, the SU-800 was pumping out a signal that might have gone all the way to frikkin' Japan, but my light was not seeing it because the SB-800 sensor was behind the camera plane. There was no bounce or reflection out there, so the communication might have been picked up by some dolphins, but not the SB.

Ahh, another lesson from the field. In situations like that, when there are no white walls to bounce the triggering signal back to the unit, it's best to use another flash as a master. The SB-800 or SB-900, when employed as the driver for remote units, has more scatter. It

"Piece of sunset, great up-front action, water flying."

tends to radiate as oppose to travel in a line. (I haven't scientifically, definitively experimented with the working distances of all this stuff; what I'm relating to you here is based on field experiences.)

The only cure for this was for me to get an abs workout by leaning way back in my already slightly tipsy spot so that the camera and the SU commander were slightly behind the remote SB. As soon as I did that, we had flash. i-TTL flash that I was able to control right from the SU unit. I was able to shoot aperture priority, vary my f-stops (and hence my shutter speeds), and have the unit react appropriately. Or inappropriately.

There is no way you won't get variation in flash output here when working CLS. The camera is constantly seeing different things: highlights, black water, a lot of sunset, and then a little sunset. Different strokes of exposure are gonna produce varying light outputs. A couple of strategies are possible here.

You can live with it, and keep adjusting the power output of the flash with your commander by pushing or pulling the EV.

You can eyeball the exposure you like, and hit the flash value lock feature, which then locks the flash at that exact output.

Or, you can send a TTL signal to the flash to go manual, and lock the power down. (You can also go straight-up manual, no TTL, and fire it with a radio system, but then you have another item out there on the outrigger to worry about.)

Manual is an attractive option, perhaps, 'cause you know that the light will be steady. But the rower is moving. On manual, he will get more light when

he leans into his stroke than when he pushes back on it. Both of these moves change his body position relative to the light. Also, the flash will have a different feel depending on how much ambient light you let into the scene via your shutter speed.

I preferred to control it from the camera, varying the power and the overall exposure in relationship to the position of the boat and the setting sun. I didn't want to be locked into a flash value without a quick means of changing it.

Got a keeper. Piece of sunset, great up-front action, water flying. Shot at 1/60th at f/14. I had a very narrow window to make this happen, as you can see from the second picture (previous page). Once the sun is below the horizon, I am locked into longer and longer shutter speeds to pick up sky detail. The flash is still dominating the foreground, rendering the rowers reasonably sharp, but the length of shutter here is starting to kill me. Lots of blur, both in the water and on the shadow side of the rowers. This was shot at 1/5th at f/4, with −1.3 EV dialed into the camera. The sea was turning black, the sun was gone, and so was the picture. ☐

It Don't Gotta Be Human to Light It

WHEN WE THINK FLASH, we think face, right? People. I mean, we grow up with parties, birthdays, and weddings where the flash is going off in our memory. Smile! Flash!

The plant don't smile. But that don't mean you can't light it. In fact, in this situation you have to light it. Look at my first picture (right), which should pretty well confirm my reputation as the world's worst landscape photographer. Indiscriminate plant at the edge of a canyon I can't remember the name of, rendered badly. Nice!

It's not the plant's fault, nor is it the camera's. The fancy-pants exposure system inside the camera is doing its job, and pretty well, at that. It is looking at the whole scene and assessing the exposure, which is well beyond the dynamic range of even the highest-end DSLRs.

So it stays in the middle, looking for safe ground, and plops itself right down in the middle of the exposure highway, trying to get either end of the scale, but in the end, blowing the background and not quite getting enough of the foreground. The camera is making fairly ruthless exposure survival decisions here, losing fingers and toes but preserving the core.

The background is where the action is. All that red rock out there is presumably why we get up at sunrise and go take a look. So, I programmed my aperture priority setting to −1 EV, which brings in the nice color and saturation we are looking for in landscape shooting (opposite page, left). The downside? Bye bye plant!

Unless we pop that sucker with a flash. I grabbed my SB-800 and held it out over the overgrown weed, banging it straight down, while holding the camera and making exposures with my right hand.

Easy enough. No problems triggering the flash, and now I can see the plant and the canyon (opposite page, right). (Check your LCD here! Pretty good gauge that you are on the right track. Bring a Hoodman loupe! Otherwise, Mr. LCD will be useless in the rising sun.) Doing this is easy and fast, which is great 'cause I had been up since pre-dawn and I was starting to hear the call of the wild pancake, which shortens my patience for photographing things that don't talk to me. I also wasn't going to waste time putting the camera on the tripod and later marrying the foreground and background available light exposures in Photoshop. Life's just too frikkin' short.

"The camera is making fairly ruthless exposure survival decisions here, losing fingers and toes but preserving the core."

Okay, from red rock to sandy shores. Craggy cliffs to wide open space.

Why bring a flash to the beach? There's plenty of light out there. Who needs a flash? Just wander around. Seek the light. Wait for it to peek through clouds. Feel the breeze. Go with the flow. There's a poetry and romance to it.

This is understandable. It's tough to imagine Masefield penning, "I must go down to the seas again, to the lonely sea and the sky / And all I ask is a tall ship and a Speedlight to steer her by." Doesn't quite have that romantic ring.

But the chances are there, and with just one light, you can do a lot and make things happen, even when you haven't got a tall ship and the sea and the sky aren't necessarily cooperating.

On the gray coast of Oregon, with clouds quenching the light everywhere, the reeds are in the same exposure register as everything else in the frame. Your eye travels listlessly through the blah-ness.

Pop on a Speedlight, add a touch of warming gel, and bingo—you zap the foreground of the picture with a bit of contrast and pop, which brings out color and texture.

It also gives you a bit of exposure leverage, so you can minus out some EV for the background, making it moodier and stormier, and you can close down your f-stop a touch more, making the lighthouse a tad sharper. Closing down your aperture will also give you a longer shutter speed, and with a lengthy shutter and a flash mix, you can get some interesting results from reeds and grasses blowing around in the wind.

Both these pictures are roughly the same in terms of f-stop/shutter combo. The available light frame is f/16 at 1/15th while the flashed pictured is f/20 at 1/10th. Both exposures are made at −1.3 EV. The difference is in the pop of the foreground.

And then...

When you do have that human subject, you still got the flash in your pocket, warmed up and ready to go. Take the dome diffuser off and zoom that puppy so it has a bit of direction and punch, not unlike the setting sun, which is giving some musty color to the clouds up in the atmosphere but doing doodley squat for you down here on the beach. Frank, who has a great face for a portrait, looks out to sea, and just past the SB-800 that is handheld at camera left and about 10 feet from his face.

Hit him with that hard, warm light, ask him to gaze at the horizon, and you can just about feel the white sails shaking and the gray dawn breaking. ☐

THE LADY OF THE LAKE, her arm clad in the purest shimmering samite, held aloft Excalibur from the bosom of the water, signifying by Divine Providence, that I, Arthur, was to carry Excalibur. *That* is why I am your king!"

Listen, strange women lying in ponds distributing swords is no basis for a system of government."

—*Monty Python and the Holy Grail*

The Lady with the

Light in the Lake

If, all of a sudden, Deirdre produced a sword from the watery depths of Abiquiu Lake and crowned me king, it wouldn't have surprised me. She has such unabashed magic and presence in front of the camera, and we have worked together so often, that I pretty much start shooting pix and she goes to work.

Though on this one, if she did have a sword she probably would have lopped my block off, 'cause that lake was cold.

I highly advocate using a body of water behind your subject at the extremes of the day. The naturally reflective nature of the water really saves your neck by giving you lots of extended time for golden hour, which, truth be told, is most often like the golden 10 minutes or so. It's a big bounce board—not just for the light, but also the color. Try shooting this against some trees or grass. Bye bye environment, context, depth of the frame, and a whole lot of visual interest. Deirdre becomes a head floating in blackness, not water.

It is also crucial to get your camera right at the level of the water. Those of you reading this book who also watched David Hobby's videos remember him semi-dunking his camera in the pool, trying to get the camera's POV right at the waterline. (You should remember; he played it back on instant replay.) That really resonated with me, 'cause I've

"I highly advocate using a body of water behind your subject at the extremes of the day."

done that more times than I can remember. The most effective angle for a water portrait is, well, almost in the water.

The light here is crazy simple. Shoot-through umbrella, camera right. Crucial thing is to flag off a lot of the surface area of the old brollie, so you still retain an umbrella quality of light without the umbrella quality of spill. This would have been the perfect opportunity for the Lastolite EzyBox, you say? The new one with the double diffuser, that nice quality of directional, non-spillage softbox light, and which also comes with a handle that's tailor-made for situations like this?

Yep. Except that it was in my equipment case that wasn't with me at the lake. Gaffer tape to the rescue! Some really big swatches of black gaf gave me the surface area of a small softbox.

This is where i-TTL really shines. Deirdre is constantly changing her distance to the lens as she moves, looms, and then settles back into the water to become a piece of the picture environment. The lens tracks her and gives distance info back to the camera, which is matrix metering for the whole scene, as the monitor pre-flash is registering contrast and color. It works really well. I wanted saturated background color, so I dialed in −1 EV on aperture priority, and then I was able to settle into the water and dial power messages to the flash. Up a little, down a little. Lots of control over the light.

The SB-900 is also very close to my subject. Virtually no power drain, thus fast recycle. This greases your shoot wheels. Here is where you shoot a lot, and fast, keeping your eye in the camera and chatter to a minimum. You know how we always get exasperated by the stuffed, awkward suit with the striped shirt and the plaid tie who can't figure out what to do with his hands? The kind of job we usually/often/always get? Here, the last thing you want to do is interrupt the beautiful flow of a creative performer in front of the lens with overdirection or technical hiccups. Just shut up and shoot. Let the camera and the light do the talking. ☐

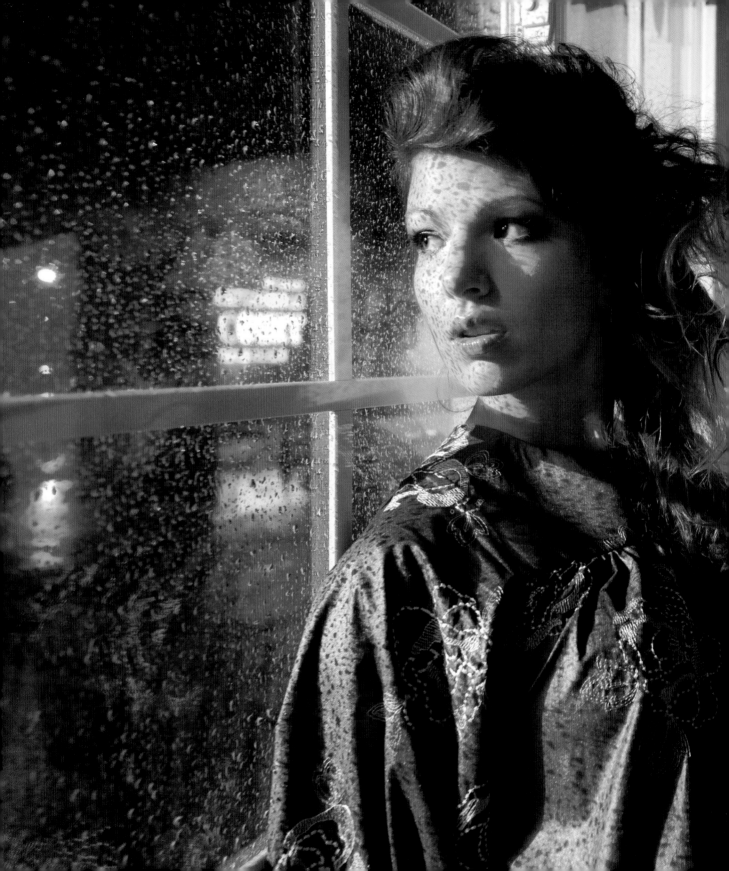

One
Light in the
Parking Lot

PHOTOGRAPHERS LOVE SEEDY MOTELS. They just do. Lots of character, usually a bit of neon, rooms with an if-these-walls-could-talk kind of disrepute. Seedy motels smack of illicit liaisons, last stands, one-night stands, and desperate deeds done in the dark. Great photographic fodder.

And there are always rooms on the ground floor. Those, in fact, are often the only rooms. Perfect for the light-in-the-parking-lot approach.

This is simple stuff nowadays. I moved the SB-900 about 30 feet away from the window and gelled it warm, so it would not be screamin' white light in the midst of a bunch of fairly warm sources, all of which I'm blending into the exposure. The camera is doing the heavy lifting for me here. It is looking both inside and outside the window, seeking exposure zones. It reads (no surprise here) the world as being dark, so I countermand the impulse to go bright by programming in –1.3 EV. I don't want daylight here, or medium gray. I want dark.

I also want a wet parking lot. The SB-900 is comfortably ensconced inside a Ziploc baggie, as it is pouring outside. I couldn't have ordered this up better from Noir Films Central Casting. In the movies, the streets in night scenes are often glistening and wet, which increases reflections and light pickup off the pavement. I didn't have a water truck in my budget on this shoot, so I left it to fate and got lucky with rain. It would be good for me to remember this luck next time I'm on location and

I'm cursing the rain, but I'm a photographer...so I probably won't. We could have 30 great sunsets in a row, but then we get that one bad night and we're out there shouting at clouds.

The raindrops on the window give that scattering of light and shadow over Risa's face, which is not something I thought about up front, but which I loved instantly when I saw it—and, of course, I would tell any editor who asked that I planned it that way.

The neon burns its way into the exposure, being the brightest thing in the frame, and I told Risa to look out the window like she was hidin' from a no-good man. The light catches her face and, being pretty punchy, throws a really clean, hard cheek shadow, and gives her face some drama and edge.

On a rainy night in a cheap motel, umbrellas are just for the rain. ☐

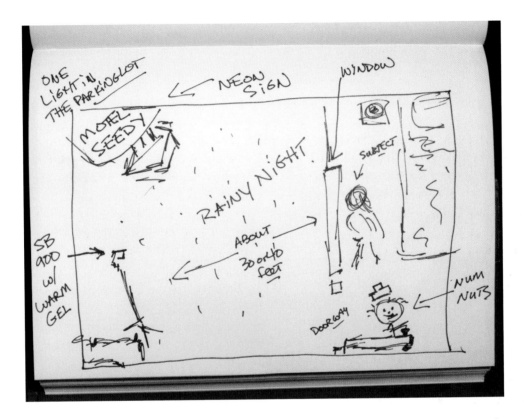

"Seedy motels smack of illicit liaisons, last stands, one-night stands, and desperate deeds done in the dark. Great photographic fodder."

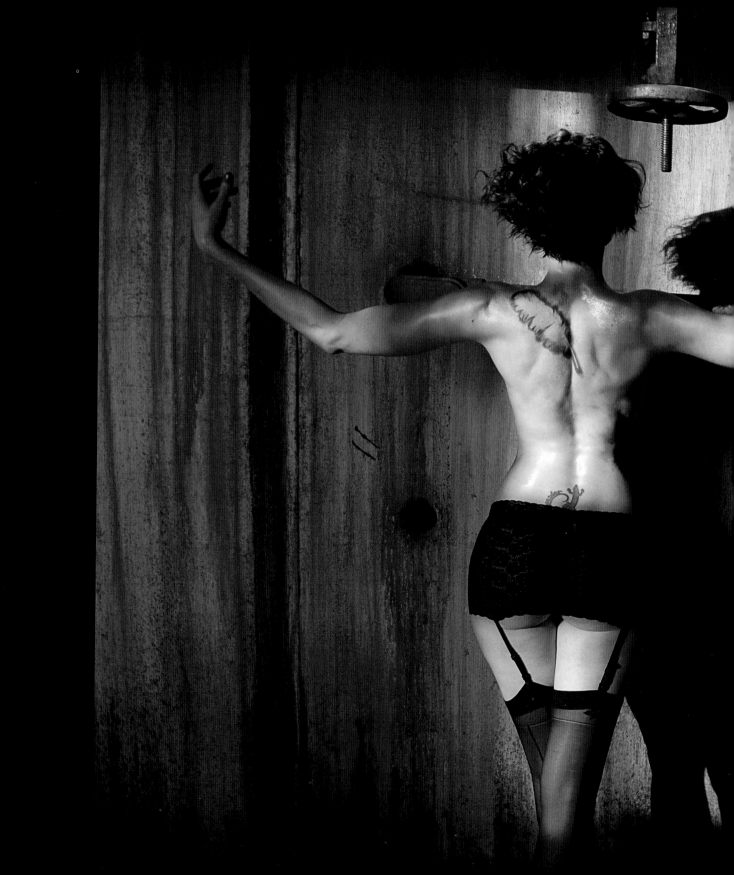

One Light in the Window

IT SHOULD BE NO SURPRISE that light will take on the shapes and shadows of what it passes through or hits. That's why it's always great to experiment a bit and put it out there someplace a tad unexpected or where it just plain looks cool.

DANGER
2,300 VOLTS

This basement definitely looked cool. As for Deirdre, well, it's a given she's pretty cool, so the question I was facing here was how to light this and not mess up all the inherent coolness?

There was an old battered window just to camera left, and up above my shoulder. Passing a light through that decrepit frame with slats and broken glass was bound to be more interesting than using an umbrella. The window corrals the light, shapes it, and gives it a bit of dilapidated, craggy character that matches the patina and feel of the dungeon-like setting.

It was a no-brainer, and absurdly simple with i-TTL technology. Popped an SB-900 on a stand, with the sensor turned toward the window. I took an SU-800 and connected it to the camera with an SC-29 cord. Took that trigger device and held it at arm's length, up and back toward the remote flash, which was about 10 feet from the window. Zoomed the remote SB-900 to 200mm, without a dome diffuser. (Remember, the further the flash from the subject, the harder and sharper the shadows. You increase the punch and depth of the shadows by zooming the light.)

Deirdre does her thing, which is always amazing, and makeup artist Copper went to the wild side and painted feather designs on her skin. I shot on manual so I could eliminate the small amount of ambient light hanging around the basement and also control the output of the flash via my commander unit. Exposure ended up being 1/250th at f/2.8, ISO 400, with a +2 EV programmed into the SB-900. The flash is also warmed up with a full CTO gel.

I remember thinking to myself after shooting this, "Why +2 into the Speedlight at f/2.8?" The flash wasn't that far away. Turns out I goofed, no big surprise there. I had −2 EV programmed into the camera body. Didn't bother changing it, though, 'cause I was shooting in manual, which overrides the EV adjustment—for the camera, not the flash. But the flash still sees a −2 and behaves accordingly, which I didn't know at the time. Hence I had to push more power into the light.

"Increase the punch and depth of the shadows by zooming the light."

This is a perfect scenario for i-TTL. The flash was spitting distance from the camera, but it was outside and above the basement level where I was shooting. To have shot with the flash in manual mode, in order to make adjustments—as you always have to do—I would have had to walk down a long hall, up a flight of stairs, and around the wing of the building to get to the light. Probably a 200-yard walk to program a half-stop adjustment. Then go back downstairs and find I should probably have gone for maybe one full stop instead of the half.

Life's too short. i-TTL can save you time. So can an external battery pack. When you put up a light somewhere that's tough to get back to, it's advisable to plug in an external battery pack. You're throwing the light quite a distance and that's gonna stress the AAs in the unit. Last thing you wanna be doing is running back to change 'em out. ☐

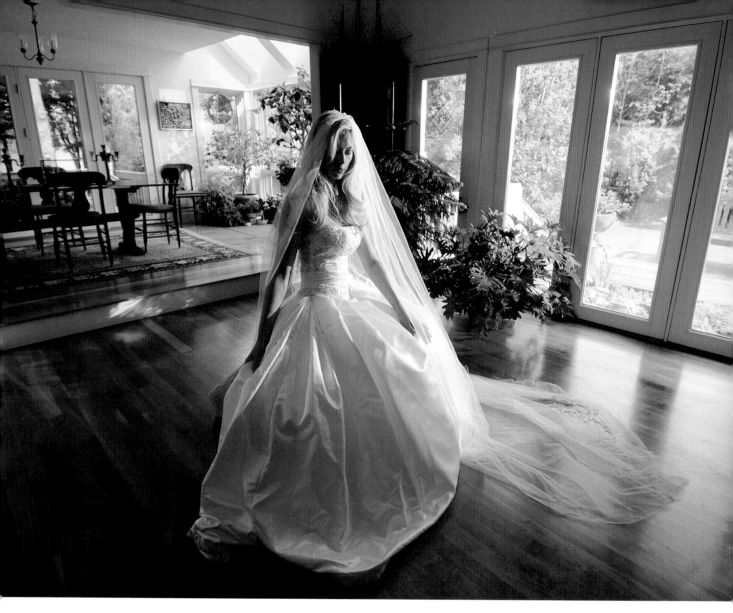

One Light
in the Garden

"She gets pensive, depth of field is limited—
so the veil goes dreamy—and the light looks
like a 12' silk."

THE LIGHT FOR THIS LOVELY BRIDE is about 40 feet away from her, camera right. Out there with the tulips. It is a raw, hard light, no umbrellas or diffusion allowed from that distance, due somewhat to power reasons but mostly because an umbrella-ed (now there's a new word!) light from that distance ain't really gonna look any different than a hard light. Not much, anyway. The further away that source gets from your subject, the bigger the swatch of diffusion you need to get any softness or play out of it.

But here's the good news. The hard light in the garden works okay. Take a look. It is bright and directional. Shoot the room with wide glass. Move fast and get it done. Then, again tapping into the beauty of i-TTL, pop on fast glass—something like an 85mm f/1.4—and move in close. Shoot wide open. Handhold a Lastolite TriGrip diffuser panel just out of the frame, close to her face. Just like hard sunlight hitting something like frosted plexi and, bang, you've got beautiful portrait light.

She gets pensive, depth of field is limited—so the veil goes dreamy—and the light looks like a 12' silk. Takes only a couple of minutes to put the light out there, or if you have an assistant, they can go out there and big-foot it through the garden.

Light like this is worth killing a few tulips for. ☐

PART **THREE**

Two or More

Or, "Do you feel lucky?"

Show the Tattoo!

Or, The Remarkable Rehabilitation of the Notorious Bubbles

AHH, THE POP-UP FLASH. Let's talk straight, okay? It is the condom of on-camera flash. Use it if ya really gotta, right? I mean, that little winky dink just flat-out sucks as a light source. It's handy in a pinch, and if you master the menu and make it serve as a driver for a handheld or remote wireless flash, then it positively cooks.

But as a light? Like I say, if ya gotta, use it. Or if you reaallly, reeeeaaalllly don't like somebody, or if you get caught up in a rugby scrum of paparazzi and get knocked over and your SB unit goes tumbling and you roll into the gutter in between the horde and the limo and you look up desperately from that angle as the door opens and out steps Paris and Britney in short skirts (and nothing but short skirts) and you can retire on the stock sales of the next series of frames, then by all means, go for it. Use the damn pop-up.

But let's keep it outta the gutter, cool? Here's a frame with a pop-up (page 164, left). Hoo, boy. Not a girl you take home to mom.

See that big shadow in the bottom middle of the frame? That's the lens shade, bubba. Yep. That little

light is so close to the barrel of the lens that it will clip virtually any type of shade and throw a mean, weird shadow onto your subject. Nasty. Almost as nasty as Bubbles here, who just added felony flashing to an already impressive rap sheet of misdeeds.

Let's progress, shall we? Our goal here is to show Bubbles the light. There are a couple of attachments on the market that can redirect the pop-up and make it softer and slightly more pleasing. But they are, at best, a halfway measure. A small step in the right direction.

A bigger stride towards the land of good light comes with a real, full-blown, hard-working hot shoe flash. Here is what you get with one of those puppies right on the hot shoe (below, center).

A bit better, right? No more disconcerting shadow, and a slightly improved look to the light. More volume, perhaps, resulting from the increased surface area of the grown-up Speedlight. Bubbles perks up slightly, looking less inclined to go for the sawed-off if you cross her.

But, you still don't wanna date her, right? Still a little rough around the edges. What's the next step to rehabilitation? How can we rescue Bubbles from the harsh shadows?

Bounce! Soften! There are bunches of ways to do this, quick and cheap. Amongst my favorites is the Lumiquest family of flash attachments. I use the 80-20 for institutional settings. It blends flash well with racks of overhead fluorescence. I also use the Lumiquest Big Bounce, which is kind of like putting a white, reflective elephant ear over your flash. I guess you could also use the Gary Fong dome diffusers, which produce a nice, soft light as well. Trouble with them is that it kind of makes your flash look like a photon torpedo.

But, from the distance I am shooting Bubbles (I don't wanna get too close; she might knife me), the light is better but still hard (below, right). I got the flash off the camera, so the major improvement is that I lost that shiny, nasty highlight on her prisoner ID board.

Okay, next step. TriGrip diffuser! I swear that, if you use it right, your client will think you had a big-ass silk and a bunch of assistants out there with you. Move the TriGrip in as close as possible. Use the dome diffuser on the SB unit, 'cause presumably you are looking for soft scatter here (opposite page, top and center). If you want a little more punch and direction, take the dome off. If you want glamour fill but got no more lights? Push in another TriGrip, this one with the silver/gold side reflector combo. Think of it as incredibly cheap fill flash. Play with both. Play with the silver and the gold. You can use

"Bubbles perks up slightly, looking less inclined to go
for the sawed-off if you cross her."

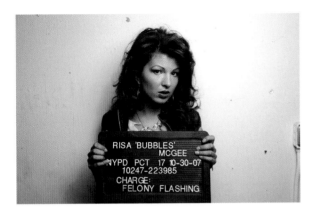

'em handheld, which is easy with an i-TTL solution. It is remarkably fluid, and it gives you a remarkably better light (below, left and right). It takes, oh, about 35 seconds to do this.

Okay, photographers are not ones to leave well enough alone, so one improvement that could be made here, and quickly, is to increase the surface area of the light. Bigger source equals more wrap, more softness, and, boy, Bubbles is just about ready to go from hard time to community service. First solution here is with the 3x3' Lastolite panel, rigged on a C-stand. A C-stand complete is just about essential with these panels—indeed, with just about any softbox type of light. If you put them straight up on a stand, you lose the angle/dangle capacity. A stand will hold the panel, for sure, but you lose that

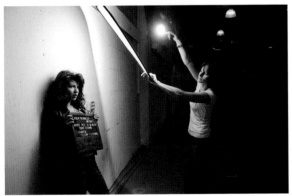

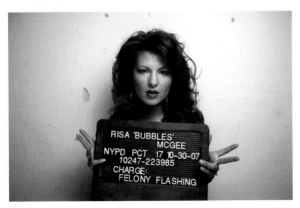

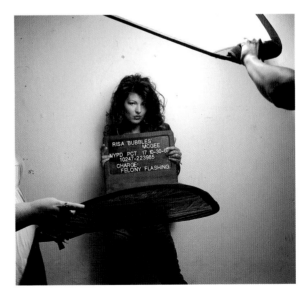

crucial edge of control because you can't pitch it. It pretty much has to stay straight up and down.

With the extension arm on the C-stand, you can swing that puppy in and angle it a bit. For the sake of a bit of difference, I put two SB-900 units through the silk, or diffuser, both dome-less, which means they are punching pretty hard light through the diffusion. This is great cheekbone light. See the result for Bubbles (left, top and center). It is soft and hard light all at once, which really emphasizes her cheekbones and facial structure. If I hadda liken this light to a similar studio-type light, I would call it an i-TTL beauty dish. How much edge you give to the face depends on how steep you angle the Lastolite panel.

Now Bubbles can legitimately pull off that look that says, "Who, me, officer?"

Okay, you got cheekbones, and some edge. Wanna soften that edge? Pull in the TriGrips again and play with white, silver, and gold fill-board light.

White—obviously neutral. Silver—shiny, metal-lic, fashion-y. Gold—warm, glow-y. Take your pick and put the reflector just out of the bottom of the frame. Hoo boy, now you got the officers checking the evidence and circumstances, wondering how they could have arrested this poor girl.

She's ready for the next step here, which is to be set free with an apology and perhaps even a pro-posal from the arresting officer. Put up two umbrel-las. Turn the SB units into them and reflect that light back through the 3x3' Lastolite panel. Keep the fill board in play. Oh my.

Time for wardrobe, a limo, theater tickets, and her favorite table at Elaine's. That nasty booking incident? Horrible mistake. □

Gellin'

AHH, THE VALLEY OF THE GELS, as Greg Heisler used to call it. (Check out Greg's work. He single-handedly changed magazine photography in terms of light and color.)

At night, the streets of New York are a raucous riot of light sources. In the days of slide film, you would just about sniff the air, like some sort of old trapper, to determine what kind of color correction you were about to use. Often that correction would be in the realm of a magenta filter over the lens, which would eliminate some of the greenish-yellow color that abounds from fluorescent, sodium vapor, mercury vapor, or any of the other of the toxic light sources that dominate a cityscape like New York.

It is much easier now that we basically have computers in our hands instead of manual cameras.

These machines have brains and a highly evolved sense of color. In the generation of camera now—say, a D3—the auto white balance is a very sophisticated color judge. It can look at the weirdest of scenes and, most of the time, suss it out better than the eye of even an experienced shooter. I use it all the time. Huge breakthrough, in my opinion. It's another thing we don't have to worry about, though on a certain level it gives us yet another thing we really do have to worry about—not knowing.

Not knowing. As in, the development of a lazy-ass, camera-gonna-fix-it-for-me-and-if-it-still-ain't-good-I-can-layer-the-shit-out-of-it-in-Photoshop type of attitude. There's no excuse for not knowin'. You need to know about how color behaves, and how colors relate to each other, and how the camera, in all of its automated glory, is gonna react to color. This requires experimentation and a willingness to just go after it till it sinks in. I call it the building of the rolodex—that mental card file that, on location, kicks in and starts flipping through potential solutions based on what we have done before, mistakes we have made, and the like. My personal rolodex is chock full of hard lessons learned from excruciating mistakes, as well as a really well-developed list of great breakfast diners all across the country.

In this instance, the auto white balance sorted out the street scene really well, but I didn't like it. I'm going for the man-of-mystery, bad-guy-on-the-street, noir kind of look here. The auto rendition was, well, too nice. So I changed up my white balance to tungsten, and then I fine-tuned it to be even cooler. (Depending on which camera you have, you can shift your stated white balance by increments.)

That move pushed the look of the frame towards the blueish piece of the spectrum. Slightly cool.

Appropriate for my subject. You can see the overall effect it has on color by looking at the red glow in the background. That is coming from a red-gelled SB-900, camera left, out of frame. There is no diffusion on that light, and it is zoomed to 200mm, producing a hard, concentrated source. In a daylight or even auto white balance, that red would be real red, more fire-engine red than you see. But here it has a cool red color, with blue highlights even filtering into the overall red field. At the edges, that red wash of light that the flash is producing gives way very quickly to blue.

That is because the value I programmed into the camera is rendering everything very blue. Remember, when you program a value into the camera, such as color balance, or EV, it is a global adjustment (to borrow a Photoshop term). The lights, and how I gel them, will produce local, selective adjustments.

Hence the splash of red fades to a blue field quickly, and provides some separation between the man of mystery and his seedy background. His face is lit warm. Of course! He's lighting a cigarette. But there ain't no Zippo in the world gonna cover his face with nice, filled-in portrait light. That is coming from a little close-up flash, the Nikon SB-R200, being handheld just off frame, camera left. It is a hard light, no diffusion. But it does have three CTO gels on it.

Why three? Remember the very blue global adjustment made in the camera? That has to be counteracted with very, very warm light. Hence I just kept layering on CTO until I liked it. His face then goes warm and keeps your attention, and the warmth up front vibrates against the cold blue of the mean streets. □

Quick Rigs for 30-Second Portraiture

WHEN MICK AND THE BOYS SANG "Time Is on My Side," they weren't singing the anthem of the photographer. Time is rarely our ally. Ever been on a job where the promised two-hour timeframe becomes one hour, which in turn becomes ten minutes? Twice last week, you say? No surprise there.

Speed is the watchword of photography nowadays. "How long is this gonna take?" is our subject's most popular question. Which is cool. Look, many of our shoots are not exactly the stuff of which photo dreams are made. So why not get 'em over with quickly? I vastly prefer a short, brisk whipping to a long, drawn-out torture. And besides, if I only have to shoot Mr. or Mrs. Important for five minutes, I'm actually making pretty good money! We're done here, right? Thank you, move along. Here's my invoice.

There are a number of ways you can produce good quality light and still move fast. Some approaches are pretty standard, and some you kind of reverse engineer. Determine the kind of situation

you will be in, and then figure out something appropriate.

I had a *Life* assignment to create portraits showing the emotional bonds between zoo animals and their trainers. Often paired for long periods of time, the animals develop a very particular trust with their keeper, which they don't share with strangers—particularly strangers with odd-looking, flashing equipment.

Wild animals in cages! Me inside the cages with them! What could go wrong?

Coverage was important here. I was dealing not only with the human face, but also with some very large, dark creatures. I needed to spread light and make it wrap, and wrap quickly, around some unusual combos of man and beast.

I figured a good bet to do this would be a light panel, specifically the Lastolite 3x3' Skylite diffusion

"Face it: every day, there are about 30 million billion digital pictures being taken. How do you make yours stand out? How do you make the editor notice you? How do you get that call back for more work?"

panel. It is lightweight, easy to put together, and provides a big, soft surface over which to spread light. Another advantage? The back brace. This light-shaping tool has a crosspiece that runs across the middle of the panel, which creates a perfect spot to mount Speedlights. Note: I said Speedlights.

I used two SB-800s here. Could you make do with one? Absolutely. Pop one light through this panel and it looks great. With lighting on location, though, it's all about the next step, the slight advantage, the edge. Face it: every day, there are about 30 million billion digital pictures being taken. How do you make yours stand out? How do you make the editor notice you? How do you get that call back for more work?

That little edge. Something extra. Another piece of gear. Working faster and better.

In this case, I used a second Speedlight, which is by no means an earth-shattering, stop-the-presses move on my part. Pretty simple, actually, and logical. Doubling up the light gave me a broader coverage of light through the panel. Bigger light surface, better light. It didn't double the power. That wasn't my intent. I'm still working CLS, dictating the f-stop from the camera via aperture priority exposure mode. I can tell one light, two lights, 30 lights to give me f/5.6.

Not only is my coverage better (upping my quality of the light), the throw of the light is more likely

to get around, say, a walrus. Also, hammering one Speedlight would have stressed it pretty good. Two units spread around the light and the work. I also hooked both lights up to an SD-8A external battery pack, which means I got 12 more AA batteries working for me. I could very well have just one crack at this picture, and only for a few seconds. Recycle time is at a premium.

I attached both of these to the back brace of the Lastolite panel with two Bogen super clamps, each with a Bogen magic arm. That way, I could extend the lights back and away from the diffusion material, giving the light a chance to spread before hitting it. It does very little good to put up a big diffuser and then jam your light right up against it. I also left the dome diffusers on the SB-800 units. Again, more spread. Softer light.

I would go in the enclosure with the trainer and the animal. Calmly, slowly. He or she would get the animal comfy, and then I would approach with camera and lens, moving it in until the trainer would give me the word. "Close enough."

Then the intrepid Scott would move in with the light panel. Closer, closer, closer. Again, the trainer would referee. Then, triggering the remotes (both in Group A) with a hot shoed SB-800, I would shoot like a madman till the animal got stressed. (As if I'm not?)

It was in the walrus cage that the Lastolite panel revealed its other function—a walrus deflector. The seemingly placid beast had quite enough of the photo session, thank you, and went diva. It was amazing to see how fast something weighing 1500 pounds with no legs can move. She took off after Scott, backing him into a corner where the panel became...the walrus shield.

Scott used it to fend off our finny friend until the trainer got over there and read her the riot act. She slunk off to get some more fish. Altogether, the perfect lighting rig for the job! ☐

Do You Have a Bedsheet?

HMMM.... EVERYBODY'S GOT a white bedsheet hanging around somewhere, right? A big swatch of white linen? Tablecloth? An extremely large pair of underwear?

I was in the Czech Republic and got an invite to visit one of the country's more prominent puppet makers. It was great, kind of like walking into Geppetto's workshop. Lots of wood, hand tools, unfinished puppets everywhere.

 Here, I'm going for what might be called artisan light. Soft light. Cloudy window light. Soft light radiates around in a directional but easy way, and the shadows it casts have dimension and depth, but they are forgiving shadows. When you look at something like a hand-crafted puppet, you really want to look at it, dwell on it, and let your

> "When you look at something like a handcrafted puppet, you really want to look at it, dwell on it, and let your eye play with the details and richness of the handiwork."

eye play with the details and richness of the handiwork. Hard, slashing light would rob the eye of that detail feast, which is presumably why you would shoot the picture in the first place.

Also, psychology plays into the choice of light here, methinks. Without reading too much into it, there is a connection we make when we look at old-world, traditional handcraft and plain old window light. These arts and crafts grew up in a time before banks of fluorescence turned us all into hothouse plants. It was way before the glow of computer screens and high-intensity halogens. This ain't a clean room, in short.

It's an old-time workshop, and in those days the artisans sat by a window to do their work 'cause the rest of the joint was dark and smoky from the smoldering hearth.

Hence the bedsheet. It is a big source and covers the whole window. I am putting two SB-900 units through the sheet, but those two lights really become one source when they hit the sheet. I get no extra power from doubling up out there, I'm just ramping up the volume of the light and stressing the batteries a tad less. The sheet evens out and eases the light all over the scene, so much so that there is no real blowout on the objects near the window. They retain detail and don't go off the highlight chart. I even have a piece of the sheet in the pic, which would ordinarily be a no-no, but it doesn't really draw attention. It passes as a piece of the window, or a curtain that might always be there.

There is a doorway to camera left, and that is my path for the i-TTL signal. The 900s have their sensors cranked towards the door and, in this instance, I am triggering them with an SB-800 and not the SU-800. Reason for this is because, while the flash unit may not have the linear direction of the SU commander, it is a more radiant signal. More omni-directional. It spills out the door and is a lock to trigger both flashes, which are only about five to seven feet from the camera. The radiant (and therefore less directed) signal enables me to move the camera around a touch, and move my angle up, down, and further into the room, closer to my subject with no real triggering worries.

You can work quickly this way, and the light is very flattering, which was good 'cause a couple of the puppets were very demanding. □

Window Light Is a
Beautiful Thing

EXCEPT THERE OFTEN ISN'T quite enough of it, or it is just a little
too soupy, or the sun is currently lighting the windows on the other
side of the building that you're working in. So you see a shimmer
of available window light, and it looks great, and it is where you
might want to place your subject, but the daylight wandering in that
particular window stops a tad short of being workable.

So how do you ramp it up, amplify it, tweak it, and shape it so that it
still looks and feels like window light, but is actually flash? How do you
make that flash behave like light from a window?

Obviously, ya gotta put the flash outside the window. That raises
issues. Like, it's very convenient if you are working on the ground
floor! Upper floors are still doable, but it often takes some grip she-
nanigans with booms and sandbags to get a light out another window
far enough so that it radiates back through the window where your
subject is sitting.

For the purposes of this story, let's stay on the ground floor. You
have a scene that lends itself to the creation of a beautiful, classic
window-lit portrait except, as we have noted, there just isn't enough
of the window light to go around. So walk outside and take a look
around. Is there room or access for a light stand? Most often, the an-
swer is yes. You are in business.

Put the SB unit on the stand and face it towards the window. That's
the basics. But that is just the starting point. Putting the light out with
the geraniums is the right move, but putting it out there creates poten-
tial problems. All solvable, mind you, but problems nonetheless.

First, you have to have the picture done in your head. You have
to know going in what kind of feel the light will have. There are soft,
dreamy window-lit portraits, and there are hard and shadowy ones.
Knowledge of the final look of the light dictates what you do next.

Let's go soft for starters. That requires a diffuser of some sort. The
best store-bought look I have found comes from the Lastolite Skylite

panels, which come in 3x3', 3x6', and 6x6' sizes, or just about the right size for any number of windows. As you can see in the production shot, my 3x6' just seals up the window. No hard light allowed in. As noted in the previous story, this look can also be readily produced by using a white bedsheet, pure and simple. Throw that puppy in the window with a little tape, and the effect is the same.

You see two flashes in my shot. Another case of Joe "Overkill" McNally? Not really. The one light is pointing straight at the diffuser and is providing the main punch and direction of the light. The other I have pointing down. The reason for this comes from just looking at window light a bit over the years. You will often see, even on the cloudiest, softest light of the day, a little fill bounce coming off the floor or the window sill. Just a tick of light that will hit the bottom area of the window and reflect back upwards. This often creates that dreamy, wonderful quality you see when you look at someone standing in real good window light. The window is one light source, to be sure, but it effectively creates the feel of two lights—a main and a fill.

So I will often put two sources out there. (Don't have to worry about multiple shadows 'cause the big-ass diffuser is making everything look like one big light.) This downward-directed SB can run at the same power as the main unit, or you can feather the power down a touch and have it run at, say, a stop or so under the power of the main. This method will translate into a little lift or glow to your subject's face—something Donald hardly needs, but it's welcome anyway. He's got a great portrait face, and the window light does him proud.

He's also located strategically. The adobe walls of this old house bend away from the window and go to blackness really quickly. His silver hair stands out in the darkness, and there is nothing in the background to distract from the pleasant journey the reader's eye can take around Donald's amazing face and twinkling eyes.

Now for the hard part. By that I don't mean difficult, I mean hard. Hard light. Slashing shadows. Also easy to do via the mechanism of putting your flash out on the lawn somewhere. No diffusion this time. Not on the window or on the flash unit.

"Knowledge of the final look of the light dictates what you do next."

Moreover, the flash unit needs zooming to its max telephoto value—in the case of the 800, that's 105mm, or, with the new 900, you've got 200mm as an option.

That will give you the maximum punch and concentration out of the light source, and also the greatest effective working distance of the light to the subject. This is important, 'cause shadows get harder and more cut the further away they are from the light source. Think of the sun. On those clear days, the hard sun hits things with absolute clarity and force, creating razor-sharp shadows. If you try to mimic that feel with your flash three or four feet from the subject (or window), you will have a tough time. The shadows will be fuzzy and vague.

So move that pinpoint source of light as far away as you dare and let the photons fly. The window frame itself corrals the light and forces it in the direction you want. Anything in the way—tree branches, plants, your assistant—will cast a shadow, hard and fast. Locate your subject fortuitously in this slash of light, and you be rockin'.

Triggering all this using i-TTL is a bit of a trick. You want to stay synced up and maximize all the fancy i-TTL/CLS technology, but you won't get it unless that outdoor flash sees the impulse from what-ever you are using as a commander on the camera. Here is where the SU-800 and an SC-29 cord are invaluable. The flexi SC cord maintains the whole computer conversation between the camera and the flash and, because it is movable, you can snake that signal around cor-ners and down the hallways, or out into the yard. The SU-800 signal is pretty strong, so it can punch right through a diffuser if it is close enough. You need somebody to hold that puppy out there, or pop it onto a stand and direct the triggering signal at the lights. It works! And it maintains CLS control of the system. Ahh, the wonders of modern technology! ☐

Smooth Light

ONE OF THE KNOCKS against small flash is about the quality of light. Small light, hard light. Party pix. Flash! Big smile! Bad shadows.

Smooth light is not only possible, it's actually pretty easy with i-TTL technology. There are a number of tools and strategies available to you.

First, make your small light behave like a big light. The new SB-900 has a couple of features that help get you there, primarily the illumination pattern that you can dial in via the menu, which allows you to program the quality of light right at the source. You can dial in standard (with a bit of expected fall-off at the edges), center-weighted (which collects the light in the center, with lots of fall-off), and even. I routinely choose the even option, because it means the flash spreads with even intensity from edge to edge when it comes barreling outta the source. A small thing, perhaps, but significant.

Next line of defense is the dome diffuser. Use it—even when you run the flash through another type of diffuser, such as a panel or an umbrella. I mean, why not? You are going to all this trouble to make the light nice, and the dome diffuser is going to help you do this by spreading the light and giving you some scatter. Too much loss of power, you argue?

I don't think so. These small flashes give good bang for the buck, and with digital ISO optimized around 200, you have tons of power and resultant f-stop. So diffuse away.

Next step: more volume. Double up the light, meaning use two units instead of just one. I know, I know, it sounds like expensive over-kill. But it's not, trust me. Sure, it does mean you gotta get another flash, but that extra light—whether you use it in tandem for a main light or have an extra source for a background or kicker light—is worth whatever cash you have to dump for it. More lights, at least on occa-sion, mean more versatility. It means more potential expression and reach of imagination, which can translate into better pictures, which could mean better and more lucrative assignments, happier clients, and a more thriving business. All good things, yes?

So I often double up my main light. It distributes the workload, giv-ing me longer battery life, quicker recycle, and a slight edge in creating the look of the photo. So try two!

I either put this twofer into one umbrella or, in this case, put each flash into its own. I use the Lastolite All-In-One umbrellas, which, again, are designed smartly to give you a variety of options. You can use them in a reflected way, with the opaque silver/black skin on them, or you can peel that off and use them to shoot through. Again, more versatility, more options, more looks to the light.

I prevailed upon my daughter Claire to take a break from her sum-mertime pool lounging to pose for some pictures with her friend Amanda. Two SB-800s are overhead, bounced into two Lastolite All-In-Ones and then running through a Lastolite 3x6' Skylite panel. The panel is diffusing light and blocking the sun (we shot this in my driveway, in the hot sun, with some black paper hanging from the overhead door).

Aha, yet another layer of diffusion! Try it. The light can take it. You get plenty of power, even with all this layering and bouncing and softening. The panel, as I mentioned, is functioning on two levels. It smoothes the reflected umbrella light—making the two umbrellas behave, effectively, as one source—and it is blocking harsh sunlight from hitting my subjects. That is important, as I don't want slivers of noontime sun interrupting the feel of my light. And by blocking the available hard sun, I knock down the level of the ambient. That means I can dominate my picture environment with my light.

I like the light. It wraps, and it is smooth. It's tough to articulate about light in a reasonable way. I use terms like smooth, rounded, harsh, angry, voluptuous, poppy, dreamy, soft, rich, evil...sounds like I've described your average afternoon on *All My Children*.

But the smoothness and wrap here is important, not just 'cause it looks nice, but 'cause it easily accommodates the gesture of my subjects. I had suggested they do something to illustrate the close-ness they feel as friends. Their response was to turn towards each other instead of facing the camera. If I were using a hard light, or a smaller source, or even one umbrella, the turn of their faces would wreak havoc. There would be a bunch of fall-off and shadowing, and the simple look they give each other—which is what the picture is all about—would be largely gone.

Another advantage to throwing a big soft blanket of light over your subjects is that they can move. They can look at the camera, or look away, or look at each other, or go profile. When you don't put them in a box defined by hard edges of light, they can move and express and, in this case, be mildly unpredictable, goofy, expressive teenagers.

The light is soft and smooth with no lines, just like their faces. ☐

When in Venice

I'M A LAZY ASS SUMBITCH. Despite my track record of doing more when less would suffice, and an ongoing penchant to light the bejeezus outta just about everything I see, I really am not looking to work hard. Especially in Venice. You don't go to Venice to work hard.

> "The cloudy white balance setting provides a slightly warm version of straight-up daylight, and I often prefer this mode when doing portraits."

So, when staging a photo—say, in this instance, a portrait—I'm gonna look for things that are already lit. Like this room. This is one of those grand Venetian rooms in an ancient palace with magnificent views and light. The whole building is about to topple into the canal and the furniture is so rotted you can't sit on a chair, but it sure is pretty to look at. I looked in there and saw the golden fabric on the wall glowing from a bunch of huge windows at the other end. Hmmm. More than halfway home, I thought.

The feel of the room is golden and warm, so I went with the flow and programmed the camera to a cloudy white balance. The cloudy white balance setting provides a slightly warm version of straight-up daylight, and I often prefer this mode when doing portraits. There is history here. In film days, Ektachrome slide film had a tendency to go blue on a cloudy day. (When sunlight radiates through heavy cloud cover, it cools down and goes a bit toward the blue spectrum. Nowadays, using Photoshop terminology, you would call it a color cast.)

It ain't easy being blue, as the song goes. When they find a corpse in the ice chest in a horror movie, then blue is okay. But living, breathing humans look better slightly warm, in my opinion. Using those old slide films, a way to compensate for the cool shift was to put an 81A filter on the lens. (Nikon calls it an A2. Go figure.) This slightly amber filter would pull the film back into line, and it would help out skin tones tremendously.

In digital cameras there is an internal filter system, if you will. I highly advocate playing with your white balances. "Experiment" is the watchword of digital photography. You are not burning film and money at the lab as in the film days. You don't have to even take notes, as the metadata will tell you when you zigged but should have zagged. No pixels have to die. Shoot! Compare! Find what you like. Maybe you grew up on Rob Zombie films and you like your people in all sorts of colors.

Cloudy white balance is essentially an 81A filter, without the trouble of the filter. Okay. So what does this have to do with flash photography? Plenty, actually. Flashes come from the factory balanced for daylight. They are keyed to be neutral. If you take a brand new neutral flash and combine it with a neutral white balance, such as daylight, the effect is gonna be—you guessed it—neutral!

I have a well-developed capability for pointing out the obvious. But here's the thing. Neutral is just a hop and a skip from blue, and that spankin' new flash tube in that just-outta-the-box flash will have a tendency to burn a little blue-looking, even though the Kelvin math tells you it's daylight. As you use the flash more and more, and it ages, it will warm up a bit, but right outta the gate, it could be advisable to program for warm or cloudy white balance.

Which is what I did here. I have two SB-800 units firing through a shoot-through umbrella that is just over my right shoulder, almost perched at the camera's point of view, as close to the model as I can possibly push it. I have no filters on the flashes, and I'm not worried about that because I have a cloudy white balance operating and the room is awash in gold light. Light picks up the color of what it hits, so any increment of available light that filters into my exposure is gonna be warm.

The lady in black! Julia is a lovely dancer I have worked with a number of times. She shimmers mysteriously behind the black veil, so I took it one step further and purposefully moved the camera during the exposure, which is, in most cases, a photo no-no.

But not here. She is facing away from the ambient light, so really the only light hitting her is coming from my flash—which, you will remember, fires at a very fast speed. I could throw the camera in the air and she would still be sharp. But what moves is any area governed by ambient light. I am using f/11, which gives me a lot of depth of field, and which, of course, when shooting in aperture priority mode will drag my shutter for a while. A quarter of a second, to be exact. During that quarter second, I shake the camera. Her face, the hat, and most of the veil stay sharp because that area is totally dominated by flash. No competing available light there. But where the flash falls off and the ambient light takes over, there begins to be a bit of a blur, or what looks more like vibration.

Not something to do all the time, of course, but this is a handy way to jazz up a portrait now and then. I used to accomplish this naturally by shooting a 6x7 Mamiya Pro II RZ camera with a motor drive. Great camera, but big and bulky—camera shake was inevitable. The results are unpredictable, so shoot a bunch. ☐

"'Experiment' is the watchword of digital photography. You are not burning film and money at the lab as in the film days."

Dancer
in the Ruins

I WAS INVITED IN 2008 to teach at Photo-World Manila. The organizers mentioned they could organize a lighting workshop on the historic island of Corregidor, and bring along dancers for subjects. Twist my arm!

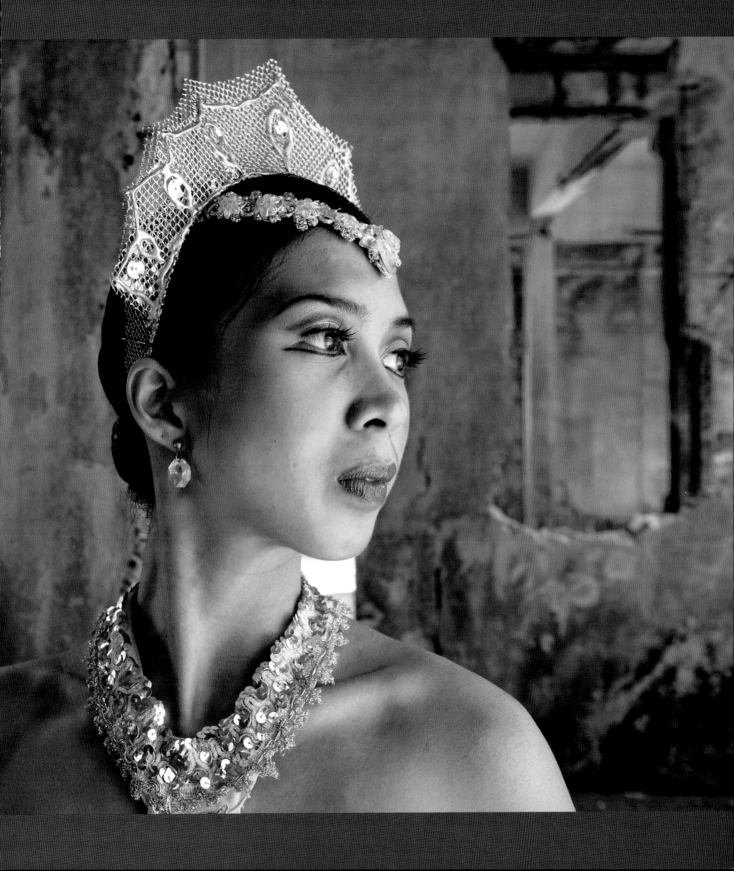

So we be on Corregidor, with about 25 students in my class, six dancers, my D3s, a 14–24mm, a 24–70mm, and a 200mm f/2. For lighting, I had four SB-800 flashes, one SU-800 Wireless Speedlight Commander, and some grip stuff. What to do?

Scout around!

Kind of fell in love with the ruins of the officer's quarters, and the array of shapes and colors. Made this snap. The LCD on the D3 is very handy, by the way. It's like having a mini HDTV in your hands.

Liked this enough to pursue, so I put a dancer in a logical place. Made another snap.

(What I am doing here is what I always advise. Just go click. Instead of the uncertain world of Polaroids, we now have the certitude of an LCD, which is instant and accurate, and it will show us exactly the look and the feel of the frame. It accelerates your scouting process, often very important. Before you start lighting anything, you have to determine what the camera is going to see.)

She is basically hatchet lit, meaning that there is no light really hitting her from the camera's angle, but highlights creeping in from either side from the windows. Not good for a lovely, delicate ballerina.

So we dragged out some lighting.

As you can see, we're using a C-stand and a 3x6' Lastolite panel in vertical mode. Got 2 SB-800 flashes, one high and one low. Separate groups: upper flash is Group A, lower flash is Group B. Why two different groups? Independent ratio control. I knew I wanted some low glow on her 'cause there was a lot of ambient light bouncing around in there off the floor. Gave the place a nice feel. So I thought I might want to pump some power (plus EV) from the low flash. When you lump all your lights into the same group, they will all power up or down together. In separate groups, I can tweak each flash by increments of a third of a stop, which gives me a lot of fine-tuning capability.

Put her back in the same spot. No go. I mean, I had an exposure and decent light, but it is all over the place, scattering to that wall behind her waaayyyy too much (page 194, left). Big source, tough to feather and control and gradate. Hmmm... what to do?

"Shortening up the distance between your subject and the light source is an effective way of controlling your background."

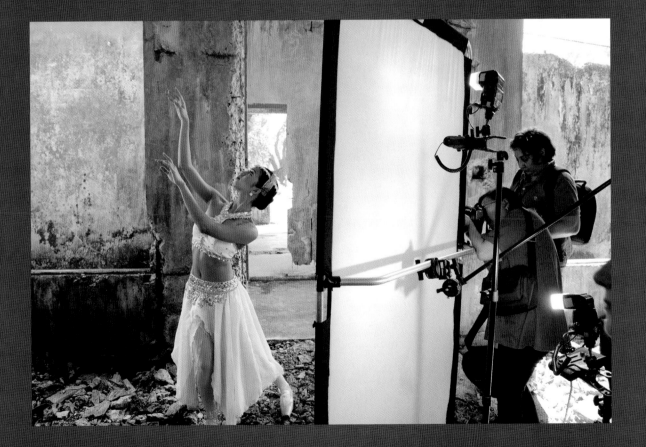

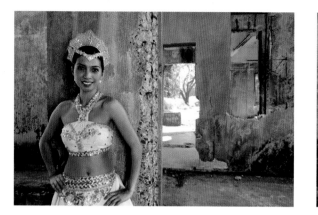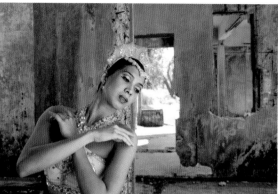

Move her closer! Shortening up the distance between your subject and the light source is an effective way of controlling your background. As she moves into the light, it gains quality and softness. The light falls off more dramatically behind her, saturating the wall and making it far less distracting. More light hits her, and less hits the wall behind her.

In this position she is also further from the wall. As a general strategy, most of the time I will beg, borrow, or steal every inch of space I can to move my subject away from the background. That way, I have a chance at establishing two zones of control. If my subject is bang up against the background, whatever light I use up front is gonna travel back there. It can be a trial to establish a different feel or look to the background, given how much it is being influenced by the foreground, or subject, light. Get as much distance as you can, and your day gets easier.

What distracts me to this day in the final shot is the little piece of highlight under her chin. Should have taken the time to clean up my frame, but I only shot about five frames before turning the lighting solution over to the class. One of those shoots where you just wanna kick yourself afterwards. Good example of my not thinking like the camera meter. I should have read that highlight and known it was gonna blow a hole through the picture. □

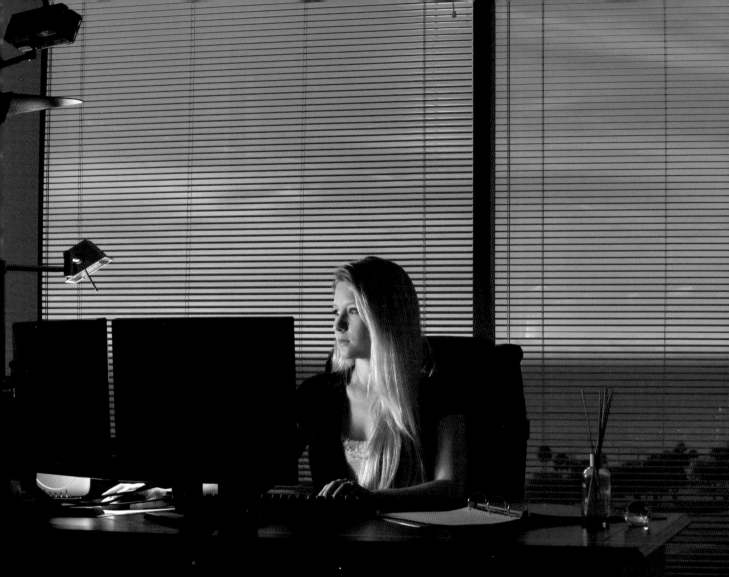

It's Right There on Paper

ONE OF OUR BIG challenges as shooters is to make the humdrum sing, the ordinary look cool, and otherwise transform everyday reality into something visually appealing. There's no genre of photo assignment where this is truer than corporate portraiture and annual report work.

Here's a small office with a desk, a chair, and a computer! Go crazy!

Not only are you supposed to work magic on this scene, you are supposed to do it quickly, 'cause, you know, there's 17 other offices to shoot today.

I try to work these environments as best I can and keep things simple. Using i-TTL technology to adjust the flashes, without running around to each one individually, saves time. There is always a lot of ground to cover.

My ultra-fancy light-shaping tool here is Xerox paper. I took one SB-800 on a Justin Clamp and attached it to the left edge of the computer at camera

left. The omni-directional ball head of the JC enables me to swivel the flash back into the monitor and use the screen, which I covered with copy paper, as a bounce card. It made for a pretty nice light.

Now for a little drama. Drop the blinds, which become an immediate graphic element, tried and true, done before, but still much more interesting than the blank window. The sky through the blinds is pale, midday Florida blue. Not a cloud to be seen. Zippo contrast or color.

I shift the camera into tungsten white balance and underexpose the sky by two stops. Blue sky!

But also, blue flash. Using a daylight flash in tungsten white balance makes the light from that flash very cool. A full CTO gel takes that daylight-balanced flash and turns it into an incandescent, or tungsten, flash. Which means the effect of that flash will now be white, or neutral. Not cool. Not warm. It is now balanced for where I am working, which is in tungsten white balance.

But I don't want balanced. I want warm. See the lamp right by the computer? That's an incandescent work lamp. Most of the time, looking at a desk environment, you would expect that light to have a yellowish color. That's where I headed, and that required another gel on the clamped SB-800. The additional gel pulled the flash away from a neutral, white light feel and made it look like the desk lamp.

Now I got deep blue outside and real warm inside, and the feel of the office has gone from average blah daylight to the feel of working late, with deep colors and a concentrated pool of light right there at the desk. The exposure for this frame is 1/250th at f/16. As I've said a number of times, these small flashes pack a pretty good wallop of light. Even with two heavy gels and the dome diffuser,

the remote SB-800 has no problem getting me to f/16, which is pretty much where I needed to be to underexpose that bright Florida sky.

I am in the hallway, by the way, shooting this with a 70–200mm lens, and the SU-800 is hot shoed to the camera and triggering the remote flash without a problem. In a small office, with white walls, the commander signals bounce around, and there is rarely a difficulty in making the remote "see" the signal.

Alright, got this done. It's a "work" type of environmental lighting treatment, not really a portrait light. The last thing the client wants from me is a couple hundred frames of the same thing from the same angle, so as soon as I can see on the LCD that I have multiple good selects and variety from this setup (thank you, digital!), I move on.

First step is to get a more pleasing light for Tracy's portrait. That means more frontal light, something that will fill her face in a pleasing way as she makes eye contact with the camera. To accomplish this, I move my "light source," the sheets of Xerox paper, to the right-hand computer. Ditto the remote SB-800. Now there is a much more frontal wash of light onto Tracy. She looks right at the lens, and I zoom tighter. I am not looking for that intense burning-the-candle-on-deadline feel for this. I just want an open, flattering look at her lovely face.

The problem is, as a single light source, for a portrait it's too low. It's below her face, and as the only source of illumination, it casts upward shadows that appeared a touch ghoulish. Not the look that most corporations embrace.

One of the truly easy things about working with i-TTL Speedlights is how simple it is to introduce additional flashes and make them all play together nicely. To counteract the low feel of the computer-based SB-800, I introduced another 800, handheld by my assistant, Brad, just over Tracy's face and out of frame. This Speedlight is in Group B, and it is firing through a Lastolite TriGrip diffuser, also handheld by Brad. The computer flash remains in Group A. From camera, the master commander SU-800 "tells" the overhead, or Group B, flash to fire at a power level that will make it the dominant, or main, light. In turn, the commander signals the Group A flash to power down slightly, making it a fill light, which works well from its position.

"I try to parse out a situation into as many possibilities as I can before moving on. It gives the art director multiple possibilities, which means they will like you and might even call you back for more work."

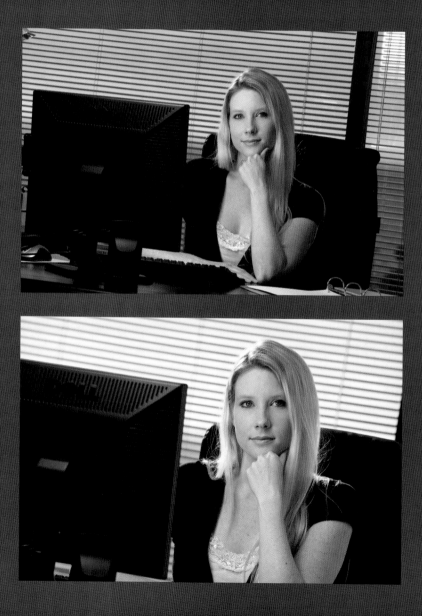

This type of power combo would have the overhead, Group B, light firing at, say, 0 compensation, while the fill, Group A, fires at a −1 power rating. This is a typical power relationship between the dominant light and the fill light in a portrait setting. Don't like it? Stay at camera with the SU-800 commander and plus or minus the flashes to your heart's content. The fine-tuning aspects of the system give you lots and lots of control.

I'm doing this type of juggle constantly in the field. It is not about changing up f-stops or making huge adjustments in power levels. It's about the feel of the light.

The other lever of control I have is shutter speed. I was at 1/250th for the first setup, striving to make the slivers of sky seen through the blinds a deep blue. Now, I am tighter on Tracy's face, and I want the whole feel of the picture to be softer, a bit more pastel in color. Shifting to 1/125th (leaving the f-stop at f/16) gives a more open feel to the sky, and less of a deep, rich blue. I can air that out even further by opening up my f-stop at camera to f/8. This is where that i-TTL flash/camera communication plays huge. I open two full f-stops at camera, and the remote Speedlights follow along. At the new exposure, as you can see, not only does the window get blown out, but Tracy's hair comes more alive with blond and blue highlights.

Wait a minute! Blue highlights? Yep. The light that is hitting her hair is largely daylight, and remember we are in tungsten white balance, where daylight goes blue. Hence, blown-out highlights will be white, but as exposure varies and deepens, depending on what that daylight might hit, it will go blueish.

For her skin tones, I peeled off the extra CTO gel, by the way, lest I turn her into a pumpkin. The slightly warm cast to her face is the product of one full CTO, plus another in the realm of ¼ or ½. Experiment with these combinations to find what you like or what is appropriate for your subject.

As I did here, I try to parse out a situation into as many possibilities as I can before moving on. It gives the art director multiple possibilities, which means they will like you and might even call you back for more work. It keeps your head alive during a deadening day of corporate shooting, where the environments you are presented with are often desperately dull, and repetitive to boot. ☐

Shadow Man

WHO KNOWS WHAT EVIL LURKS on the streets of Gotham?

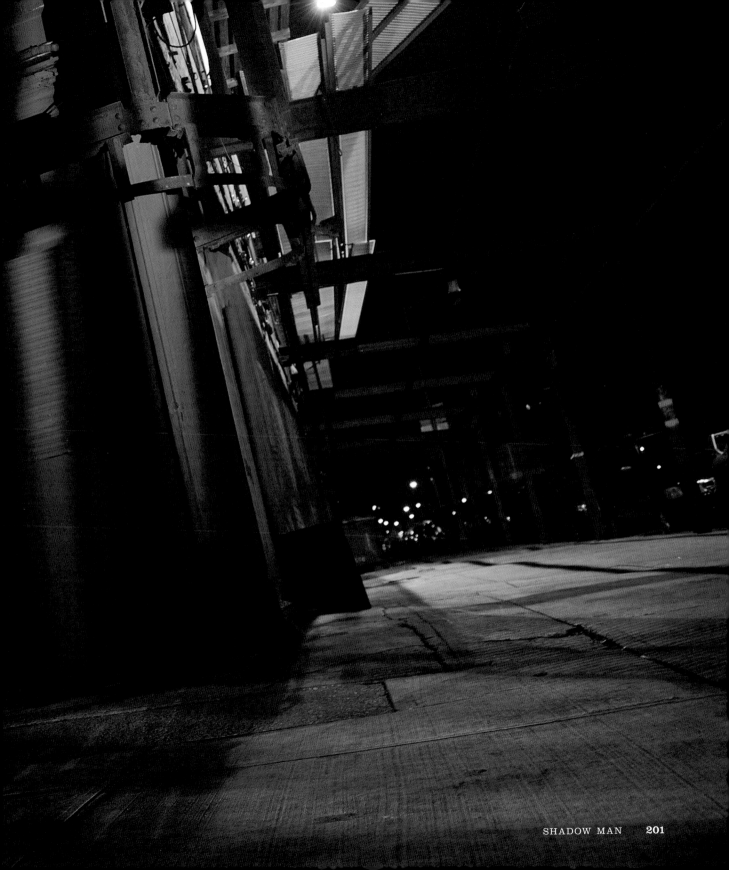

If you're gonna go *Pulp Fiction*, ya gotta have the light to go with it.

Hard, low, shadowy light turns my buddy Mark into a player in a noir novel. This is simple to do. Direction, angle, and color all play a role, and while that may seem to be a complex mix of elements, the digital camera and flash technology we have at our disposal nowadays makes sorting most of this out a series of pushed buttons. Of course, it helps to have read a lot of bad novels, and to have your sense of color and light spring from the pages of a *Spawn* comic book.

Get the camera angle. I always advocate this as the first, crucial step. Where you put the camera is always more important than where you put the light. The light informs the picture, elucidates it, gives it beauty, form, and definition, but the picture has to be there first. If you are uncertain of what the photo is, trying to light it is like answering a difficult multiple-choice question. Make a stand. Spike the camera. The picture drives the light.

I chose to go low with Mark. So low, in fact, that I am lying in one of the grungiest gutters in Manhattan. That sucks, but I do like the angle. I want to distort a bit, skew the shadows and all the angular stuff in the pic. And Mark looms here. Not a man you want to meet, especially as he pulls the mohaska from his waistband.

Light comes from camera right, down in the gutter with me. (Hey, this lighting stuff is a dirty business.) I am actually using two sources, both SB-900s, and both on floor stands. Ordinarily, I

might have gone with just one light, but here I wanted the shadows to play out in wide and crazy fashion, so I put two down there, right next to each other, and aimed them in Mark's general direction.

The color comes from a straight-up shift to tungsten white balance with no corresponding gels on the Speedlights. Didn't want a "normal," friendly, warm-and-welcome tone to the flash quality. I wanted it simple, clean, cool, detached, dangerous. (Remember, I read too many crime novels.)

So the play of light is cool white to very deep blue. Easily done. Leave the lights alone and program your white balance to tungsten. One button push.

Zoom the lights. (Another couple of button pushes. Actually, with the SB-900, it's one button push and then a quick spin of the thumb.) The telephoto zoom concentrates the light and throws hard, unforgiving shadows. No broad, nicely filled, frilly, soft stuff going on here. The light hits the street corner with the speed of a bullet, deadly and final. Each of the 900s was smoking after each shot! (Uh, okay, not really.)

We got hard shadows here. Just as hard as the time Mark did at the big house up the river, when he got framed for that Brooklyn dock job by Johnny Boy and...shit, sorry.

Those hard shadows came courtesy of my assistant at the time, Brad. We drug a couple of wooden cargo pallets in front of the lights and stood 'em straight up. Thing was, there wasn't quite enough room in between the wooden slats to translate enough light. So Brad big-footed the pallets, busted out some of the slats, and then put 'em back in front of the Speedlights. That gave me definitive

"Get the camera angle. I always advocate this as the first, crucial step. Where you put the camera is always more important than where you put the light."

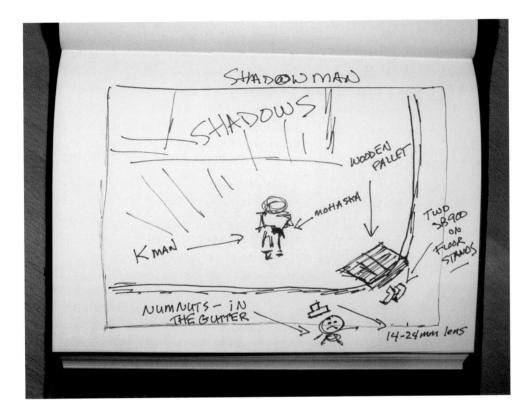

slashes of light and I moved Mark into one of those. Always ask your subject if they can see the lamp head of the light. If they can, the light will see them.

Done. Hadda scram. Fuzz closin' in.

So alright, it was a couple of button pushes and a few stomps with Brad's size thirteens. Still, pretty simple. Pretty basic. Lotta fun. □

Faces
in the Forest

DUNNO, BUT RUNNING INTO these guys in the woods might constitute a bad day. Actually, that's kind of the feel I was trying to generate here, kind of a running-through-the-forest-*whoosh!* type of feeling, and then *boom!*—you end with an arresting, eyeball-to-eyeball confrontation. Of course, I wasn't running with the camera through the forest. I didn't move my feet. Nor did my subjects.

But the lens moved. Zooming or moving the lens while exposing is a time-honored technique. It's been around, frankly, as long as there have been zoom lenses. It requires a subdued quality of light (usually), something you can work with at slower shutters speeds. High noon on a sunny day is not the time to try this.

Subdued light, especially when you stop down the lens (make the opening smaller and the number bigger), will give you that work-able, zoomy length of time for the shutter to be open. The slower the

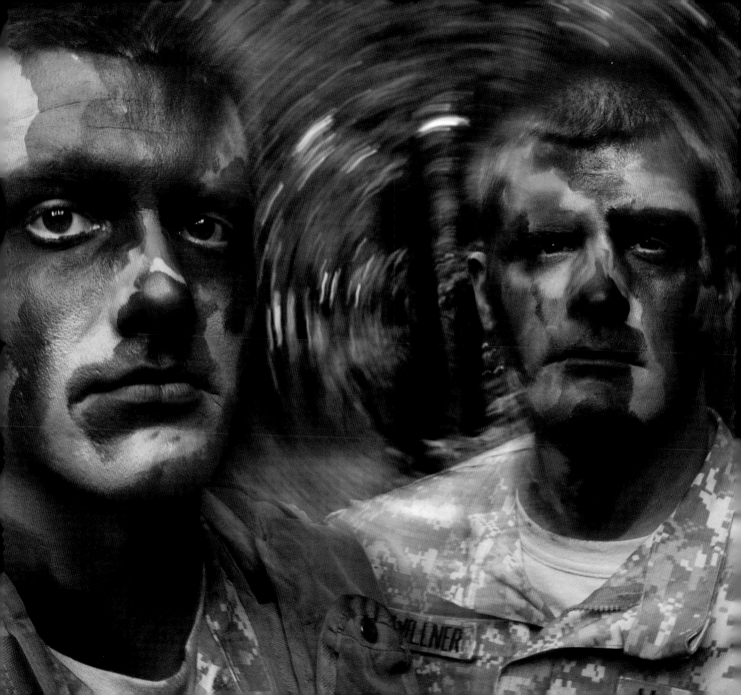

shutter, the greater the zoom or spin effect, but the greater the risks of camera shake and blurred subjects. (For the two frames with this story, the "spin" move is shot at 1/10th at f/16, and the shot of the single soldier, the "zoom" move, is shot at 1/5th at f/16.)

These kinds of camera moves during an entirely available light exposure have their pitfalls, to be sure. You can end up with images that have no essential core of sharpness, mostly 'cause everything in the frame is being governed by the same quality and amount of light. In other words, it's all the same value, and if you zoom poorly or move shakily, the entire deal is gonna look like one of those frames you make when your shutter button bumps into your hip as you cross the street with the camera over your shoulder. I have lots of these. I will eventually stage a retrospective show of these exposures, referring to them as photographs from my "uncertain period." That would amount to my whole career.

But what if you use flash? The flash introduces another quality of light—one you are in control of. The flash, you will remember, fires at a very fast speed—let's say 1/1000th of a second or so. (It varies, in relation to the amount of power you are pumping through the flash head.) As already noted, this "speed" of the light is referred to as flash duration.

The flash gives you stopping and sharpening power. Generally, what is lit by the flash—the area of the photograph that the flash dominates, exposure-wise—will be sharp. The rest of the ambient world will be blurred. How much? Depends on how fast you zoom or move that lens, and over what millimeter range. How much you can push that lens one way or the other directly correlates to your shutter speed. At 1/15th of a second, say, the zoom movement will be short. At a full second, well, you can start zooming, go out for coffee, come back, and finish it. The results will be more pronounced, with longer streaks of motion correlating to the longer period of zooming.

For our special ops guy in the forest, I went to Lo.1 on the D3 to minimize ISO (Lo.1 gives you ISO 100 on that camera). Doing that enabled me to lengthen the shutter speed. The camera burped out an exposure of 1/5th of a second at f/16 on aperture priority mode. The background is dropped to about −2 EV. He was lit with two overhead SB-800s through a 3x3' Lastolite panel. The panel is angled overhead pretty steeply, almost table-topped, so there is a bit of a brooding feel to the light, given my subject. (Table-topping a silk or a light source generally means it is angled almost flat overhead of your subject, just about parallel to the ground. Top light, in other words. I call it *Goodfellas* light. It's like the light that's suspended over the table at the back of the restaurant where the Don sits, meting out judgment and punishment. The overall scene is lit fairly softly, but the eyes are shaded. You know you better kiss this guy's ring, pronto.)

Same feel here. Got simple overhead light, but I'm not using it at a normal, sort of "Hi, how are ya?" type of angle. It is producing a rim of shadow around the helmet, playing up the ominous aspect. The whites of the eyes, are, well, white, and they pop like a special effect at the movies against the camo face paint.

No need to go further with the light. Simple is

best here, 'cause you're about to introduce the quirk of the zoom move. Tripod just about required, though again, given the mentality of location shooting that says rules are meant to be broken, taking the camera off the tripod could produce something unpredictable and cool. Be steady on the zoom move! To do that, *start* the move before you hit the shutter button. That will mean the exposure will occur with the lens elements already in motion, which will translate to a smooth zoom. (And trust me, there ain't nothin' better than a smooth zoom, if you know what I mean.)

Try it. Then try it again. And again. In fact, try it about a hundred or so times. Not all will work out. Others will hit the sweet spot and give you a good range of choices. I have always believed that the best way to zoom is from telephoto to wide, which means you will pick up depth of field and the appearance of sharpness during the move. I've also heard it argued that you should go from wide to telephoto, which gives a different feel to the picture.

Here's the deal. Try it both ways. Or, spin the camera. Give it, you know, a good hard, uh, twist. Then the world spins instead of zooms, but again, your foreground subjects stay sharp—because they are flashed. Your applied light is dominating the up-front part of the picture. Remember I mentioned I dialed in −2 EV in aperture priority mode? That is helping my sharpness enormously. I effectively took the ambient level of light down from its already shaded middle value and saturated the heck out of it. Made the forest look a bit dark and spooky. That means my guys front and center here have almost no ambient light hitting their faces. Whatever

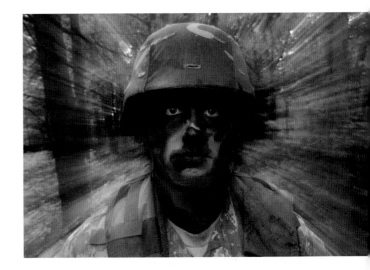

"The best way to zoom is from telephoto to wide, which means you will pick up depth of field and the appearance of sharpness during the move."

natural light that is out there is behind them, forming a minimal backlight. On their faces—nada, zilch, just about f/nothing. I pull da guys back into good exposure with my Speedlights, which I can program in increments of a third of a stop to get detail back in their faces just the way I want it. Pretty cool, actually. Out there in the woods, working this way, I've got the same control I would have in a fancy New York rental studio—just minus the cappuccino bar. ☐

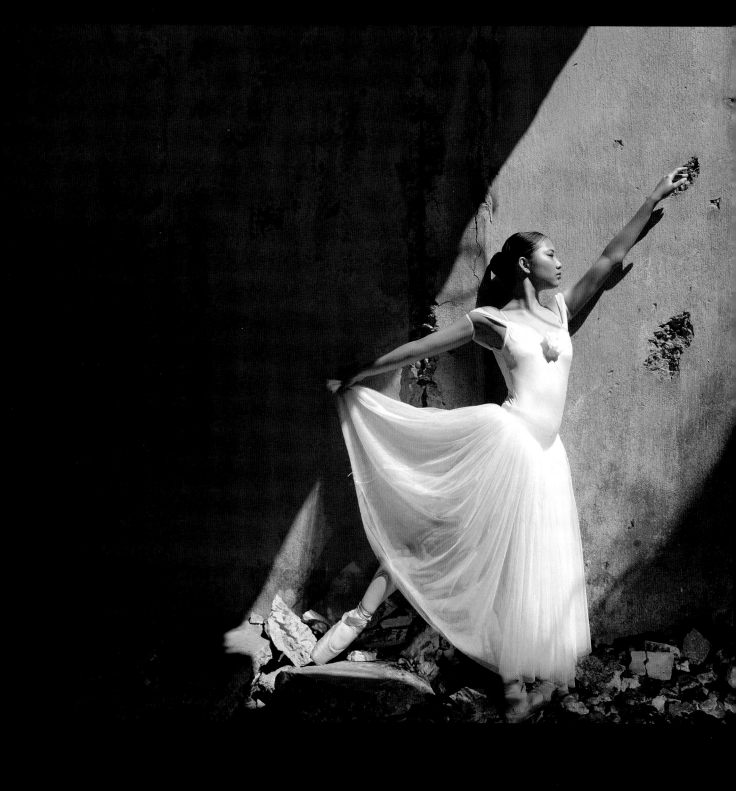

Dynamic Dancing

THERE'S LOTS OF TALK and fuss now about HDR techniques, and the layering of, well, layers and layers of frames made with different exposures and focus points, all with the intent of making a single frame of photography appear to get its arms around everything from 0 to 255 and to focus from the tip of your nose to the depths of infinity. It's all pretty cool and doable, with the power of Photoshop and in that very magical land known simply as "post."

Remember when to "post" something meant to mail it?

But expanding the dynamic range of our materials has been with us since the first exposure, made by the redoubtable experimenter Niepce. That shot might have been the first wonder of post production, except it was all done during the 12 hours the shutter was open. That exposure time ensured the sun traveled overhead of the scene completely, so the final result literally has no shadows. Pretty cool and, I'm guessing, unexpected. Hence the first location photo quite likely had all the components of any location shoot—luck, surprise, unanticipated nuances, outright guesswork, and a-seat-of-the-pants, let's-see-if-this-puppy-flies mentality. Niepce would be a good newspaper shooter if he were around now, methinks.

How do you cope with a scene that is so sharply delineated as to be f/bazillion over there but f/nothing over here? Neither film nor digital can deal with that. It is up to us, the ones with the eyes in the lens, to intuit when that fancy machine we have in our hands, the one with the 3700 menu options, is about to default to the option labeled I Give Up. (I've personalized my D3s, so that option is actually called Over to You, Numnuts.)

If you expose for the highlight, you will lose crucial shadow detail. If you expose for the shadow side, it will look like you launched an ICBM through your sensor. Your eyes make these adjustments seamlessly, in nanoseconds. What an amazing thing the eye is! The human eye, by certain estimations, lives in a 12- to 13-stop world. The fanciest of digital cameras make do with five stops. When confronted with a scene like this, how do you help the camera out? How to find the middle ground, and quickly?

Flash! Think of it as Photoshop in the field. It can rescue you from becoming a mushroom in your basement, spending countless dark hours in front of a glowing monitor, moving sliders endlessly, and seeking redemption with the Curves tool.

The dancer against the wall is a case in point. Sometimes, in photography, you'll get the shaft. (Couldn't resist.) If you're lucky, it will simply be a shaft of light—and not any number of other kinds of misfortunes that might befall a shooter during the course of his or her career.

This shaft of light is filled with drama. Expose for it properly, and you will also fill your frame with blackness. If that is what you seek,

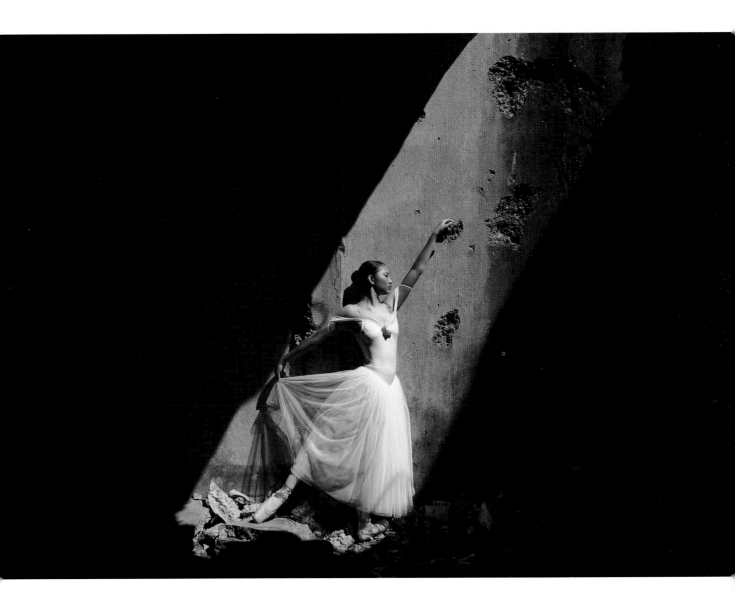

"How do you cope with a
scene that is so sharply
delineated as to be f/bazillion
over there but f/nothing
over here?"

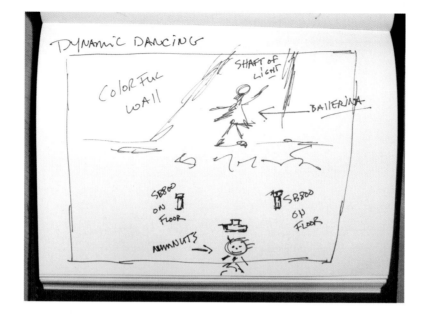

then shoot away. But why make a wall that looks like a beautiful old painter's palette disappear? Moving fast here, and taking my cue from the existing light, I put two SB-800 units on the ground in front of the camera position, left and right, pretty evenly spaced from both the dancer and the camera. No stands, no gels, no nothing. Just laid 'em on the ground in the rubble.

The reason I put 'em down low was that the pattern of light hitting the dancer was almost directly overhead, and if there was going to be any logical bounce it would most likely come from the ground. Putting the flashes down there and feathering their exposure power from my commander unit (SU-800) on the hot shoe enabled me to pull the wall back in slightly, give it some color and detail, and at the same time not blow away the essential feel of the intense overhead sunlight. There is a fair bit of power coming from those floor units. You can tell by looking at the direction of the shadows low on the wall.

The dancer wore white, which is making me and the camera do our own sort of dance. Kept changing the power slightly, varying the intensity of the daylight exposure with the power of the fill flash exposure. All you are trying to do here is find the middle ground, where you keep the drama and the power of the scene—which is why you put the camera to your eye in the first place, presumably—but also render context. Context translates to information. It locates the photo, and gives your viewer something to chew on or, in this case, dance with. □

Gettin' Fancy

ONE OF THE HUGELY OVERLOOKED custom functions of the higher-end DSLR cameras is the ability to quickly and seamlessly make double exposures. Hell, the camera even figures out the gain for you. In the old days, it was pure guesswork when you re-exposed a piece of film. Go a half stop under for the second exposure? Full stop? Pure seat-of-the-pants, hope-for-the-best, Hail Mary stuff. Now, the camera thinks it through for you.

What's even more overlooked is the ability of the double exposure function to interact with Speedlights on TTL. Here are the pieces.

Go to the shooting menu and find the double exposure feature. Program the number of exposures. In this instance, two. The auto gain should be on. Hit OK. Remember, you have to do this before every exposure. After the double is done, the camera defaults back to normal operation. So go to this menu item before every frame, and activate it.

Get your subject and determine the frame and the gesture within that frame. Allow a little extra air into your composition, 'cause two exposures often takes you by surprise and you find you are too tight when you go to make the second. The subject here is Jake Gardner, a star with the New York City opera. I shot this backstage during an intermission, which meant I had about 10 minutes to make it work.

Make sure you are in a focus mode that enables you to see your focus cursors, and move them laterally, point by point.

Your lights get placed outside your frame, obviously, lighting the subject in a profile manner, which means they are slightly *behind* your subject. If the camera position is six o'clock and the subject is at the center of the dial, the lights are not at three and nine; they are at ten and two. If the light wraps around your subject's face and fully lights them on the camera side, your double will be a mess. You need the face to rotate into blackness as the light falls off. That way, you have play area where the two faces mesh that is dark.

Put up your light sources. I highly recommend light panels for this. They produce a linear and soft, but directional, quality of light that graces the subject's face nicely and falls off rapidly. Put one at ten o'clock, Group A, and one at two o'clock, Group B. I use the Lastolite panels, in the 3x3' size.

First shot, subject goes profile, looking off towards Group A. Make an exposure. A flash exposure, mind you. When doing multiples, go to the top end of shutter speeds for flash sync, usually 1/250th, and combine that with an f-stop that makes ambient light go away. Remember, you are laying down two exposures in the same frame, so you must absolutely control that frame. No stray dog ambient light gets in! Also, shoot on black. Any background details that might pick up a piece of

flash or highlight might read in the picture, some-times right through your subject's head. Remember that after you make that first exposure, the sub-ject moves. During the second exposure, behind where his head was originally, there can be noth-ing, no detail at all. If there is, it might be seen right through the first image, 'cause he's no longer really there to physically block it.

Kill Group A. Make Group B active.

Subject turns towards Group B. Subject reverses profile. Make an exposure. You are done. (With i-TTL, it is easy to make the exposures identical. There may be some variance to the power you dial into the remote flashes—one may be 0, the other may be +1. I refuse to speculate why. This is life on planet i-TTL.)

Where and why do the focus cursors come into play? They are your register points for the double, as well as your focus points. Heat up the cursor on your left side of the frame, one that conveniently can be located on the subject's near eye. When they turn to the other profile position, cursor over to the corresponding focus point on the right side of the frame, and locate it again, over the eye nearest the camera. This way the face stays evenly in register throughout both exposures.

Repeat the steps, with your subject making the gesture as directed. You can shoot this as a raw file, but you cannot tether to your computer when you do this. It all happens in the camera, which means you rely on what your LCD is telling you.

This is not hard. ☐

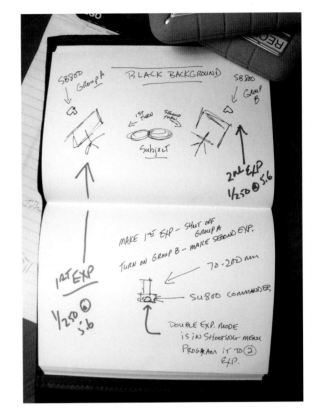

"Remember, you are laying down two exposures in the same frame, so you must absolutely control that frame."

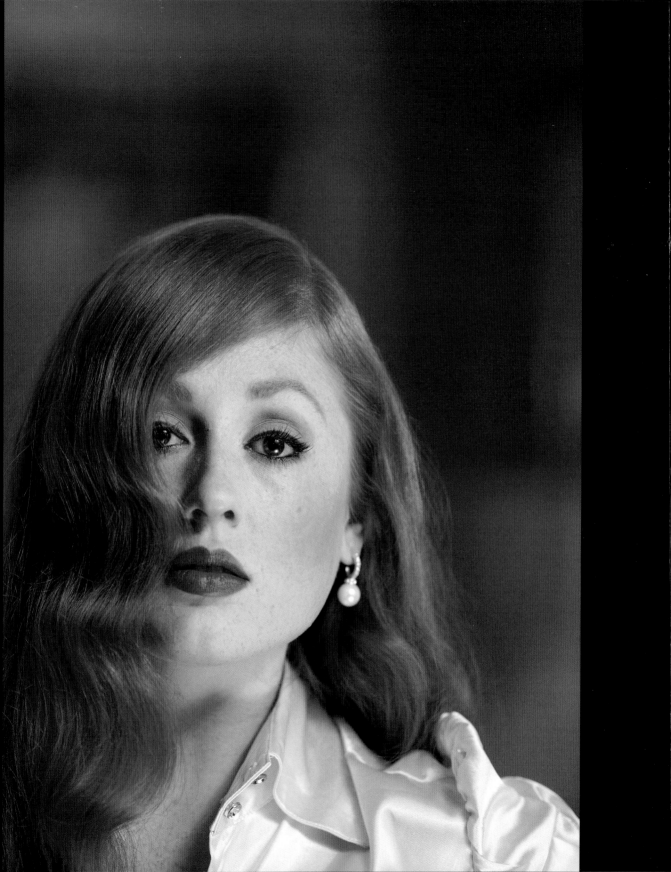

This One Goes to Eleven

ZOOM THROW. The SB-900 goes to 200mm. You know how, on the back of the SB-800, you push the multi-selector to go from the little trees to the big trees, and you zoom to 105mm? Well, the big trees just got bigger.

The ability to control and shape the output of a small hot shoe flash unit is a big deal. It means you get a longer throw, more concentration of light, and perhaps a bit more of a defined edge between highlights and shadows. I told the folks at Nikon that they should do something jazzy to announce that you can zoom an SB-900 all the way to 200mm—maybe program the unit to go off like a Vegas slot machine every time you hit 200mm. I don't think they're gonna do it.

My friend Vanessa, shown here, is one of the more beautiful ballerinas I have ever worked with. Not only a lovely dancer, she also has a face that is right out of 1940s Hollywood glamour.

We did this really simply. There is an SB-900 on a boomed, shoot-through umbrella (Lastolite All-In-One) camera right, just out of frame. And the background is lit with one SB-900, gelled with a full CTO, again camera right, angled into the area behind Vanessa and giving it some warm glow. That flash is zoomed to 200mm and has no diffusion.

Important point here. I want the background light to travel in a straight line over a distance. Zooming to 200mm on the Speedlight is the way to go. For Vanessa's face, I want soft wrap so, as you can see in the production shots, the dome diffuser is left on for the foreground SB-900, which means it is automatically at the widest zoom (17mm). From

there, I send it through an umbrella, making it softer still. In the SB-900 menu I selected "even" light. The unit allows you to program center-weighted, standard, and even modes for the spread of the flash. I went with even, again, producing smooth and wonderful light for her face.

As mentioned above, the background light is warmed with a full CTO gel. I like the filter holder that comes with the SB-900. It is designed to hold the filters that are embedded with chips that communicate color temp information to the camera. (Example: With the camera set to auto white balance, you can take the CTO gel, slip it into this filter holder, and slap it on the SB-900. The "smart" filter will communicate to the camera that the Speedlight has been shifted to a tungsten balance, and the camera will shift white balance accordingly. For this to happen, the camera must be in auto white balance and the flash must be on the hot shoe. If the camera is not in auto white balance it will not shift, no matter what gel/color info it is receiving from the Speedlight.)

But the fancy filter holder also functions simply as…a filter holder. Cool! Means my flash units don't have to get all gummed up at that end with scotch tape residue and bits of gaffer tape anymore.

Here's our basic setup.

(Note: The gold reflector material on the bar is from a 3x3' Lastolite kit that has the tiny SB-R200 Wireless Speedlight [part of the R1C1 kit], again with a full CTO, sitting on it. I experimented briefly with

"You get a longer throw, more concentration of light, and perhaps a bit more of a defined edge between highlights and shadows."

putting a little bar glow off to the side of Vanessa but then decided the room had a daylight feel to it and killed it. It was also creating shadows that I ran out of time to wrangle. In the grand tradition of all photographers who are outta quarters and whose location meter is about to expire, I just shut it down. [Uh! Light cause problem. Mongo kill light.])

To make sure the background SB-900 saw my SU-800 signal, I ran an SC-29 off-camera cord off to the right and clamped it to a stand.

Then, quickly, to take advantage of Vanessa's amazing red hair (basically, she has never cut it) framing her face, we moved in a handheld SB-800, low and camera right, coming through a Lastolite TriGrip diffuser, making an instant beauty light combo. (A beauty light treatment generally means there is a main light overhead of the subject, and there is a low fill light just out of frame below the subject's face. Usually that fill is programmed at −1 to −2 EV so that it doesn't overpower the main light or dominate the scene.) That diffuser panel is below Vanessa's face, adhering to the location light maxim

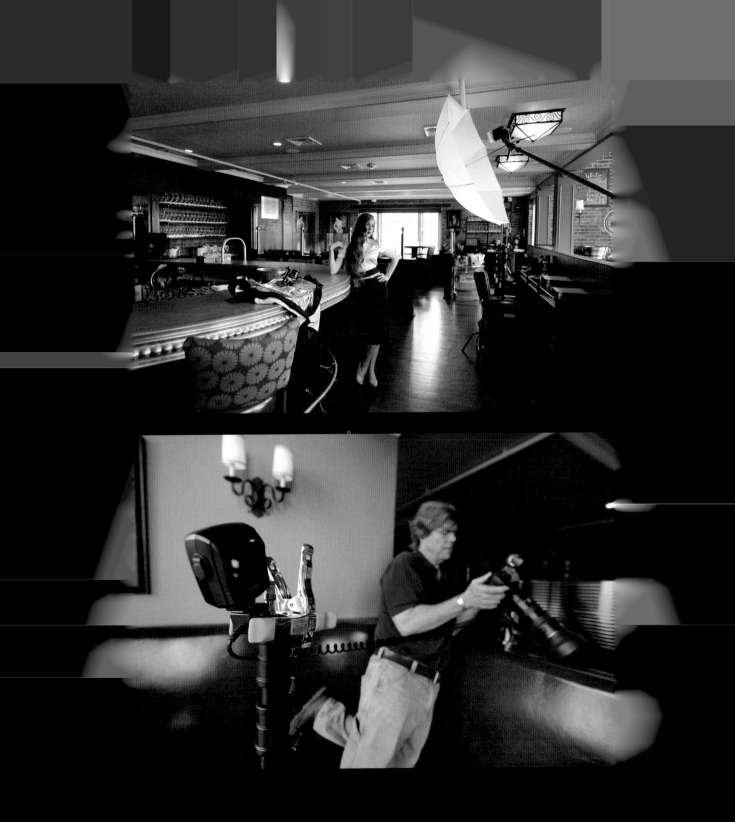

of closer light being more beautiful light. It is filling her face, not over-much, just enough for some glow and drama.

Shot these with my 200mm lens at f/2. The background SB-900 fills the restaurant with warm glow, which feels even more glow-y, given the severely limited depth of field. The lights up front are dialed down a touch, running around −1 EV. The background SB-900, zoomed out at 200mm and throwing light a good distance, is dialed up about one stop. Minimal set up and minimal breakdown, which was great 'cause the restaurant was starting to jump and we hadda get going quickly. □

Some Light

Conversation

I OFTEN REFER TO LIGHT as the language of photography. You can scream and shout, or you can whisper. You can be smooth as a salesman, or you can be as sweaty and loud as a carnival barker.

All these pictures were shot with the subject and the camera in the same place. The lens did not change. Neither did the background or the camera's point of view. But the light did. Hence my conversation with the subject changed. In turn, he says something different to the viewer.

I would describe the first light solution as smooth light. It comes from one source, an overhead 3x3' Lastolite Skylite panel. There are two SB-800 units, dome diffusers on, pumping light through that panel. It is boomed overhead of Mike, a Florida based trainer, model, and bodybuilder,

who stands underneath it, radiating quiet confidence at the lens. If I were built like him, I'd feel pretty damn confident, too. The light is simple and clean, even and smooth. It fits him, comfortable as skin.

Ah, but then we get cocky. The eyes are compressed, the chin is up, and there is a touch of "Don'tcha wanna be me?" to his expression. Quiet confidence just crossed the line into arrogance. The light picks up on this mood, and it radiates, too. It is no longer quiet. The overhead source stays exactly the same, but what overtakes it is two backlights, placed on either side of Mike, in a position I often call "three quarter back," as I talk about in other stories in the book. In other words, they are not completely behind him, looking directly back at

the camera. That would be straight-up backlight. If the camera is at 12 o'clock, then the lights are at 4 o'clock and 8 o'clock.

They rim him out, and create a frosted line of light all around his physique. If he's the beefcake, baby, this light treatment is the frosting. Caption this one, "D'ya think I'm sexy?"

Next, we go all the way to crazy theater with a bodybuilder performance pose. Muscles are flexed, and the expression's as big as his biceps. He is still being lit by the side lights, but the overhead smooth light is gone. It is replaced by a low, hard source—specifically, one SB-800, hitting him hard. He leans into the light and mugs for the crowd, which is, of course, the camera. The low light catches him like a theatrical footlight, and now he's on stage.

In the last shot, the rim lights are shut down and, instead of playing to the crowd and the low lights, he is caught in a single, overhead spotlight. This is one SB-800 on a boom, no diffuser, zoomed all the way to 105mm. This is, for all the world, like a balcony spot in an old theater. Shadows define his flexed muscles, giving him that peak-and-valley, light-and-shadow ripple effect. He screams for good measure.

A number of issues are at work here.

Size of source. We are always talking about how the size of the light affects the feel and quality of the light. Witness here the effect of a three-foot swatch of diffusion material moved in close to our subject. It wraps, softly and easily. As I said, smooth.

As opposed to one small, spectral source, which is anything but smooth. That changeup produced the harsh slashing shadows in the last two frames. Size changes, angle changes, photograph changes.

A word about these light panels: I use 'em...a lot. The feel of the light is very softbox-like, but when working with the Speedlights, which have a light sensor window that seeks input from the master signal at the camera, you can't bury them inside a softbox, 'cause the remotes won't see the master flash. The light panels are open surfaces, so messages from the camera translate easily.

On the last shot, I knew I had the light nailed 'cause I had a test model who had the same body-builder physique. ☐

Groups!

EVERY PHOTOGRAPHER'S favorite thing! The more people in the group, the odds that something is going to go wrong, or somebody will not look good, or someone will complain, or your lights will misfire, or the person with the striped tie and the checked suit and the white socks and the welder glasses will be in the front row are so high it's ridiculous. Scenes like this are so daunting, so difficult, so spirit-breaking as to make even the most resolute shooters dream of engaging in another profession that would presumably be more stable and remunerative, like running a roadside vegetable stand.

That's a little extreme, but you get the idea. To do effective group portraiture, you have to have a multiple personality: shooter, lighting director, cartoon character, stylist, shrink, diplomat, captain of the Love Boat, and, occasionally, a flat-out, shit-heel, goin'-straight-to-hell liar. "That's really nice! Everybody looks good! Especially you, ma'am. That's a lovely outfit! Circus in town?"

Yikes. But ya gotta do it. I try to make a game of it now. I positively drip confidence, while keeping up a line of chatter a used car salesman would envy. I have no idea if what I'm saying is sensible, effective, or downright offensive, but I try to keep the ball bouncing and my subjects laughing until it's over. Mercifully, these bloody things are generally over quickly.

Okay, quick survival guide. Do not shoot one of these with a straight flash. (Whenever I say stuff like that, I realize that if you are out there and you have one flash and nothing to bounce off, ya gotta do what ya gotta do.) But strive, mightily, to get the light off the camera—and,

"Work your lights as high as you can get them, and aim them towards the back of your group. Basically, fly the bulk of the flash power over everybody."

if possible, use multiple lights. If you shoot it with straight flash, the folks in the front row will be two stops hotter than the folks in the back, and the unflattering light will make most everybody look about as happy as a group of folks at an Irish wake.

I have gone to extremes (hey, it's me). For *Life* magazine, I shot a group of virtually every well-known jazz musician on earth on a soundstage out at Silvercup Studios in Manhattan, using about 70,000 watt-seconds of light. I had to bathe the entire set in light, and have about f/16 from front to back, 'cause I had to shoot it on a panorama camera. That meant a lot of light and a lot of diffusion. Got it done, though, and it looked good. And, truthfully, I was under so much pressure that the only thing I really remember is that jazz musicians don't listen to anybody.

But nobody's gonna do that again, especially me. Another extreme I have gone to is to do a firehouse group portrait of about 60 guys, outside the house, in the rain, with three SB-800 units. Talk about the winging-it, minimalist approach. I put two remote flashes on camera left and camera right, like a copy stand, and just banged away. Here's one strategy I can offer here: Work your lights as high as you can get them, and aim them towards the back of your group. Basically, fly the bulk of the flash power over everybody. Trust me, the front row will still get lit up by the low spill that comes out of the Speedlights. (Remember how I've said that when you set off one of these puppies, light goes everywhere?)

The light will radiate. The lower portion of it will light the front of the group, while hopefully a bunch of the light—because you placed the flashes high up—will travel to the back of the line. Also, with a flash to the left and right of the camera, try lighting the group like you would light a background by crossing the lights over each other: feather the right light toward the left, and vice versa. You may get some conflicting shadows, but you have a better chance at even dispersal and coverage. (Those potentially conflicting shadows can be softened and opened up by the flash that's coming straight from camera. This is one of those instances where you don't have the luxury of using your on-camera SB flash only as a commander. You need to program it to be a flash and a commander. You also may need to play with the EV of that on-camera flash. Probably best to dial it down just a bit, and let the remote Speedlights do the heavy lifting.)

Forget about sidelighting! Unless you have a huge, huge light source, bringing light from the sides of a group setup is just asking for trouble. Shadows will tumble left and right like so many dominoes. There will be big dark holes in the photo where some of the people used to be.

Frontal light—a big bounce or wall of it—works well. That is why, if I have a smallish or reasonably sized group, I often use a Lastolite 3x6' panel directly overhead my camera position, oriented horizontally. That is a wonderful "cover" light, if you will. And, if you use a C-stand with an extension arm to project it over the camera and towards your group, you then have a lot of leeway to pitch that source at an angle that won't cause screamin' highlights in people's glasses.

In a group, kids are actually much easier to deal with than adults. All you have to do is get 'em together and be prepared to act like a goofball. I have actually shot groups of little tykes with a stuffed animal bungee-corded to my head.

With the ballerinas here, I just acted like an idiot—which comes second nature to me—and made sure I didn't use a straight flash. At 1/60th at f/10 with straight flash, as you can see below, you turn these cute kids into a group you don't want showing up on your doorstep on Halloween. With a situation like this, it has never been truer that you have to make your small flash behave like a big one.

Quick strategies to shoot a gaggle of cuties like this with minimal gear:

- Make it fun.

- Find a white wall and spin the head of your SB-800 or SB-900 all the way around, so that it fires backwards, washes off the wall, and comes forward to cover the kids.

- If there is no possibility of a wall behind where you are shooting, crank the flash head up as if you were bouncing it, and start working with your shutter speed to blend in some of the existing light. The existing light can soften the harder pop of your on-camera Speedlight. If the ambient light starts doing strange things color-wise, you could try a preset white balance. Find a white surface (the Lastolite TriGrips work well here, if you got one stuffed in your bag) and do an exposure that mixes flash and ambient. The camera's sense of color will most likely render good skin tones.

- Make it fun.

- If you have a remote flash or flashes, run them through soft light-shaping tools, such as an umbrella or, as I mentioned, a 3x6' Lastolite panel. It's the perfect shape for a group like this, which was shot at 1/15th at f/7.1 with no EV compensation. The flash dominates the foreground of the photo, rendering the kids in a pleasing and sharp way, and the drag of the shutter to 1/15th brings in some context and background. Be careful with low shutter speeds, though. Shoot a bunch. If you go any lower than 1/15th, you run the risk of giggly kids who are moving and not sharp, even though they are flashed.

- Try a quick, light flick of light off the floor. A very weak fill bounced off the floor at about −2 EV is often effective in giving those cute faces an extra little spark. And when I say "floor," I don't mean the crimson carpet. You have to throw something white, gold, or silver down there. Enter the Lastolite panels again. A white reflector with either a gold or silver backing comes with all the kits. Throw that on the floor and you're in business.

- Did I mention to make it fun? ☐

"Get 'em together and be prepared to act like a goofball."

Lighting Kit
for the Creepy-Guy-
in-the-Alley Shot

OKAY, HERE'S WHAT you need:

- One decent-sized axe, preferably old, with wet stuff dripping from it

- One overlarge black coat, the kind guys who hang around in alleyways wear (not that I would have any experience or knowledge of that)

- One wonderful assistant, who is the nicest, most congenial guy in the world, and who can stand in front of an SB-900 on a floor stand and somehow project a shadow that is right outta *The Texas Chainsaw Massacre*

- One lovely ballerina, who looks terrified and vulnerable

- Two SB-900 units, with green and warm gels

- One Lastolite EzyBox hot shoe softbox

- One SU-800 commander unit

- Two SC-29 remote flash cords

- One DSLR (this was a D3) with a 24–70mm lens

Mix all these together, and you've got a production still from a noir movie. Here's what the pieces looked like on paper.

The i-TTL technology worked really well here. First thing to do was to control the environment and make sure the kind of already nasty alleyway light was subdued enough to project a sharply delineated shadow on the wall. Often your mission is to blend light, right? A light touch. Finesse your flash into a scene that is already interesting. But in a situation like this, ixnay on the inessefay business.

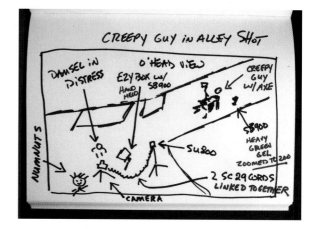

You're projecting an image, right? So, just like in the movies, the alley's gotta be dark. You can't let it ride with the existing conditions, even though there was a pretty cool feel to it. Check it out at 1/8th of a second at f/5.6 (opposite page). Not bad. If I were doing a straight-up portrait, I woulda gone with it.

But I want to project not only shadow but my own color. In this case, heavy green, kinda like fluorescence on steroids. So I jammed the camera into manual exposure mode and dialed my shutter to 1/250th of a second. This takes whatever ambient light is hanging around the alley and steps on its throat and chokes the living shit out of it, then takes the carcass and chucks it in the dumpster. (Get the picture? Gone, I mean eliminated. Really gettin' into the noir crime thing here. Cool.)

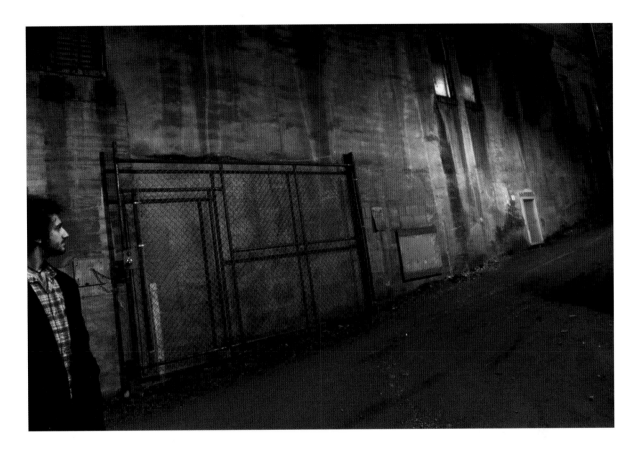

"The alley's gotta be dark. You can't let it ride with the existing conditions, even though there was a pretty cool feel to it."

Now I got shadow. Green shadow. As you can see above, the green is even radiating down the alley and skimming across our "terrified" damsel in distress, Hannah. The SB-900 creating the shadow on the wall is on the floor, and I slapped a couple of heavy-duty green gels on it, trying to make sure I got *real* green.

The counterintuitive thing about theatrical, dramatic color? Less is more. Our instincts as shooters is to pour on the power. Not enough color? Dial it up!

Captain! Have ye gone mad?!?! The flash'll never take it!

And it doesn't have to. All you really do when you power the light upwards, thinking you will get more color, is bleed the color out of the scene. Drive a lot of light through a red gel—you get pink. Hell, if you blast a ton of light through it you could turn it white, though that is an experiment I have yet to try.

Want mo' better color? Less gas. Slow it down. Let the gel marinate the white light passing through it to a nice, spicy, rich color. If I want more intense color, and I am just going for drama and intensity, I often just double the gels up on the light. If you do that, and back off the power, you will see a dramatic increase in saturation. The other thing to be aware of, and I say this elsewhere, is to seal these gels over the light.

In other words, make sure the gel covers the whole surface of the light, and tightly. If you have white light bleeding through—in other words, un-gelled light from the flash flying out and about—it will mix with the gelled light and soften the intensity of the color. So be careful. Seal the gels on there with tape. Don't let white light escape!

I ended up liking the mix of light at 1/125th at f/5.6, ISO 400. The shutter speed/f-stop combo did two things—it made the alley dark enough to

control, and it gave me enough depth so there is a good retention of sharpness and detail all the way to the back of the frame.

Looked pretty cool once we got our shadow man placed properly. Which, by the way, is tougher than one might think. You have to move and tweak, especially when you are not projecting an image from the light at a ninety-degree position to the wall. When you are skewed to the wall, such as we are here, you have to mess with its position relative to your subject because, given the angle play, the shadow will be distorted—and not necessarily always in a pleasing way. Here, pleasing was the least of my worries. Creepy and foreboding was where I was heading, and the distortion worked in my favor.

All that was left to do was to light the "distressed" Hannah, using an EzyBox hot shoe softbox. It is a great light for this, as it has direction and punch but it's not as hard as a streetlight or a straight flash. You want to emphasize the lovely curves and innocence of Hannah's face, driving home the point of her vulnerability and completing the B-movie slasher feel.

So, the pieces are in place. Now to make them all work in concert. Enter the SU-800, which is the perfect trigger when SB units are far afield. It's got good direction and power to the signal, so the trick was to place it well. Couldn't hot shoe it, as the EzyBox was to camera right and—while that SB-900 would trigger fine—the shape of the box was blocking the pre-flash from reaching the alley light. The solution was to extend the SU-800 via two SC-29 cords, and move it to a position off camera where its signal would cover both Speedlights. Once I had them both firing, I could also ratio their power right from the camera, saving my sorry ass continuous trips up the alley.

I didn't want to do that 'cause there was this guy with an axe. ☐

IF ANYONE EVER DESERVED a set of wings, it is my friend Donald. Not in heaven, but right here on earth. I want Donald to stick around for a long, long while, and keep spinning his honey on the dance floor every Friday night, as he always does.

But, with a face like Moses and a presence in front of the lens that could part the Red Sea, he does make a perfect fit for a retired set of wings I've got hanging around.

Let There Be Light!

My garage is prop city. Stuff. Kind of a museum of shoots gone by.

A couple years ago, it seemed like every star freshman playing college ball was enormous. One such lad was Brandan Wright of North Carolina. He had a wingspan that would have made him a candidate for one of the *X-Men* movies. So, Joe had to find wings! These were made by a specialty prop outfit in LA. They call themselves Mother Pluckers.

(My editor at *Sports Illustrated* was freaking over the heavenly price of this prop. He called me. "Can't you go to a Halloween store?" I remained calm and reminded him that Brandan was 6'11".)

Typical of shoots for a frenetic weekly magazine, these got made at the last minute and drop-shipped to North Carolina, arriving at the athletic stadium about 11:30 or so. I had to figure out how to hang 'em and light 'em by 1 p.m. The sports info director was allowing me one half hour with Brandan. No more. (Funny, I don't remember my time being that valuable when I was 18.)

The pic ran as the opening double truck for the story, but I was never completely happy with my rush of a lighting job. The wings went back in a box in the garage, and became an item on my Things to Do Before I Die list: #1,773—Light those frikkin' wings better.

When teaching at the Santa Fe Workshops, I figured I'd give it another go as a class lighting demo. Rigged them with two C-stands, a couple Bogen super clamps, and a few sandbags.

Lit 'em from the back with two SB-800s, zoomed wide at 14mm and with dome diffusers on. As you can see, they are banged right into the back of the feathers, and the happy accident here is that they backwash light onto the old wall in a pretty nice fashion. (Anytime you can get your lights to do two jobs at once, it is a good day in the field.)

Lighting the portrait part was trickier. As soon as any frontal light flies at those wings, the white feathers bleach out and the backlit glow and romance is gone. They get flat as yesterday's newspaper and less compelling. So, the trick is to light the face and nothing else. Hoo boy!

Improvisation ruled the day. Took an SB-900 Speedlight and zoomed that puppy to 200mm, then snookered it even further with a Honl snoot. Tried that alone, and the results were predictably harsh. Not too much spill, but bad-dog light. Dropped a Lastolite TriGrip diffuser panel over it, and got soft light—and way too much of it. Not in terms of power, just in spread.

Out came the gaffer tape. (Is there anything in this world that can't be made better with gaffer tape?) When we were done, there was maybe a 6" square of diffuser left exposed. The rest of the panel is gaffered.

Amazing what a little diffusion will do. We went from harsh, awful light to just enough glow to cover the face and shoulders but not dull the wings. On my original shoot, I used big lights, spot grids, high rollers, you name it. The solution here is three Speedlights and some gaffer tape. Heavenly. □

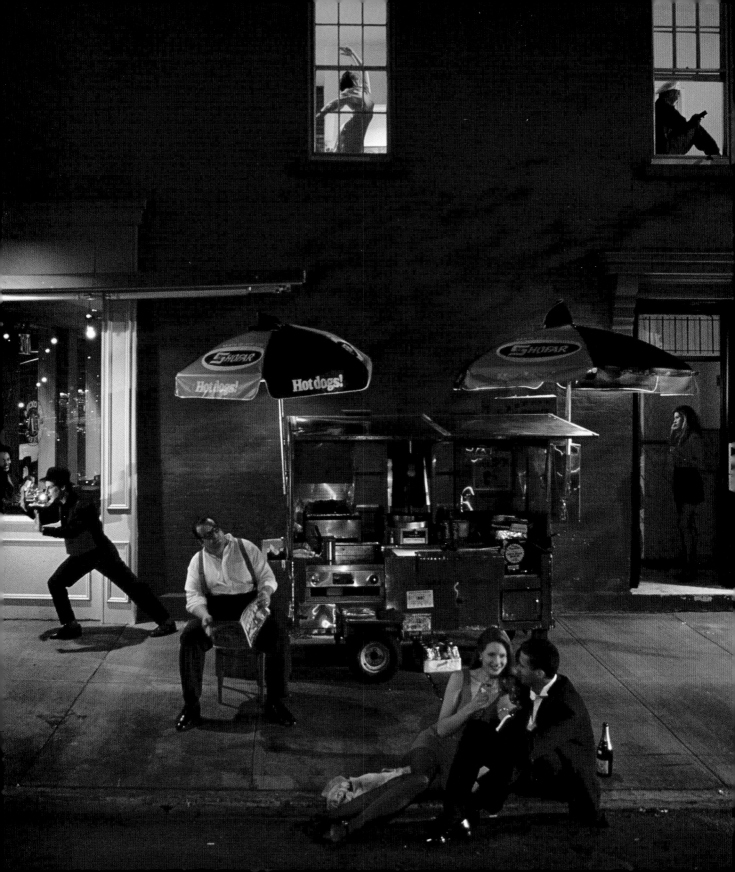

Lotsa Lights

Or, "Traveling through hyperspace ain't like dusting crops, boy! Without precise calculations we could fly right through a star, or bounce too close to a supernova and that'd end your trip real quick, wouldn't it?"

How to Give Birth
to a Speedlight

FIRST, YOU HAVE TO HAVE FRIENDS who understand the murky recesses of your imagination. Then, you have to have a workplace where twisted humor is the rule, not the exception. With those elements firmly in place, the only thing that stands between you and a photo like this is where to put the Speedlights.

One, er, placement is obvious. Now this is where you really need friends. There is no one I could ask to do this for me other than Mawgie, long-time Santa Fe Workshop model, friend, and graceful, exuberant presence in front of the camera. She's modeled for all sorts of classes at the workshops, but never did she foresee, as she put it, becoming a "gynecological model." I pointed out to her that it would be a real ice breaker as a business card.

Mawgie made arrangements at her ObGyn clinic and we trooped in there and started moving and pushing (okay!) and propping to make it as doctor-ly as possible. One of the first controls I reached for to achieve this was white balance. Shooting this room in straight-up daylight tones would render it pretty mundane, as it was a simple, no-frills doc-tor's office. When you are trying to create a mood, though, color is one of the most effective tools in your bag. The background is a frosted glass win-dow, looking onto the parking lot. There is quiet, fading daylight filtering through there. Because I shut the overheads off, it was really the only light source in the room.

As I have said a number of times, when you take daylight, especially muted daylight, and translate it through your camera set at a tungsten white bal-ance, the world goes blue. How blue depends on your exposure (underexposure will give you a rich, saturated blue) and the degree of tungsten you have the white balance dialed into. Within all the general options of white balances offered in almost any digital camera—daylight, open shade, cloudy, tungsten, etc.—there are incremental controls that allow you to fine-tune that particular realm of color you are programming. Here, I took my tungsten balance a touch lower on the Kelvin scale (on the D3, I went to B3). Thatsa one beautiful blue!

In my mind, by turning the scene blue it has a more science-like, operating-theater drama. The sterile gowns and masks go with this flow.

The mood is set. Now the, uh, child in question is an SB-900 and it is on the floor stand that comes with the unit. The dome diffuser is on, giving me the greatest spread of the light. (Jeez, there's a lot of ways you could write about this.) There are no gels on the flash.

That SB-900, being ungelled, will also radi-ate blue. Except if you keep it bright. In the upper reaches of its exposure curve, the quality of light will be white. A cool white, but white nonetheless. That is why our intrepid delivery team of Nerissa, Jen, and Leah all have relatively normal skin tones. They are in the brightest wash of that light, the miracle-of-birth light, and thus are glowing. I am controlling that source from the camera with an SU-800 Wireless Speedlight Commander unit. There are no problems with the lights receiving the i-TTL signal as the white walls of the small room bounce the pre-flash everywhere.

Now for the rest of the room. It is bathed in blue, so what will look good and perk visual interest is a couple of highlights, gelled with CTO and, there-fore, warm. Warm and cool tones always produce a vibrational color effect. They play well together. There are three other Speedlights in this photo, all very controlled, all very warm. On the lower right, there is an SB-800 with a Honl grid spot, introduc-ing mild highlight value to the equipment on the stand. On camera left there are two Speedlights: one an SB-900 with a snoot, putting a small high-light on the shelf in the background; and another SB-800 with a snoot, putting a very faint highlight on Mawgie's left leg. Very controlled, very low power. An accent light shouldn't scream. We left

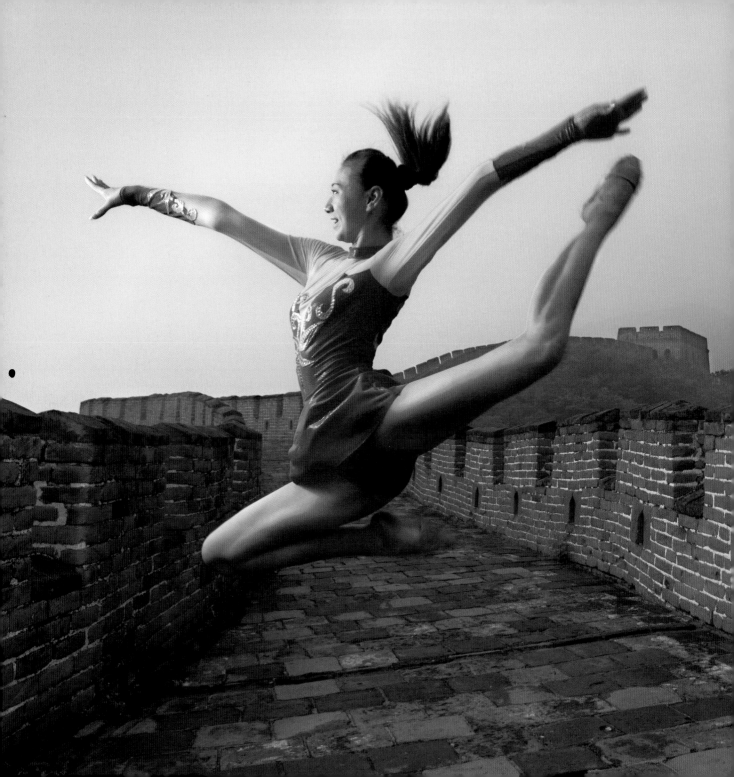

A Great Wall
of Light

UP ON THE GREAT WALL, my kid is gripping for me. Hey, it's hard to get good help these days.

My daughter Claire accompanied me to China, and we went to the Wall together, along with a very accomplished member of the Chinese National Gymnastics team. (This was shot pre-Beijing Olympics.)

The Wall is astonishing, even in bad light, which this was. I needed to get some punch and direction to the picture, and I had to do it fast, and without much gear. One way to do this is to create a strong sidelight and have your subject face into that source. When you bring light like this, the quality of the illumination is soft and hard all at once, 'cause generally there will be a beautiful quality of light on the subject's face that falls off really quickly.

This wonderful gymnast makes herself into this incredible leaping pretzel, all the while smiling into the Lastolite 3x3' panel my interpreter is holding, while my daughter Claire becomes a VAL (voice activated light stand) for an SB-800. I am triggering the light at camera with another SB-800, hot shoed and acting as a commander, not another light source.

It's great to work this way, and in China, up on the Great Wall, just about necessary. You want to fly this under the radar screen, and not go the big production route. No need to draw attention and risk official interference.

So, having been to the Great Wall, how do you make your own great wall of light? In other words, how do you turn four SB-900 units into a giant light source?

Well, maybe not a great wall, but certainly a big one. Dare I repeat myself yet again—these Speedlights put out a pretty good amount of light, relative to their size. Which means you can still get good play and power out of them, as we have seen, by reflecting them, bouncing them, diffusing them, even double-diffusing them. When you use multiple Speedlights, by directing them in concert to wash off or through a surface, you can create—a wall of light.

My friend Thomas Wingate is an American icon and a walking photograph to boot. I've got a huge American flag I had custom made for me years ago for a *National Geographic* shoot, and it got me to thinking. Flag, mirror sunglasses, shotgun, duster, cowboy hat—sounded like Thomas to me.

"There will be a beautiful quality of light on the subject's face that falls off really quickly."

The idea was simple enough, of course, until I realized any cool type of mirror sunglasses was going to be shaped like a TV monitor. Good thing my big American flag was, you know, real big, 'cause those glasses reflected just about everything in the room and down the block.

At first I tried, in vain, to just fire four SB-900 units through the flag. That immediately fell into the category of Stupid Things I've Tried on Location, which, trust me, would be a much lengthier book than the one you're currently holding. I had hot spots galore, and hugely uneven light. It was miserable. How to make four small light sources act together as one big one?

Bounce 'em off a wall. The empty space we were in had huge flat surfaces, and they were mostly white. I drug the flag over and positioned it about eight feet away from the wall. Then I took the four Speedlights on two stands, each with one flash high and the other clamped about midway up the stand with a Justin Clamp, and put them at either end of the flag. They are all turned into the wall and they all have dome diffusers on. One side is Group A and the other is Group B. I positioned Thomas and stuck my lens through a vent in the flag. The flag itself is the light-shaping tool. Nothing else in the photo. My exposure was 1/250th at f/4.

So here's the thing. I like the picture, even though I drove myself batty lighting it. There are flaws, of course, like the 200-pound shadow at the camera position. But what is helpful to note here is the power and spread of these lights. I shot at f/4. Okay, take away the flag, and I'd bet you get at least two f-stops back. Think about the potential to cover a big group with light like this, and not just a pair of mirror sunglasses. ☐

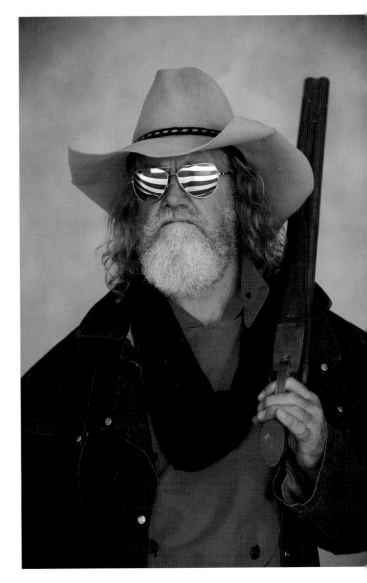

Northern
Light

MAINE IS HOME to a bunch of, well, *characters* would be a kind way to put it. Independent sorts. Salt of the earth. Home spun. In other words, outright, full-blown wackos.

No, no, kidding. State o' Mainers have their own way of expressing themselves, and it is invariably interesting. Which makes it a great locale to have a photo workshop, especially one about lighting.

Like Andy Swift—artist, mechanic, and a truly wonderful, charismatic Maine character. He

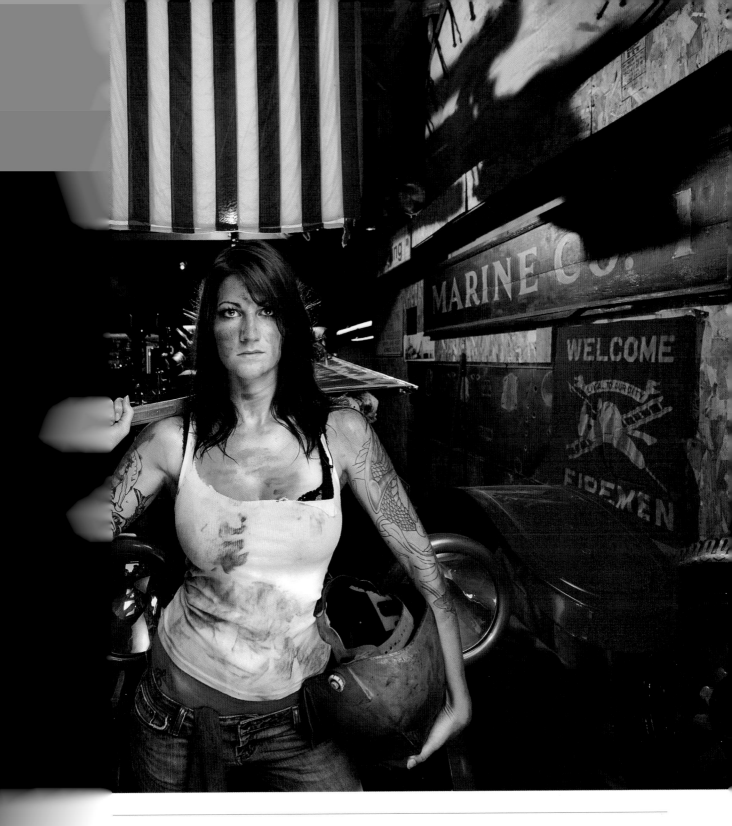

restores historic fire engines for a living, and runs his business, Firefly, out of an old chicken barn that used to house 33,000 of the feathered darlings. It is quite simply one of the best places I have ever been, chock full of stuff—fire trucks, wheels, engines, parts, tools, and toys. Andy used to have Osama bin Laden targets in his backyard, which he would regularly chew threw with a 30 cal.

The Firefly garage is a great location, but it doesn't give it up easily. Stuff everywhere, lots of dark spaces, reflective fire engines, and hot light pouring in each end of the otherwise dark barn. Tough to balance, in a word. I poked around, trying to figure out an angle.

Before you start to light, figure out the picture. I mention this time and again. Know what's gonna be in your frame. You are not running and gunning here, fill-flashing the perpetrator as he makes the mad dash from the precinct to the paddy wagon. Take your time. If you have a tripod, use it!

I immediately knew I wanted to look into the dark barn, and not work against the huge, open bay door. The light outside that door was, like, f/32,000, and the light inside was a weak f/1.4 at best. I'm not gonna fight city hall here. Where I am looking is dark, but dark I can light. Dark I can control. I like the dark. Yessss, my precious....

Okay, I'm back. Get your angle and determine where your subject is gonna stand. The lady here is Brianna Borkowski, who poses often for the workshops and has always been patient and hardworking with my classes. She is also used to requests like, "Can you tear up that t-shirt a bit, and grease it down like you've been working under the hood all day?"

Next step: main light. I used a Lastolite 6x6' Skylite panel horizontally, just over the lens, which is a 14–24mm Nikkor, by the way. I use wide glass for portraiture all the time, seeking to establish environment for my subjects. Lots of fears out there about distorting the subject, but if you handle the lens carefully, you can make wide glass work real well.

I had two SB-800s, both with diffusers on, shooting through the panel. Reason for two is simple. This light is not just for Brianna. It

does light her, but it also covers the whole front end of the fire truck. It's a broad, nice source, but Brianna's got great eyes, and they scream for the spark of a low beauty fill light, which was a seat-of-the-pants, handheld solution involving a Lastolite TriGrip diffuser and another remote SB-800.

When you light with a main and a fill like this, you are basically playing a ratio game. De facto, the main is more powerful and the fill is less so, because it is, well, a fill. That is why it is always advisable to put these two crucial lighting elements into different groups in the CLS system. Here, my main remote flash (aimed through the big panel) is Group A, and fill light (firing through the smaller TriGrip diffuser) is Group B. Remember, the flashes in a group all ratio together. They react to exposure inputs differently.

With two groups, I can play. I can make the main light dominate the scene, and feather the fill in very gently, using increments of a third of a stop. I am not concerned with numerical measurements here, or 3-to-1 lighting ratios—the kind of stuff that a lot of us learned in school or by reading some technical book of light that looked and felt like math homework. I could care less about the amounts and how they compute. I care about the feel. With fill light, there is fill, and then there is too much fill, which makes it look like a misplaced main. Don't overplay it! Especially with low light! You will make your subject into a Halloween poster.

Okay, on to the dark barn. Warm, accent light is the way to go. Why warm? Couple reasons, actually. First is psychological. People like to see, and are used to seeing, warm tones in a barn type of structure. Think piney wood, hay, golden glow, all

"I'm not gonna fight city hall here. Where I am looking is dark, but dark I can light. Dark I can control. I like the dark. Yessss, my precious...."

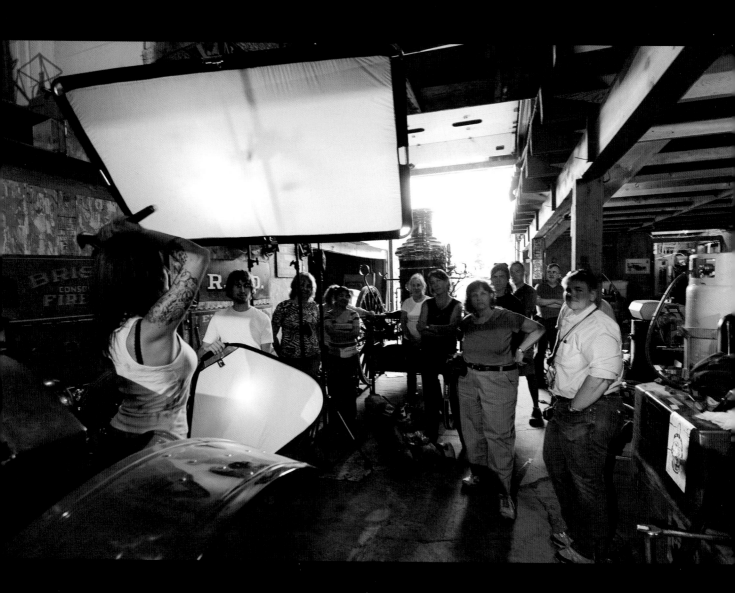

"You don't light a down-home
country barn like you would light
the Merrill Lynch trading floor."

that stuff. It works. You don't light a down-home country barn like you would light the Merrill Lynch trading floor. Secondly, the light in place there (what there was of it) was already warm, or more specifically, incandescent. The existing light was coming from a few 60-watt bulbs.

So on camera left I placed another SB unit, gelled with a full CTO, which brings its daylight, neutral temperature down the Kelvin scale so it behaves like a tungsten bulb. This flash, the fourth in the setup, is simply bounced into the wood rafter just above it, which will give it an extra bit of warmth. (Light picks up the color of what it hits.) The effect of this light is to simply fill that dark side of the picture—not to call attention to that area, just to let you know it's there.

Did that again in the way back, over Brianna's right shoulder, waaayyyy in the back of the barn. That light is just sitting on a table, in plain view of the camera, but the camera won't see it 'cause it's so damn small in the frame. What it is doing is lighting that far wall, and it gives the reader a sense that the barn goes on and on. It was also a bit of an experiment to see if the flash would trigger i-TTL flashes at that distance, which it did. Cool! Love it when it works.

And then, finally, there is one more main light in the picture. Sort of. I say "sort of" 'cause it is powerful, and it's directly behind Brianna, radiating through the American flag. That lone light is causing all the backlight and shadows in the picture. It makes the flag glow, and lights the sides of the barn in a strong way. Would have loved to eliminate the powerful shadow at the upper right of the picture, but there was a sizable thingamabob up there that would have required industrial circular saws and a crew of six to get rid of. So I let it go.

Which, all the techy lighting talk aside, may be the most important lesson here. On location, you take it as far as you can, and then, sometimes, you just have to let it go. At *Life*, Mel Scott, who was one of the truly great picture editors I ever worked for, used to say, "Just go out and make a picture. Just make a picture." In other words, quit worrying over that last tenth of a stop, and just shoot. It'll come around. ☐

"On location, you take it as far as you can, and then, sometimes, you just have to let it go."

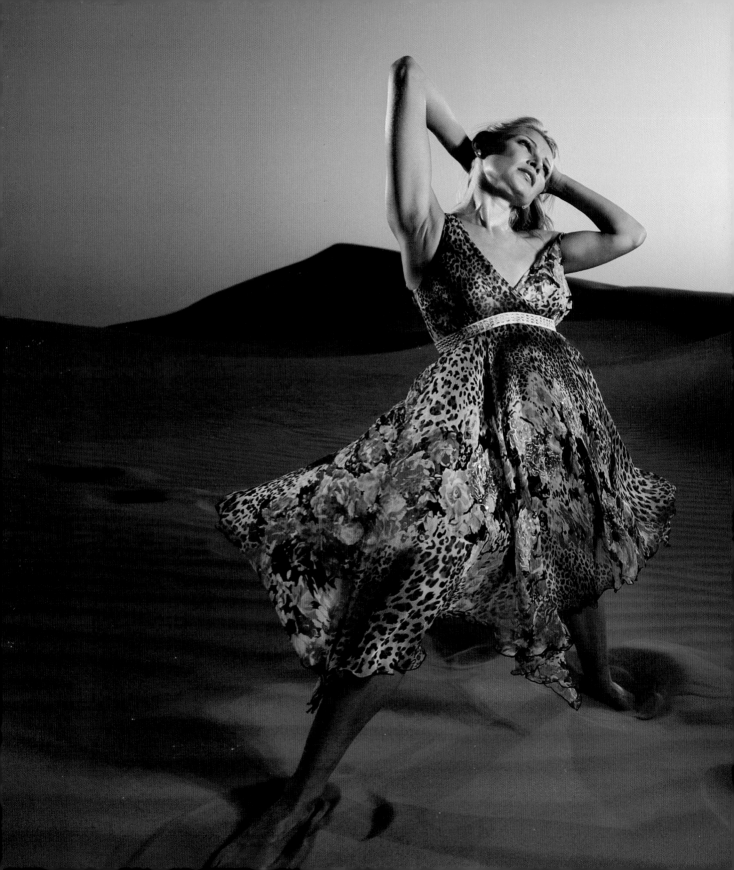

The Tree of Woe

"CONTEMPLATE THIS on the Tree of Woe."

—*Thulsa Doom, condemning Conan the Barbarian to death in the desert*

I tend to overdo things. It must be a bit about being raised Irish Catholic. I go out there anticipating disaster. I look for the simple, fatal flaw that will dash my hopes, crush my spirit, befuddle my brain, corrupt my flash cards, estrange a client, and generally doom me to a ruinous fate. This mistake, miscue, misdeed, is usually self-inflicted.

So, I bring more stuff than I need. Mostly for backup. Sometimes I even use it. At *Life* magazine, Eisie always used to say, "Bring it, even if you don't use it. It does you no good back at the studio."

Nowadays, of course, one needs to be more sparing in what one brings in the field, 'cause it just costs so damn much to bring just about anything. I teach every year in Dubai, a city watered by money and growing like a weed right out of the sun-blasted desert. Kind of an Auto FP High-Speed Sync kind of place.

As I've discussed previously, auto FP high-speed sync is a mouthful of words used to describe a cool flash feature in the CLS system that allows you to shoot flash sync pictures at unheard-of shutter speeds. Most digital cameras nowadays sync at 1/250th of a second. A couple models go to 1/500th, which historically was the province of medium format cameras with leaf shutters, like the Hasselblad. In the old film camera days, 35mm systems generally had a top-end sync speed of 1/60th of a second, which was very limiting. For instance, if you were gonna shoot a fast-moving indoor sport like basketball with flash, you were forced to use a shutter speed too slow to stop the action, even with flash. You had to go with something like a Hassy. Think about manually focusing fast action with a camera about as bright to look through as a New York City subway tunnel. Not good.

Now we have accurate auto focus, bright viewfinders, motor drives as fast as a Ferrari, and high sync speeds. Life is good. But there are still issues. Digital ISOs are often around 200 as a standard, which is great, except when you are confronted with bright sun.

Hark back to the old "sunny 16" rule, an old-school rule of thumb that would at least give you a starting point if you had to guess your exposure.

On a bright, sunny day, your ISO number becomes (roughly) your shutter speed at f/16. Thus ISO 200 translates to a 1/250th of a second shutter speed at f/16. Right there, if you notice, you are at the top end of your flash sync speed, with a small flash powered by four AA batteries. And you're gonna ask that puppy to fire away at f/16?

That does not make your little flash happy. It does, in fact, whine. Listen to it. It makes that annoying little whir/whine noise as the batteries struggle to recycle after an f/16 blast of light. A small aperture requires a lot of light, and the flash makes a full "dump"—in other words, all the power it can muster. Then, of course, you ask it to do it again. And again. It's like asking a heavyweight power lifter who just set the world record for the bench press to get back over there and do it again. And again. And again.

This is not good field strategy. First, you are gonna get a limited number of pops outta the light. And you will heat the batteries and the flash tube up to the point that you could cook an omelette on them. Also, you will drive your subject to distraction. Think about it. You have somebody in bright light, squinting and probably hot. Take it a step further. Your subject is a big-shot bank president, who de facto is inclined to not like you. You don't

"You don't wanna be there kicking the sidewalk and apologizing that each frame is taking longer than the Academy Awards broadcast."

wanna be there kicking the sidewalk and apologizing that each frame is taking longer than the Academy Awards broadcast. Make small talk? "How's the golf game?" No. They're gonna walk.

Auto FP high-speed sync is an interesting and valid alternative to having the flash launch a missile's worth of light in one pop. In this mode, you are asking it to make many, many small pops of light. It syncs up with the focal plane shutter (hence the FP) to burst tiny bits of light through the blades of the shutter as it exposes the scene. Effectively, the light stays on for the whole exposure, which is a very short amount of time. This bursting capacity enables the flash to stick with the shutter all the way to a speed of 1/8000th of a second, depending on the camera.

Somethin's gotta give, right? You bet. The power of your flash falls victim to the speed and repetition of all those little pops. So forget about f/16. Or f/11, f/8, and so on. We're looking at much wider open f-stops here, with numbers like f/4 and f/2.8. Makes sense, actually, that all those bits of light don't add up to big f-stop numbers.

They especially don't add up to big numbers if you run the Speedlights through a light-shaping tool like a panel or an umbrella. Hoo boy, we be lookin' at f/nothin' now! A way around this is to use a bunch of Speedlights, and hang 'em on the Tree of Woe, a.k.a. the big flash tree.

There is a bit of history that pointed me towards this big flash tree. I was in an experimental mode, and I am always jazzed by something different. There are no deserts in New York, unless you want to count Madison Square Garden on the nights when the Knicks play. No life there at all. But I was very intrigued with the real desert. It was so crazy hot and alien to me. Wild.

At first I tried the near desert, just outside Dubai, with a wonderful dancer who worked really well in one of my classes; she is just a terrific, easy person to shoot with. This is just off the highway. No need for land rovers or camels. I shot a few things, experimenting.

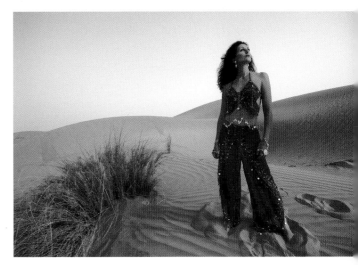

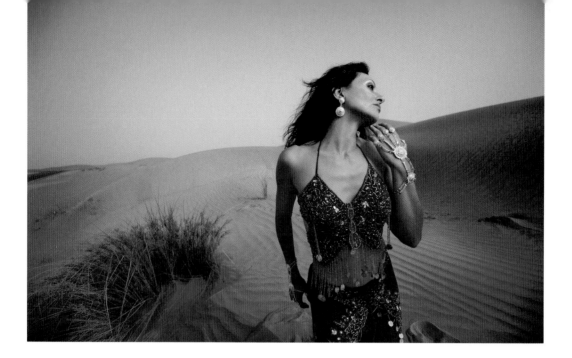

I used three SB-800s on high-speed sync, and here's what I found: they weren't enough. I didn't have enough oomph outta the flashes. The specs were running at 1/600th at f/5.6. As you can see on the previous page, it's pretty dead. Looks like the kind of light you can readily find in Buffalo.

I moved Alessia much closer to the lights and racked out my f-stop to f/2.8, as wide open as my 14–24mm could go. Using aperture priority, that gave me 1/8000th of a second for a shutter speed. She continues to move in eloquent fashion, and now, because of her closeness to the light and the wide open f-stop, I can see flash punch, and I can exert a little control over the landscape. But there's the giveback. (Always!)

She is working so close to camera that some of her begins to get the edge of distortion. Just a touch here, but I am, in this iteration, composition-ally constrained.

I went to school on this, and on my next trip to the desert I figured, okay, three Speedlights gave me this, and I want the light source to be at least

twice as far away as I had it, so that's gonna mean twice the power. So, I thought, I'm looking at six of these puppies, all coming from one direction. And then I threw a seventh in there for good measure. I grew a flash tree in the desert.

On this trip to the desert, it was more of a team effort. We thought a Lastolite panel would work, but that didn't look great so we just teed up a really big wallop of hard flash, not unlike the sun, and threw it at our subject. The point here was control. Could we wrestle the Middle Eastern sun to at least a draw?

Yes, we could. Got hard light on our model, and I was able to wrangle direction and punch out of my flash, even with the blazing desert sun behind her. Shadows became something I could control. We were even able to get a little side light on our sub-ject, courtesy of David Hobby handholding a flash off to camera left.

All of which was good information. The informa-tion, actually, was much better than the photos. Oh,

"You know what is absolutely the best piece of equipment to use on any job? The one you have with you."

well. Still wouldn't trade that afternoon surfing a Land Rover over the dunes for anything.

Couple of blog readers had a few pithy comments on the desert extravagance.

"To go through so much effort to produce such mediocre photos is hard to comprehend. Sorry for the negative critique."

My reply: "No need for apologies. If I were to grade this as a real assignment, I would give myself about a C, nothing more. But I do disagree about the effort—it was a gas. For me, photography has always been a process. Good, bad, indifferent, I still like the feel of being in the field with a camera in my hands. We were shooting for gadabout reasons, learning as we went. It was fun, so that makes the day successful to me, even if the pix aren't. Best, Joe"

Another reader wrote in to comment that I would have had better results with a Profoto 7B and a Hasselblad H2.

Couldn't agree more. That would have been an excellent solution, if I had one of those. Always more than one way to do things.

However, all the passionate comments that were raised about the gear does confirm my thinking about one thing. You know what is absolutely the best piece of equipment to use on any job? The one you have with you. □

How to Build a
Backyard Studio

THIS IS NOT SOMETHING you want up in your backyard all the time. It's kind of like the tent you might set up once a year when the clan descends on your place for July 4th. They leave, it comes down.

My recollection of the June day that we set this up in New Jersey was that it was just about as hot as any July 4th I had experienced. Blazing sun. No clouds. So hot that Tom had to spend most of the day inside.

Tom contacted me through my blog, and told me a bit about himself. I've always been taken with stories, and his is wonderful, tragic, heartbreaking, inspirational, and moving. After reading his email to me, there was no way I was not going to do this picture.

Tom had been through a lot of medical anguish and thought he was in the clear, that he could roll up his sleeves and get back to his life, which largely consists of being a father to his teenage son, Jared. Then, tragically, mysteriously, his body opened up a new wound— MS. Perhaps spurred by the trauma of his back surgeries, multiple sclerosis, dormant in his system, came awake.

Like everything else Tom has faced, he squared off and began to fight it, but it had been an uneven match against a diabolical, unfair opponent, and discouraging news and reverses had become part of his days, as regular as his medicine.

A photo enthusiast, he has a visual imagination, and wondered about this portrait—a portrait of himself as fighter, holding the line and defiant in the face of all the bad stuff his body was telling him via scans and X-rays. He has dozens and dozens of MRIs. He envisioned himself—standing, capable, ready for a fight—in front of a wall of these scans, the dispatches from the front of the war his body had been fighting.

He sent me a note about doing such a picture. I said, "When are you free?"

We headed to Jersey with a loaded Suburban. Small flash, big job. Lots of stuff. We basically were

going to build a studio out back of Tom's townhouse. This is nothing new to me. I have spent my whole career bringing the principles of the studio out on location, setting up studios everywhere from electrical closets to deserts.

One of the first mandates of the studio is— control. When you walk into an expensive New York rental studio, there's nothing there for you but four blank walls and your imagination (and if it's a real nice rental shop, a cappuccino bar). Same thing here, except no walls—just grass and a backyard fence, and blazing, roaring sun.

First step: Fix the sun so Tom could stand in shade, and so my flashes would have a prayer as I tried to control the light and the exposure. I table-topped a 12x12' solid on four stands. Standard Operating Procedure. (A "solid" is an opaque version of a silk. A silk, of course, translates and softens light.

A solid blacks it out. When you "tabletop" a rig like this, it means exactly that—you put it on four legs and make a table out of it. Or, in this case, a roof.) Raised up high on sizable stands, we created an open shade environment. A place Tom could stand comfortably, and a space I could light effectively.

Next up: Backlight the MRIs. They have to read for the camera in the same way they are read in the medical lab. They have to be backlit. The best way to backlight stuff like this is to first wash your background lights off a reflective surface. White no-seam paper is good (a white wall works as well). Use a cross-lighting technique, where the right-side lights aim to the left side of the drop and the left-side lights aim for the right. That way, they cross over in the middle, hopefully producing a surface that is even within a third of a stop. (If you pump the background lights into their respective near sides, the sides get heated up and the center goes dead. Not good.) Basically, you are creating a vertical light table and, just like a light table, you are looking for even, soft dispersion of light from edge to edge.

Okay, the seamless is up and lit. Just like in the doc's office, MRIs read best off of white plexiglass. My studio manager, Lynn, hunted for a 6' square— tough to get, and pricey—so we made do with two odd-sized pieces butted together horizontally and seamed with clear packing tape. Bogen super clamps did the rest of the job, along with A clamps. Those two plexi pieces stand behind the subject, about two feet in front of the (hopefully) glowing seamless paper drop.

The MRIs are scotch-taped to the plexi. The seamless creates a big, even wash of light that then radiates—evenly—through the taped-up medical scans. (It's tough to just aim your lights at plexiglass without first bouncing them off something big and flat. If you use four lights, you'll most likely get four hot spots. It'll drive you nuts. Redirection is key here—bounce 'em and spread the light.)

Time for a test. Had my fingers crossed on a couple of levels. First, would four SB-800s have enough oomph to not just expose the scans, but make them glow? Also, would the light sensor window in the Speedlights even see the master signal in this intense sunlight?

Arranged the MRIs, lit them with four bounced SB-800 units, went to the camera, made an exposure. Yes and yes to both questions. We got backlight. And, in intense sun, from about 30 feet, we got sensor pickup. Okay, hurdles cleared.

Next deal: Light Tom. Boomed a reflected umbrella, with the skin still on it to control spill. Using my assistant, Brad, as a stand-in, I got okay light, but there was a splashy highlight on the highly reflective MRIs.

I moved in a Lastolite panel, up high and between the umbrella and the plexi, and draped it in black material. That cut out a lot of light flying towards the background. Back to Tom. The quality of light works, but just works.

Gotta snap him with a bit more edge. I'm constrained, though, 'cause the whole bloody back of the picture is reflective. Okay, use a small source. I do this a lot, actually. Snoot an SB unit (I used to use blackwrap, now I use Honl snoots) and move it into the subject's face as close as the frame will allow. Power way down to just a flick of light. (There's a setting called "flick," isn't there?) Little pop of light, and your subject's face snaps to. You can just about see this unit, an SB-900 zoomed out to 200mm, on the right side of my frame, just below the umbrella.

That technique is killer, by the way. You don't really alter the quality of the overall light in your subject's face, but you do ramp up the contrast and sharpen the edge where the highlight rotates into shadow.

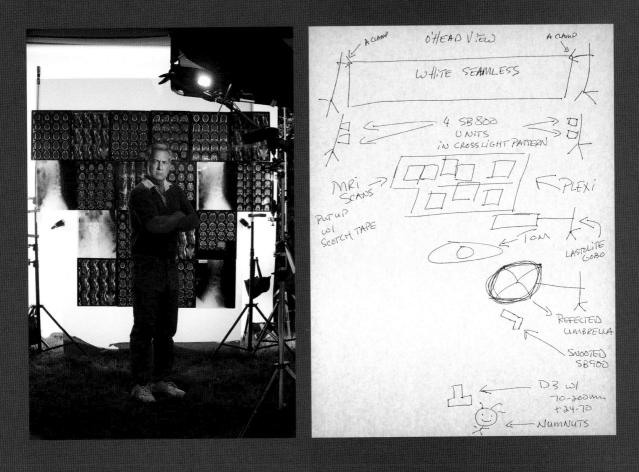

"The MRI wall reflected just about everything I did, which is why the kicker light with the snoot proved effective. Nice little punch of light, and with the Honl snoot there were no reflections or hot spots on the background."

Think of it as moving the Contrast slider in Photoshop, only much more fun! (In another story in this book, "The Killer Flick of Light," I discuss the technique more fully.)

The camera specs on the final image of Tom were 1/250th at f/11, shot with a Nikkor 70–200mm f/2.8 zoom. Lighting the background were four SB-800s, all firing as Group A. The main light for Tom was a boomed, overhead SB-900 into a Lastolite All-In-One umbrella, used in reflective mode. That is Group B. It caused a highlight on the backdrop, and it was "flagged," or "cut," off the backdrop with a 3x3' Lastolite panel, draped with black cloth. The kicker light for Tom's face is a snooted SB-900 unit, camera right, sparking Tom's face and eyes.

I tried a couple of other things, like washing a low light off white or reflective material laid down on the grass, but that caused more headaches than it was worth. The MRI wall reflected just about everything I did, which is why the kicker light with the snoot proved effective. Nice little punch of light, and with the Honl snoot there were no reflections or hot spots on the background.

I did not use that spot type of lighting approach when I did the twosome of Tom and Jared. For that, I just let the umbrella do the work, and my assistant Brad filled them using a TriGrip reflector, held low, just out of frame. For the wide shots, I also threw one more SB-800 unit way in the background, lighting the archway of greenery and the backyard fence door. I wanted something lit back there to balance off the frame, given the red wagon on the left side, which I let stay there to help locate the picture in backyard America.

That's the tech stuff. On my blog, I wrote about the shoot:

"Closing with this one. Suburban scene. Tom, Jared, a wagon, a gate, grass, bushes, trees, and then, jarringly, the MRIs. Medical dispatches from the interior, telling Tom things he never wanted to hear. They stand there, silent, yet at the same time screaming like a siren in the midst of the backyard bird chatter. Through sheer effort of will and a determination to see Jared through to stuff like his first car, his first college class, his first good job, and maybe, a couple of grandkids, Tom's gonna fight this thing. Hopefully, we made a picture that day that will hang on his wall and remind him that he's still in the game." □

Don't Light It,
Light Around It

WHEN PHOTOGRAPHERS are in the field, we charge. Just like
Marines. See the hill—take the hill. See the subject—light the subject.

For some jobs, this is perhaps the wrong instinct. A photographer rightly famous for his graphic and beautiful annual report photography was once asked how he decided on what to shoot in the factory. He replied, "Sometimes I just sit there and wait for the machines to speak to me."

Pretty good advice, actually. On location, the blood is up, the mind is racing, the juices are flowing, and—just like a big league pitcher waiting for the batter to step in—we can't wait to throw light at our subject. But if we stay calm and really look, we may find that lighting the subject is either wrong or unnecessary. Best perhaps to light *around* it.

Sometimes—not too often, but sometimes—the shape of something is the key to the picture, and if we simply let that shape define itself against a background, it is enough. The X-47A, an experimental Navy drone aircraft, was such a beast. It was so cool and forbidding, all I had to do was separate it from the blackness of the pre-dawn runway, and then just sit back and wait for the little green men to come out. (Then figure out how to light them.)

While this photo looks a bit complex, it is not. My biggest goal was to separate the shape from the ground. The amazing sunrise (thank you!) was taking care of the rest. To do this, I clamped six SB-80DX Speedlights (the precursor to the SB-800) to the rear edges of the wings and aimed them down at the ground. To take care of the foreground, I put two up in the front wheel well, likewise pointing straight down.

I gelled each of these lights with a full cut of CTO to give them warmth, which adds to the glow-y feel of the light. It would have been the wrong move to leave them neutral. The feel of the rising light is spectacular, with gleaming orange highlights, and deep blues and purples mixed in. There ain't no neutral, white light daylight up there. If my lights were pale and colorless, they would draw attention in an uncomfortable and awkward way, same as you would by walking into a heavy metal biker bar in a business suit and a tie and ordering a Perrier. Just not a good fit.

The SB-80DX units were amazingly dependable remote units, with infrared sensors, which meant you could really tuck them into out-of-the-way places and still count on them to fire. In remote mode, they were manual units, which meant you would have to go to each unit and adjust power individually. With the new i-TTL technology, you can make those adjustments right from the master flash or commander unit hot shoed to the camera.

The way I triggered these remote flashes was to put up two larger battery-operated strobes running through strip lights, placed equidistant on camera left and right. I used strip lights because they are long and skinny softboxes, which match up well with the long and skinny wings of the aircraft. However, there is very little effect from these lights. They are really just a cover type of illumination designed to push a minimal amount of light towards the aircraft. More importantly, they act as trips for the SB-80s, which are the lights that are doing the heavy lifting. The bulk of the light on the topside of the plane is actually reflected sky.

This plane was right outta *Star Wars*, and I shot it for a *Geographic* story called "The Future of Flight," so I was going for a glow-y, dramatic, spacecraft look. When we finished up, I thought, you know, pretty cool. All I'm missing here is a bunch of little Martian sumbitches. *Geographic* chose not to publish it. That's the way it goes. □

Goin' Glam and Throwin' Sparks

SOME THINK THAT small flash won't be sophisticated or jazzy enough for high-falutin' subject matter like fashion and glamour. Unless, of course, you are purposely going grunge and shooting downtown club kids with straight flash, or taking a ride on the wild side à la Terry Richardson, who seems to have made a photo career out of making pop-up flash pictures of himself and his friends having all manner of relations.

But when you have beautiful creatures such as Ciara and Risa, in an appropriately scruffy setting like this do-it-yourself, homestyle body shop, small flash can work just fine. It is a matter of putting the flashes where they create real drama and pop, not to mention beautiful color, and then being patient and smart about triggering those flashes.

In both of these pictures, the up-front light is pretty simple. For the impossibly tall Ciara (previous page), with all her dark curls and a pair of legs that could play in the NBA, it was an SB-900 into a shoot-through umbrella, placed high and to camera right. That's it. Because I am working full length, I cannot pull my usual trick of moving the light source super close to her. It is maybe eight feet from her face, which works well, as the light from that distance ends up being edgy and crisp, and pops out the colors of her makeup and the dress.

For Risa (page 275), who can weld with the best of 'em, I introduced two foreground sources—a beauty light combination, one high and one low. The overhead light, placed to camera right, is a horizontally oriented 3x6' Lastolite panel, with two SB-900 Speedlights. The reason for the large size of this source is simple—it covers Risa beautifully, and it also covers the entire front of the photo. I don't have to worry about a second source to, say, light the car. It's done.

The second piece of the beauty combo is a shoot-through umbrella with an SB-800. (We have discussed beauty light elsewhere—the classic tandem of an overhead, or main, light working together with a low fill light placed below the subject's face, out of frame. Very flattering when done properly. The fill light is usually powered to be one or two

"If you look more closely, you'll see the sun
is attached to a C-stand."

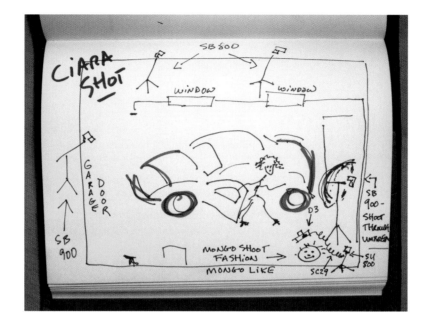

stops lower in power than the dominant overhead light.) The shoot-through is just under the camera lens. The overhead Speedlights firing through the 3x6' panel are Group A, and the low umbrella fill is Group B, so that I can send them separate power messages via the SU-800 commander at the camera, which is a D3.

In both instances, the foreground, or subject, light is done, and relatively simply. But if I let the car barn go untouched, unlit, and therefore shadowy and dark, the setting will be flat and lack depth. There were trees all around, making the ambient window and door light pretty dim, even though it was a bright day. I wanted light—warm, wonderful light—pouring into the garage.

It was easy enough to place them. One light per window, and one way outside the open garage door. Each had a full cut of CTO to warm them up. All had their dome diffusers off and they were zoomed to the max. It was a mix of SB-800 and 900 flashes, so the zooms were set at 105mm for the 800s and 200mm for the 900s.

The key here was not placing the lights, really. That was a piece of cake. The finesse part of the job was locating the SU-800 commander. My camera angle is such that the lens does not see the remote flashes. But my commander has to see them all. In situations like this, the SC-28 or SC-29 cord is essential. I ran the cord up above the camera position, and my assistant, Karen, placed it on a stand with a hot shoe clamp. As I shot, she kept an eye on the backlights to make sure they were receiving the signal. She stayed at the SU-800 stand, peering at the remote flashes, looking for all the world like a submarine skipper at the periscope. "Signal moving left, 10 degrees! Full power on the i-TTL! Plot firing solution!"

For the welding picture, these outdoor remote flashes simply provide some garage color, ambience, and depth. For the fashion shot of Ciara, they became her backlight as well, highlighting her dark hair and skipping off of metal car parts hanging around the shop. Outside the big garage door, there is an explosive highlight that, at a quick glance, looks like the sun. But, if you look more closely, you'll see the sun is attached to a C-stand, which I didn't bother retouching out. It looks like another piece of car junk with an SB-900 dangling from it, and it's fun having it in the shot. Reminds me that you can use these to make the sun, or at least make it stay around just a little longer. □

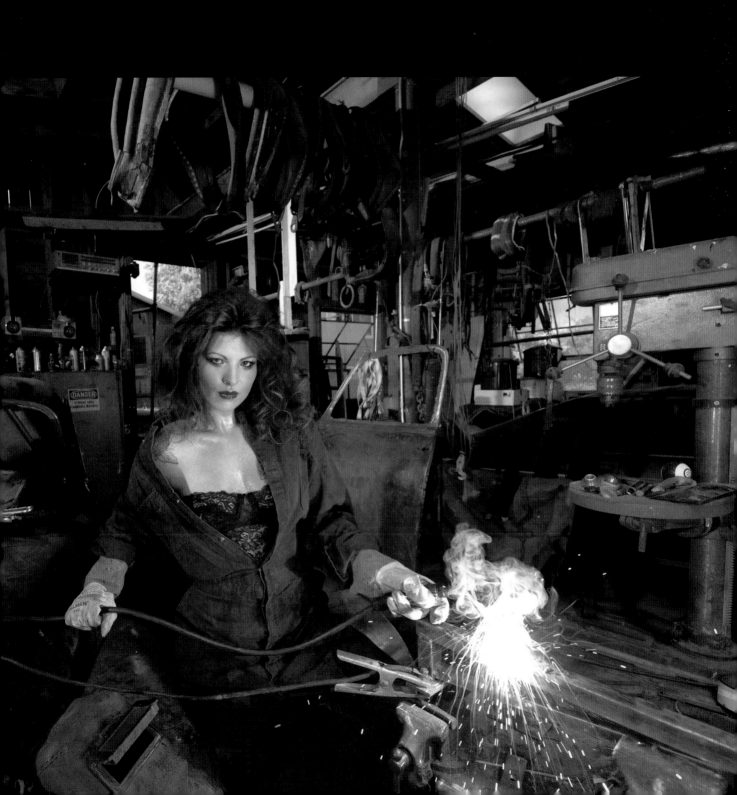

And Now for Something

Completely Different...

DON'T TRY THIS AT HOME. I had access, briefly, to six of the little SB-R200 close-up Speedlights. Cool! What'll they look like all at once?

The R1C1 Closeup Speedlight system comes intact in a case that has the feel of an old-style doctor's bag. Open it up, and there are all the implements one could imagine using for close-up flash photography. It's got two Speedlights, an SU-800 commander unit, rings, diffusers, gels, clips—you name it. It's even got this twisty, bendy arm thing with spring-loaded clamps at the ends of it, called the SW-C1, that looks like it would make for a good set of nipple clamps if you ever got bored on the road.

But the ring thing accommodates six SB-R200 flashes. So I put 'em on, then hot shoed the SU-800 to my camera, and, at the very end of the day, shot this at about one second at f/11. The model looms, and I complement/distort this with a wide lens, low and close. The one-second shutter drag exposes the dark, contrasty detail in the sky.

The attachment ring for all the flashes clips onto your lens right where you attach a filter. The downside to doing this is that your short, handhold-able wide angle lens feels about as front-heavy as a 600mm f/4. That's a lot of flashes out there. But the beauty and experimental fun of the system is that they all behave as if they were one light, and you control the exposure with a touch of a button on the SU-800. Also, given the complete circle effect of the six Speedlights, it really behaves like an i-TTL ring light. And it puts a kinda cool morse code–like, dash-dash-dash catchlight in the model's eye. □

Beach Light

FOR SUPREMELY ATHLETIC BODIES, a rim light is often very cool. By using lights that are winged out behind and to each side of the subject, you effectively draw a line of hot light all around the physique in question, and the heat of that light will help you define the body and give it some glow. A spritzer and some baby oil is also very helpful.

I mention to wing the lights out behind the subject, or into a position I sometimes refer to as "three quarter back." (I mention this in "Some Light Conversation.") If you imagine your camera at 12 o'clock, and the subject is the center of the dial, these rim flashes would then be at 4 o'clock and 8 o'clock. It usually works best to take the dome diffusers off and zoom the flashes a modest amount, about 50mm. It can also be helpful to use multiple Speedlights, though not necessary. (Quick tip: If you are using one Speedlight per side, don't zoom

it too tight, and twist the flash so the long side of the flash head is lined up vertically with your standing subject. That way you'll elongate the highlight along the body.)

Here I used three per side, per stand. They are attached via Justin Clamps at corresponding high, middle, and low positions. This kind of approach has a lot going for it. First, since I was using multiple sources I could zoom these pretty tight and still get a continuous line of coverage along my subject's body. That can be important because the closer you

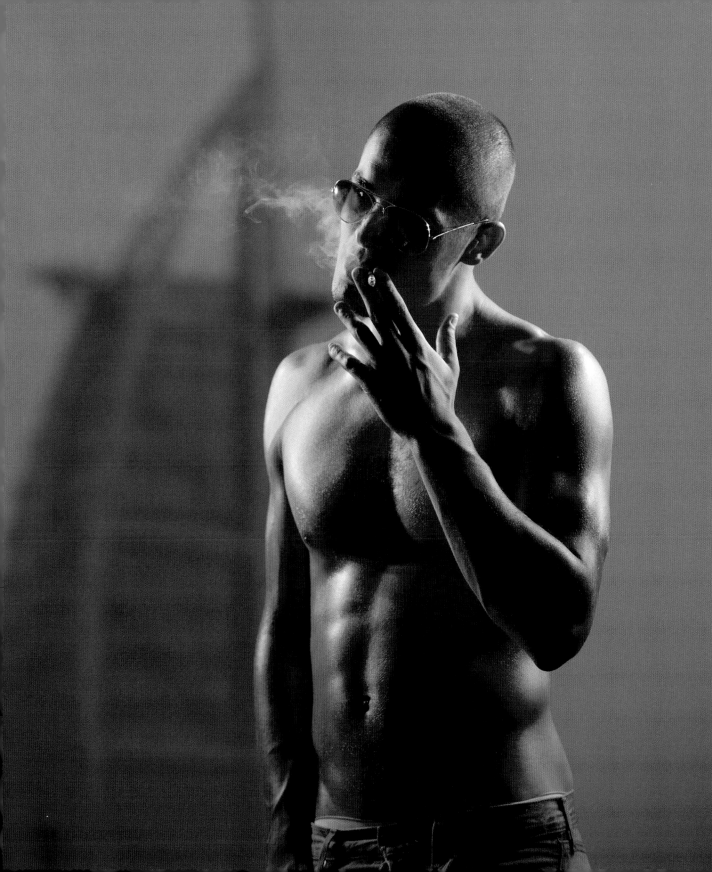

get the light and the wider you might zoom (say when using one light per side), the more likely you will flare the lens. Any time you angle a hard light back even slightly towards camera, you run the risk of nailing the lens with a strong highlight.

If you find yourself in this situation, there are a couple of ways around this. One is simple and cheap: black gaffer tape. Put a couple of short pieces together and "flag" the flash tube off so the lens doesn't see it. (I often use the terms "flag," "cutter," and "gobo" interchangeably, which would get me fired on a movie set. But I am referring to anything that cuts, shapes, or blocks light, and that could be anything from a piece of gaffer tape, to somebody's hand, to my assistant's winter jacket, to a TriGrip, to a 4x8' piece of foam core board in the studio. Whatever it might be, it will make flare go bye-bye.) Very cool stuff called Honl gear has come out recently, if you don't want to go the MacGyver route. The Honl system allows you to velcro on snoots and barn doors that act as directional spots and flags. They can eliminate flare and help direct your light. (Take a look at these in the "What I Use..." section.)

'Cause that's the whole point here—direct, intense, specific light. This creates drama and separates, or rims, your subject out of the background. Even a dead black background.

Or, in this case, with the ultra-cool Salim standing on the Dubai beach in front of the ultra-cool (and expensive) Burj Arab hotel, the high-speed Speedlights beat the background back and subdue it. Via FP high-speed sync, I shot this at 1/8000th of a second at f/2.8. At that exposure, I can draw down the hazy bright Dubai daylight and turn it into a monochrome, drop the Burj out of focus, and turn the athletic Salim into a highly polished piece of sculpture. (This is where the baby oil produces sheen and highlights. Curious that a number of women in the class had no problems volunteering to rub baby oil on Salim to achieve this effect.)

You can shoot two people fairly easily with this type of setup. Just make sure they are each turned out in profile towards their respective flash (or flash tree). The amount of "fill" light, which in this case is the sun, is up to you. You control how dark and contrasty things can get

"The shutter speed controls your ambient light. The light from the flashes gives you the f-stop."

via your shutter speed. The shutter speed controls your ambient light. The light from the flashes gives you the f-stop. Again, when you are using these controls, I liken it to being a chef in the kitchen. Via these controls, you mix the flash and the sun, all in appropriate measure.

The setup pic above is a touch misleading. There you see six light stands, four of them with a single SB unit. This foursome is a second setup, designed so multiple shooters in the class could try different effects. The main setup that produced this picture is, as mentioned, the two C-stands, each with three Speedlights. I snapped this setup pic as a local soccer team walked through our impromptu beach set. All six flashes used for the rim light effect under discussion are going off, a tribute to the sensitivity of the light sensor window on the SB-800. The other units are not triggered because they are set up on a different channel.

The CLS system offers the shooter four channels and three groups. The channels offer multiple shooters the ability to work side by side and not trigger each other's units. Very handy at an event where there might be more than one photographer assigned. Also helpful in a class situation, so that in a confined environment you don't have people literally tripping over each other's lights.

These little flashes will never overtake Mr. Golden Sun. But, via the mechanism of FP high-speed sync, you've got a chance to go out there and give it a fair fight. □

Plane,
But Not Simple

THERE ARE 47 SPEEDLIGHTS of varying types around this aircraft.

"Why?" you might ask. I could wax eloquently about the challenge of it, and the unique problems it posed, and the learning curve, and how after you face a huge problem like this it makes other types of assignments that might have terrified you in the past seem like child's play. All of that hoo-hah would be true, actually, in degrees.

But, to be perfectly candid, I'm a freelance photographer, and I was offered money to do it, so I said yes. And that's fine. I've been a freelancer for the better part of the last 30 years, and the constant challenge of moving forward and staying alive is a lot about turning your time behind the camera into money. I am unabashed about this.

When Nikon approached me to use a large number of Speedlights to demonstrate their scope and capacity to light a big space for a training video for the Air National Guard, I thought it would be cool, and hard. But I thought it would be cool first. I jumped in with both feet.

There were lessons to be learned, for sure. (We used SB-80s, 26s, 50s, and even some 30s.) All had internal optical triggers, and all had to be positioned so the camera couldn't see them but they could see each other. The terrific thing about it, for me, was using light upon light to create depth in the photograph.

All photographs have three basic areas: foreground, middle ground, and background. Light is one of the principal tools we can use to create interest in each of these three areas. If you stop short and you don't light through a picture like this, you lose some interest and depth. Hence the lighting grid here extends all the way back into the hangar.

The other challenge here was lighting *within* the photo. It is one thing to establish your field of frame (i.e., what the camera is seeing) and then light from the perimeter, outside that frame. From a safe, unseen vantage point you are lobbing light onto your subject. But in this instance, a lot of the lights had to be in the frame itself. How do you light the subject you are shooting with lights that are in and around that subject, and not see 'em?

One strategy is to move stuff into the photo that would logically carry light anyway. Thank you, mechanic's cart! That baby plausibly carries a light with it, or at least can support a guy with a flashlight. Plus, positioned well, it can hide a bunch of lights.

Also, many thanks to the various trap doors, equipment hatches, wheel wells, and cargo openings of the KC–135. With some clamping (this was pre-Justin Clamp times, which made hanging small flashes an adventure) we were able to tuck away a ton of lights in the nooks and crannies the airframe presented to us.

But given the line of sight, tucking some too thoroughly up and away caused the light sensor to be blocked. If a unit doesn't see another light, it'll just be a bunch of useless weight on the runway. To overcome this, we used some of the Speedlights not to light, but just as trip lights, to fire other units. If I could just get one Speedlight in a doorway or a cockpit or a wheel well to fire, its neighbors would almost certainly fire. It became a game of sneaking light around corners and triggering another, which

would then fire and trigger a bunch. It was like playing a very large game of dominoes. Topple one, and they all go.

As I mentioned, we daisy-chained 47 of these puppies out there, and even had the base fire department come in and wet the tarmac, very carefully. (That actually helped the line of sight, ratcheting up the reflectance and surface bounce I was getting off the ground. Never thought of that advantage before this, but boy, it made me wish I could take a fire truck to all my location shoots.)

My memory is shot at this point, and I somehow fixated on having used 53 units during this shoot, and even blogged that number a while back. Hmmm. 53?

That was the number that stuck in my head. I kept thinking on it and, in the interests of veracity, accuracy, and all that stashed-up guilt from being raised Irish Catholic, I did some research and the official number came back as 47. The source here is Bill Pekala, the General Manager of NPS (Nikon Professional Services) over at Nikon, who worked the shoot with me and has a mind like a bear trap for all things photographic. Great guy. A photog's friend, in a word, who leavens his photo discourse with various down-home Tennessee-isms that are part country wisdom and part Nikon manual.

Dunno why 53 stuck with me. It might have come from chewing the fat with Bill over a couple of beers, and doing the old "Remember when we lit up that KC–135 with like 50 or so flashes?" type of thing. I'm sure some day in the home, on the porch, in my wheelychair, it'll be up to 103, and somehow the entire mission will mysteriously acquire an

"If you stop short and you don't light through a picture like this, you lose some interest and depth."

element of danger. "Remember all those flashes? They ran on steam, remember?! Damn dangerous! Had to wear a bomb suit just to handle 'em!" This conversation will, of course, be attended to by the rolled eyes of those who can hear me say anything, and the odd cackle or two.

I should have remembered, of course, 'cause I made a precise diagram of the lighting pattern. □

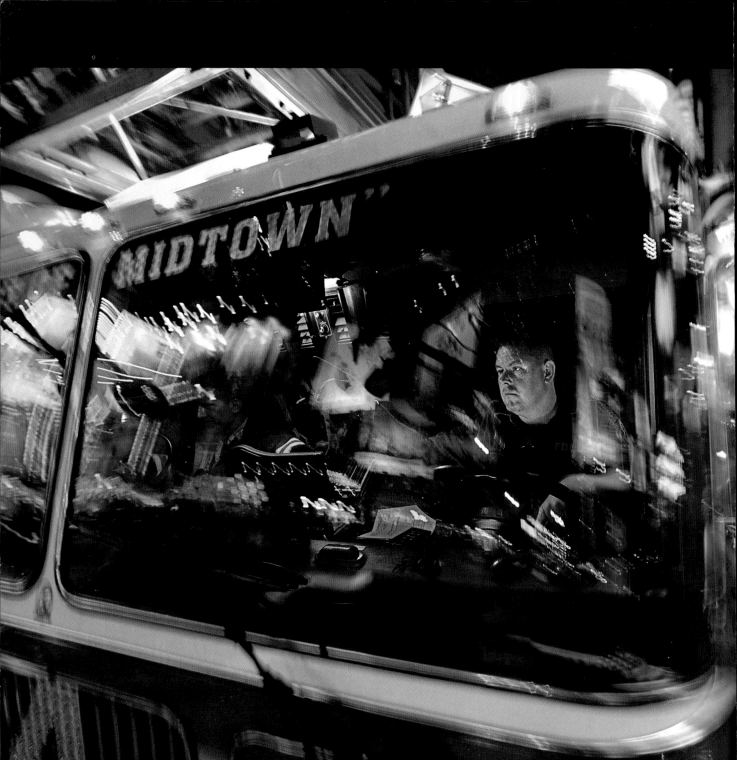

Rollin' with Pride of Midtown

PRIDE OF MIDTOWN. That's what the 54 house calls themselves. They are unquestionably the most popular and most photographed firehouse in New York City. Literally millions of tourists are spread around the world, at home, with pictures of this house and "the guys." In terms of runs, they are the busiest fire company in all of New York.

The guys are incredibly patient and easygoing about the constant stream of pedestrian traffic that flows in front of their doors, and the resultant, endless requests for photos and a smile.

 I got to know this house a bit after 9/11. Richie Kane, the driver on 4 Truck, and a heckuva shooter himself, always told me, "Hey, you wanna hang a camera and roll the truck, we'll do it for you."

Strategy-wise, it's good to do this with a ladder truck and not an engine, 'cause the up-top ladder gives you a base of operation and a sturdy, extended platform to hang your rig from. The gear needed to do this pic:

- Four Bogen Magic Arms, each with two Bogen Super Clamps
- One heavy-duty Gitzo monopod
- One SC-29 Off-Camera AF TTL Cord
- One D700 with 14–24mm f/2.8
- One SU-800 Wireless Speedlight Commander
- Three SB-800 AF Speedlights with SD-8A High Performance Battery Packs
- Three Justin Clamps
- Gaffer tape; gels; ballhead; metal cable lanyards; zip ties; Pocket Wizards

Get the main light positioned first. Here, that is pretty much standard placement—something on the dashboard, affixed with a Justin Clamp and a full CTO warming gel. The flash from here, muted and adjusted properly, simulates instrument-panel glow, at least in theory, though these shots have been done so often that everybody knows a flash is down there.

Okay, one flash is not enough. The cab of the truck is large, and black. More punch is called for, or the driver will look like Dracula on a high-speed run to the blood bank.

Had the notion that I could maybe hide a flash behind and some-what obstructing the rear view (which is okay, given the way Richie drives). This flash got a heavy red gel, and then some gaffer tape

The main thing to remember—whether you're hooki
your camera to a fire truck or to your son's bike
handlebars—is to get the camera angle nailed right
where you want it."

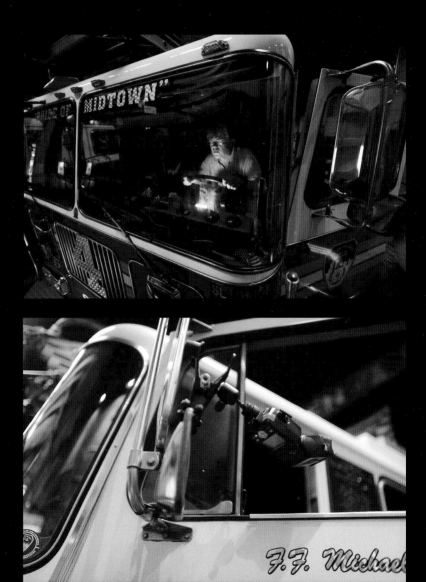

treatment, and a series of zip ties to make sure it didn't go missing during a run.

All the while, you have to finesse camera placement and angle. I'm at 14mm on the zoom and the camera is upside down for convenience sake. (Hey, it don't know.)

First few tests showed we had to bury a third flash in the cab, filling the passenger side just a touch. Again, trying to avoid the big-black-hole-in-the-photo type of deal. But three SB-800 remote flashes have to see the monitor pre-flash from the

SU-800 Wireless Commander. We hot shoed it—no go. This is where the SC-29 off-camera cord is invaluable. Pop the SU-800 onto the SC-29 cord, then run that SU-800 out along the monopod, lock it into place with another Bogen Super Clamp, and boom—the Speedlights see the signal and you still have full wireless i-TTL. I could have programmed the flashes into SU-4 mode and popped 'em with Pocket Wizards, but then I've got three flashes to ratio manually, and I'm crawling all over the truck, sometimes in the street off a run.

I'd rather play with the values from one source (the SU-800) and program flash punch from there. It's talking to the camera, and vice versa, so there will be a natural variation to the feel of the light as the truck zooms from light to dark areas of the street. I put up with this variation, and actually embrace it, 'cause while there are occasions where the flash/exposure value will go wacky and you'll lose the frame, I can't tell you how often that wireless evaluation of a fluid, changing-exposure situation has come back right on, and saved my butt.

A shot like this is strictly the province of wireless Speedlights. Small, powerful, and controllable. You don't do this with larger battery-pack strobes. The ability to hide the lights is just as important as the light itself. We ended up using three lights—all gelled, all hidden, but still able to see the i-TTL signal from the SU-800 extended by the SC-29 cord. I'm pretty decent at locating that trigger unit so the flashes can see it. I think it comes from years of laziness, laying in hotel beds (they're so comfy at Motel 6!), trying to drown out the noise of the truck traffic that's rattling by on the multi-lane freeway that is just yards from my window and just past the

motel dumpster, which is, in fact, right under my window. I channel-surf like crazy, trying to numb myself to sleep. Often, the TV remote doesn't work well. So I bounce it off stuff—the ceiling, the head-board, a pillow, the Pizza Hut box, anything that might spread the signal and get it to the damn TV. I mean, I wanna efficiently bounce back and forth between *American Chopper* and *Judge Judy* and I don't wanna be gettin' in and outta bed, ya know? I apply those same bounce principles to the camera's commander unit, be it a Speedlight or an SU-800, or even the pop-up flash.

In addition to the quality and placement of the light, ya gotta deal with the color of the light. Here I was like an actor going over the top with a role—you could go flat-out color crazy, 'cause you got one of the world's biggest concentrations of neon rolling right outside the windows of the truck. White light not wanted! I went for warm tones (plausible inside the truck), and for the accent light I went red. Between the traffic, the movie marquees, and the emergency lights of the truck, it was a color playground.

The camera's kinda out there, right in the middle of it. I'm pretty nervous 'cause New York City streets ain't exactly the Autobahn. I use the Manfrotto Hydrostatic ballheads pretty religiously, but opted here for the Really Right Stuff system, 'cause I was unsure whether I would go horizontal or vertical, and the RRS L bracket seemed to make sense. Still, I got lots of gear hanging off a monopod that, when the truck is really rolling, is out there bouncing around like a swizzle stick. Plus, it was Mike Corrado's D700, an IP model no less. It would have been hard to explain to the powers that be at Nikon that it

got crushed by a fire truck. That's where more zip ties and cable lanyards came in. I didn't want the camera disappearing under the wheels of the rig or, worse, flying through Richie's windshield. (In the interests of safety, and given the fact that this was a live fire vehicle, Mike, Richie, and I rehearsed getting the clamps and the monopod off the ladders. We got it down to about 30 seconds, within limits in case of a call.)

Had some misses, but got a couple of real good hits from this solution. Richie rolled the truck, and I got in behind him with a bunch of firefighters and drove the camera with a Pocket Wizard. The main thing to remember—whether you're hooking your camera to a fire truck or to your son's bike handle-bars—is to get the camera angle nailed right where you want it. Then reverse engineer the rigging you need to get the camera to that spot. You'll invari-ably make compromises when you do this (I can't tell you how often I have wanted a Dick Tracy hov-ercraft on location so I could fly the camera exactly where I wanted it and just hang with it there), but often, with a little ingenuity and some basic brack-ets and clamps, you can get your camera out there. Once you have the angle, the logic of the light flows naturally. Where are the dead spots? Where can I hide a light? It's kinda like reading a treasure map or looking for Jimmy Hoffa's body. Forensic lighting! ("Sir, it appears as if a heavy-caliber Speedlight was used. From the angle of the photons, it must have been hidden somewhere on the dashboard, out of sight, of course.")

A job made for small flash. Actually, a job not possible without small flash. □

Appendix: What's This Button Do?

THE NIKON SB-900, SB-800, and SU-800 Wireless Speedlight Commander can be used to control other SB-900, SB-800, SB-600, and SB-R200 Speedlight units wirelessly. To do so, the SB-900 or SB-800 Speedlight must be connected to any i-TTL–compatible camera's hot shoe to enable these Speedlights (or SU-800 Wireless Commander) as a "Master Flash Unit." In other words, check your camera's manual. This wireless stuff generally applies to the recent generation of DSLR cameras.

Setting the SB-900 as a Master Flash Unit

(Say the above using the voice of Optimus Prime from the *Transformers* movie.)

Set the SB-900 to the Master mode by using the Power ON-OFF switch/wireless setting switch. One click, the unit is on as a TTL flash. Press and turn the power switch one more click, and it's a remote. Press and click up once more, it's a master. This is nice. Easier than the 800.

1. Turn the switch while holding down the button in the center. Did I already say that?

2. Align the index on the Power ON-OFF switch/ wireless setting switch to MASTER. Done!

Setting the Flash Mode, Flash Output Level Compensation Values, and Channel Number on the SB-900 Master Flash Unit

1. Press the Function button 1 on the Master flash unit to highlight "M." Function button 1 is the far-left button.

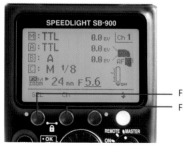

Function button 1
Function button 2

2. Press the MODE button, then turn the selector dial to choose the desired flash mode, and press the OK button. Or, you can just keep punching the MODE button, same way you do with the 800.

TTL Through The Lens

A Auto Aperture flash

M Manual flash

--- No light output (Although in M --- a pre-flash will occur! This is where it might be confusing. It looks like it is flashing. Relax. It is a pre-flash, not an exposure-making flash.)

3. Press the Function button 2, then turn the selector dial to choose the desired flash output level compensation value, and press the OK button.

4. Press the Function button 1 to highlight Group "A." (Turn the selector dial to choose a group other than "A.")

5. Repeat steps 2 and 3 to set the flash mode and flash output level compensation values of the remote flash units in Group "A."

6. In the same way as with Group "A," set the flash mode and flash output level compensation values of the remote flash unit in Groups "B" and "C."

Note: After setting the output compensation value, press OK twice to reveal "Ch" above Function button 2. This is important, believe it or not. I have forgotten this little two-step and been very frustrated trying to change my channels. Remember to punch the OK button in the center of the selector dial twice to get the "Ch." Then you can change channels.

7. Press the Function button 2, then turn the selector dial to set a channel number and press the OK button.

See the padlock symbol running between Function buttons 1 and 2? If you simultaneously depress those two function buttons, you will lock the settings you just made. Not a bad thing to consider, 'cause if you're like me, you'll thunder-thumb your way around the back of the unit and inadvertently change the values or the channels. Depress them again together to release the locking function.

Setting the SB-800 as a Master Flash Unit, or, People with Really Big Thumbs, Go Buy an SB-900

1. With the unit on, press and hold SEL for two seconds. The display will change.

2. In the first four-box grid that comes up, the wireless symbol box—with the Speedlight symbols and the squiggly lines—is the one at the upper right. Toggle over and it will highlight.

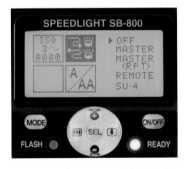

3. Press SEL for one second. The one ↑ will change to two ↕ and the OFF selection on the right will become shaded. Now you can scroll through the options, by toggling up and down (+/-).

4. Scroll down and select MASTER by highlighting it and pressing SEL for two seconds. (You can also tap the ON-OFF button as a shortcut.) The display will change to the Master view. The Master view comes up with M and A active as flashes. You can tell they are active by the fact that they have a compensation value reading next to them: "0.0." Whenever M or any of the Groups A, B, or C are active as remote flashes, they will have a compensation value next to them. They are inactive if they have three dashes (---) next to them.

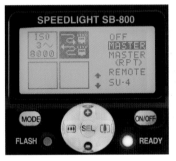

5. Press SEL to highlight "M." By pressing the +/- buttons, you can change the flash output compensation value for the "M" group. Pressing MODE while a group (M, A, B, or C) is highlighted will change how the Speedlights in that group will react.

 TTL Through The Lens
 A Auto Aperture flash
 M Manual flash
 --- No light output (Although in M --- a pre-flash will occur—again, this can be confusing.)

Press SEL to jump from Group M to A to B to C. Set the amount of flash output compensation for each group using the +/- buttons.

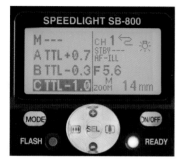

6. Use SEL to highlight "CH" and use the +/- buttons to select the channel you will be working in. (There are four channels, allowing multiple photographers using the Nikon Creative Lighting System to control their own Speedlights.)

Note: The channel you choose for the Master Speedlight must be the same channel the remote units are set to. Make sure you check this. With multiple Speedlights firing and pre-flashing, it is often hard to tell when one is not working. Double-check that you have all the flashes on the same channel.

7. Attach the Master Speedlight to your camera.

If you ever get into the woods with the SB-800 and can't figure out where the heck you are in the menus, simultaneously depress the MODE and the ON/OFF buttons, to the left and right of the white SEL button. The unit will default back to a regular TTL flash setting, and you can start all over. Also, on the back of the white fill card, there is a cheat sheet. No one ever reads it because no one ever uses that white bounce card.

Note: During shooting, if you wish to change the power output of the remote flash units, do so from the Master SB-900, SB-800 or, if you are using the built-in flash, you can do it here, too, from the camera menu. The change will take effect immediately. That's what they mean by wireless, right? You don't have to walk over to the unit to change the power.

You can still read the instruction manual if you want, and I guess I have to say that so somebody doesn't get irate about a piece of minutiae I haven't mentioned here, but to get a flash going as a Master, the above is all you need to know. The SU-800 is a Commander unit, in effect a Master flash without being a flash. Very good little unit, less expensive and smaller than using a flash unit as a Master. The LCD is simple to sort out. If you can program a 900 or an 800 to be a Master, you can figure out the SU-800. Trust me on this.

Using the Built-In Flash on the D80, D90, D200, D300, D700 as a Commander Flash

The built-in, or "pop-up," flash on these models can be used as a Commander flash to trigger remote Speedlights.

1. Go to the camera menu. That means you hit the Menu button.

2. Go to the Custom Settings menu. That is the pencil symbol/icon on the far left, just under the camera symbol.

3. Highlight and select Bracketing/Flash. Consult your camera's instruction manual for the Custom Setting number for your particular camera model.

4. Select Flash control for built-in flash.

5. The default is TTL, so toggle down to "C" for "Commander Mode." Toggle right.

6. Grid comes up. Options will vary according to your camera, so here you should go back to your manual for your particular camera model.

7. But—this is key. If you do not want the built-in flash active, and you wish to drop it out of the final exposure (basically we are talking about just using it as a trigger), when the TTL box is highlighted next to Built-in flash, use the multi-selector wheel to toggle up or down until you see two dashes (--). Now the built-in flash is just set to trigger your remote units. Another key thing to remember, folks: Pop up that little flash.

Now you can continue to activate either of your other groups. Toggle right, and you will start to highlight the REMOTE GROUPS. Toggle through them as you wish, and dial "+/-" into each group.

And a note from the Telling You the Obvious category: Make sure you choose the appropriate channel.

Note: Remember to hit OK before exiting the menu. If you don't, all the crap you just did will not take, and your photo won't look anything like what you anticipated, and you will have to go back into the menu and do all this toggling hoo-hah all over again.

More Buttons: Remote Wireless Flash

The Nikon SB-900, SB-800, SB-600, and SB-R200 Speedlights can be set as remote units and can be triggered by using an on-camera SB-900 or 800 set in "Master Mode"; or directly from the built-in flash on the D80, D90, D200, D300, or D700; or by using the SU-800 Wireless Commander.

Setting the SB-900 as a Wireless Remote Unit

You can set the SB-900 for remote operation using the Power ON-OFF switch/wireless setting switch. It's in the lower right, by the way. I make a game of it, and try to set this one-handed using my thumb. (It's the little things that amuse you on location.) The 800 is definitely a two-handed operation, or one hand and the tip of your nose or chin.

1. Turn the switch while holding down the button in the center.

2. Align the index on the Power ON-OFF switch/ wireless setting switch to REMOTE.

This is three clicks of that button. I mean, you're making the unit a remote, right? So this makes sense. Cool. Much simpler than the 800.

Setting a Group and Channel Number on the SB-900 Remote Flash Unit

1. Press the Function button 1, then turn the selector dial to choose a desired group name, and press the OK button.

2. Press the Function button 2, then turn the selector dial to choose a desired channel number, and press the OK button.

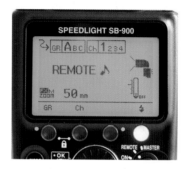

Note: Be sure to choose the same channel number as set on the Master flash unit or in the Commander mode on your camera. Okay, okay. Remember you can lock these up if you want.

"Read what the LCD is telling you. It is your friend."

Setting the SB-800 as a Wireless Remote Unit

1. With the unit on, press and hold the SEL button for two seconds. It sometimes can take more time—I think it depends on how fresh the batteries are, but that is a guess on my part. It seems like forever when the sun is setting and you are trying to do a portrait at the last minute of the day.

2. Locate the shaded box and use the toggle to highlight the squiggly lines (the wireless symbol box).

3. Press SEL for one second. The one ↑ will change to two ↕.

4. Scroll down and select REMOTE by highlighting it and pressing SEL for two seconds. The display will change to the Remote view. It says REMOTE in large letters. Read what the LCD is telling you. It is your friend.

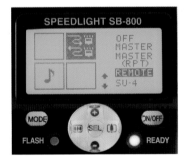

5. Press SEL to highlight "CH," and use the +/- buttons to select the channel. (The Remote and Master units must be set to the same channel or they will not communicate. Duh.)

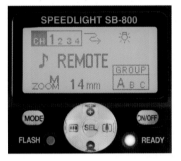

6. Press SEL again to highlight the group. Use the +/- buttons to choose Group A, B, or C. (The amount of output compensation set for Groups A, B, and C on the Master flash will determine the amount of output from the Remote Speedlights. That's why they call it the Master. Wild guess on my part.)

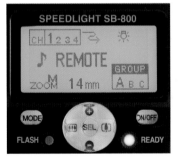

You will notice that I do not show how to set up the SB-600 as a Wireless Remote Unit here. That's because I never use them anymore. Spring for the dough to buy an 800 on eBay, or get a new 900. ☐

Index

light
 artisan, 174–176
 available, 100
 balance of, 18
 beauty, 218, 272
 color of, 35
 creative use of, 100–101
 direction of, 36
 doorway, 56–57
 flick of, 89, 92, 264–266
 fluorescent, 109–111
 hard, 179–181
 parking-lot, 152–153
 quality of, 36
 redirected, 263
 smooth, 182–185
 window, 56–57, 112, 154–157, 177–181
 See also flash
light shapers, 26–27
light stands, 25–26
lighthouse keeper, 80–81
Lumiquest attachments, 26–27
 Big Bounce, 27, 85, 164
 Lumiquest 80-20, 27, 109, 111, 164

M

magenta filter, 70, 168
Maine characters, 248–253
manual exposure mode, 8, 14, 93
Master flash units
 SB-800 settings, 295–296
 SB-900 settings, 294–295
matrix metering, 8–10, 65
McNally, Caitlin, 106
McNally, Claire, 105–106, 184, 246
metering modes, 8–10
military portraits, 58–62, 204–207
Miller, Jody, 130–135
mirror sunglasses, 247
monitor pre-flash, 17, 87
MRI scans, 262, 263

N

NASA photography, 115

National Geographic, 51, 57, 115, 130, 134, 269
neutral density filters, 127
New York *Daily News,* 9, 41
Newman, Arnold, 36
Nikon CLS system, 30
Nikon Speedlights. *See* Speedlights
noir crime shots, 231–235

O

office portraits, 195–199
outrigger canoes, 136–140

P

parking-lot light, 152–153
parties, 105–107
Pekala, Bill, 285
plants, 141–142
pop-up flash, 162–164, 297
portraits
 backyard studio, 260–267
 beach, 278–282
 close-up, 276–277
 corporate, 195–199
 desert, 254–259
 garage, 248–253, 270–275
 glamour, 216–220, 270–275
 group, 224–229
 lighting for, 94–97
 military, 58–62, 204–207
 quick rigs for, 170–173
 water, 60–62, 146–149
pre-flash, 17, 87
ProMax system, 26–27

Q

quality of light, 36

R

R1C1 Closeup Speedlight system, 277
rainy night, 152–153
rear curtain mode, 13, 14
red eye, 14
redirected light, 263
reflected images, 247